A CALL
TO VISION

A Call to Vision

A Jesuit's Perspective on the World

BY DON DOLL S.J.

MAGIS PRODUCTIONS

CREIGHTON UNIVERSITY PRESS
OMAHA, NEBRASKA

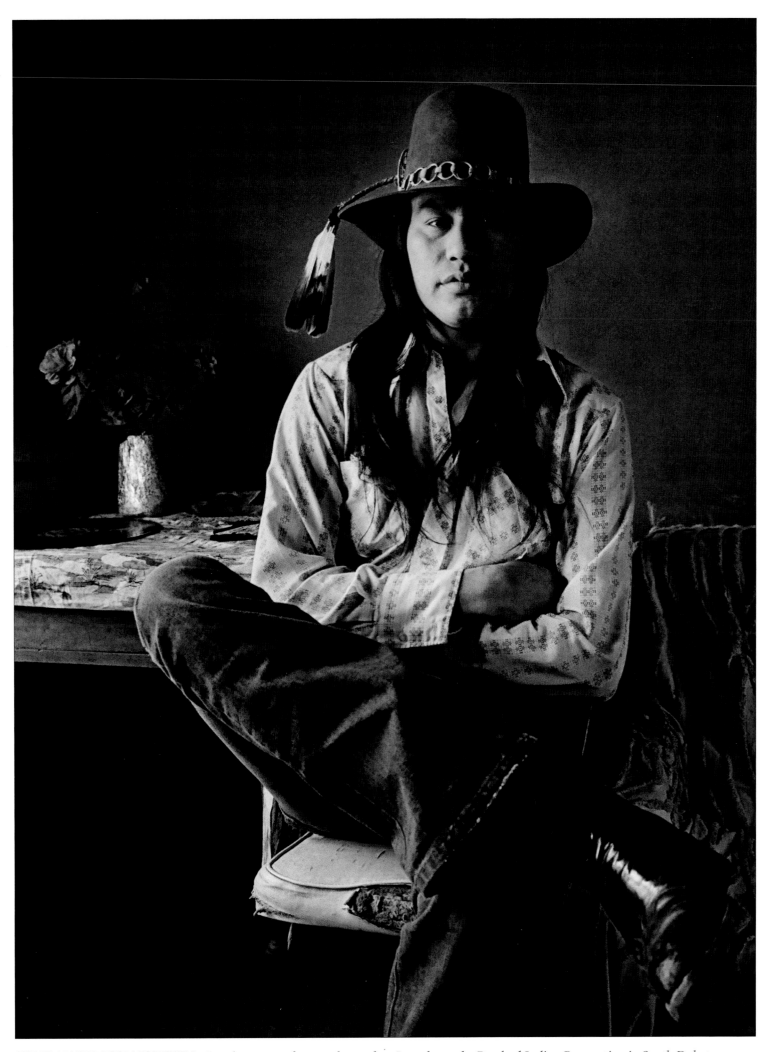

SEWEL MAKES ROOM FOR THEM · *Sewel was one of my students when I taught on the Rosebud Indian Reservation in South Dakota.*

ON THE COVER · *As I was walking along a trail below Mount Everest in Nargarkot, Nepal, with Cap Miller, S.J., a Jesuit anthropologist who spoke the local language, we came upon an 89-year-old woman cutting grass for her single cow. As another person appeared on the trail, she folded her hands and gave the traditional Buddhist greeting, "Namaste." Translated, it means "the divine in me worships the divine in you."*

I AM GRATEFUL TO GOD, TO MY BROTHER JESUITS, MY FAMILY, MY FRIENDS, AND TO ALL WHO HAVE SHARED IN MAKING MY "VOCATION WITHIN A VOCATION" POSSIBLE.

In particular, I am grateful to FR. MICHAEL MORRISON, S.J., and CHARLES AND MARY HEIDER. It was Fr. Morrison, former president of Creighton University who created the Charles and Mary Heider Endowed Jesuit Chair with a generous gift from Charles and Mary. It provided me with the time and resources necessary to complete many creative endeavors, including this book.

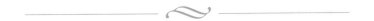

EILEEN WIRTH, PHD, my friend and colleague made A CALL TO VISION a reality with her skills as an interviewer and writer. For a year we met regularly as I told her my story, to which she applied her considerable word-smithing skills. I am grateful for Eileen's assistance in bringing this work into the world. Without her dedication it would not have happened.

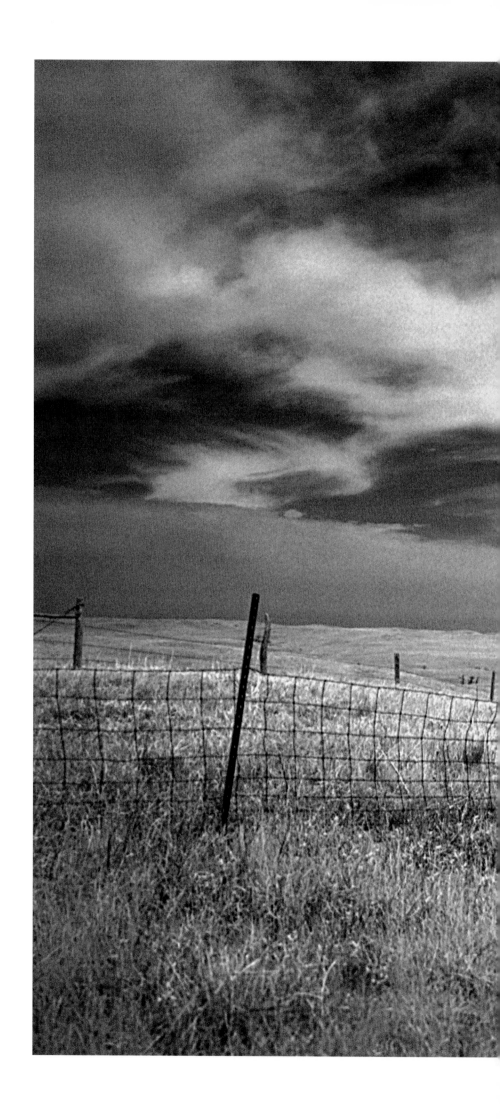

Upper Cut Meat church cemetery, along Highway 18 on the Rosebud Indian Reservation in South Dakota.

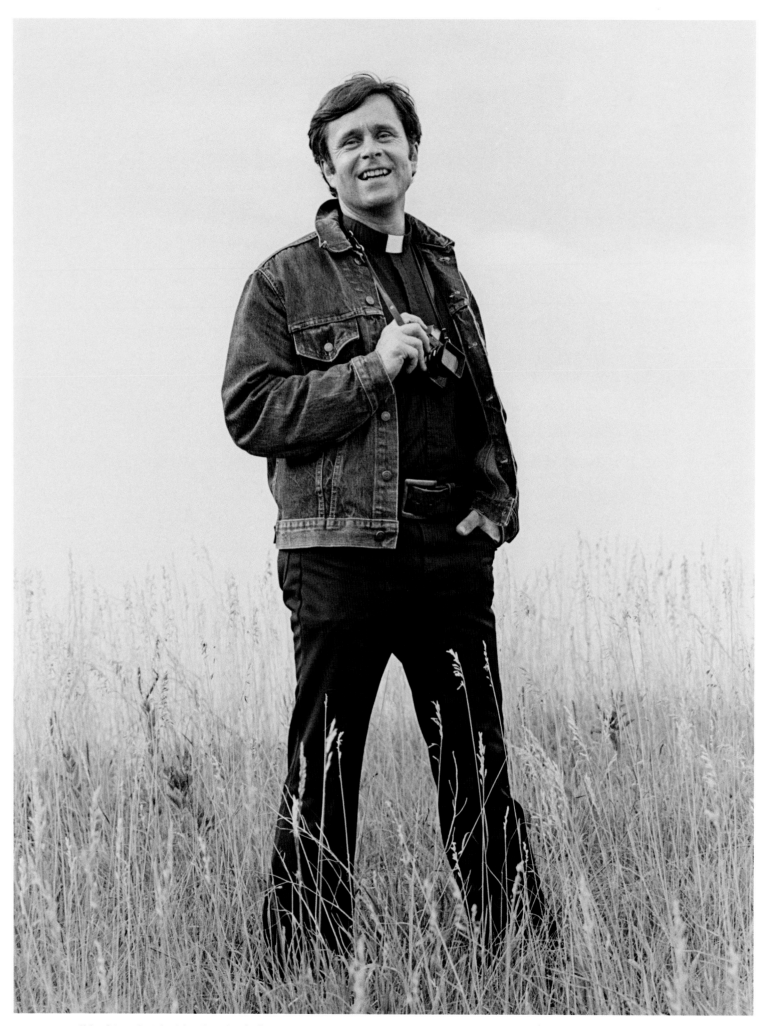

In 1976, Doll had just finished his first book, "Crying For A Vision." Photograph by Jim Strzok, S.J.

INTRODUCTION

FATHER DON DOLL S.J. spoke to a group of Indiana University photojournalism students a little more than three decades ago when I was a student in Bloomington, and that is where we met. His photographs were stunning, and they made a lasting impression on my fellow students and me. He showed documentary picture stories about the daily lives of the Yupik Eskimos in Alaska and Native Americans in the Dakotas. He also talked about his experience of being on assignment for National Geographic magazine. But what impressed me the most, I remember, were the black-and-white photographs he made that documented his mother's battle with cancer and his family's efforts to assist and comfort her as they struggled with their own grief and loss. I had never met a photographer who had the personal courage to photograph, and then to show, such an intimate and personal picture story.

He shared the teaching stage that day with the legendary Associated Press photojournalist Eddie Adams, the photographer best remembered for his iconic "Saigon Execution" picture from Vietnam that won the 1969 Pulitzer Prize and changed the course of public opinion about America's war in Southeast Asia. And while I was impressed by the iconic journalist Adams, with his gruff and worldly persona, it was the intimate and soulful images of a gentle and pained people who had been photographed by Don that I most remember from that day.

After the seminar I asked this cleric for his business card. It was minimalistic. Under "Don Doll S.J." it simply said, on a solitary second line, "Priest. Professor. Photographer."

My comeback was, "You have three jobs?" Don's response was, "No ... it's all really just the same job. But that's how people tend to define me."

> To Don, his photographic subjects, his students, and his parishioners are all one: the children of God.

It's true, we often seem to need to define people with a title, either for their accomplishments or for the role they play in our lives. But to see just who this Jesuit priest from Wisconsin really is, one needs to step back far enough to see the bigger picture, and to look at the journey of his life over a series of decades. Because what we call him, and what he really does in life, are not quite the same things.

Don Doll is a connection, a bridge, and a man of vision.

As a priest he is a connection between God and the faithful, the spiritual, and those who seek a relationship with a higher power.

As a professor he is a bridge between a lifetime of knowledge and experience and his eager students.

As a photographer his images have been published in magazines and books around the world. His personal vision of the lives of his global subjects – as seen through his eye and his camera – has taken us to places we could never have reached on our own. Sometimes his stories would have been too tragic and painful to experience ourselves.

Using photojournalism as a tool while responding to his personal call to vision as a priest, Don has spent a lifetime teaching and preaching and sharing thousands of candid and storytelling moments. His photographs – many of them gathered here – illuminate for viewers the very human experience of people who are traveling on a spiritual journey. From his earliest days on the Rosebud Indian Reservation, until today at Creighton University in Omaha where he is the holder of the Heider Jesuit Chair in the Department of Journalism, Don is living out in a singular way the three definitions of his life that we've placed upon him. We may fall into the trap of seeing him through our three defined lenses. But to Don, his photographic subjects, his students, and his parishioners are all one: the children of God, to whom Don responds accordingly.

The photographs that follow represent moments from the life of faith Don has lived since he was ordained in 1968. He has used prayer and his cameras to interpret a vision of the understanding that God has for his people. If you are seeing his work for the first time, I know you'll likely feel the same way I did those many years ago. Here is a man who heard a calling from God and responded to it as a life-long act of contemplation via documentary photojournalism. His photographs encourage us to also see the world and its people in the way that God urges us to understand and empathize. For Father Doll's call to vision, and for his lifetime of teaching us a new way to see as well, we are grateful.

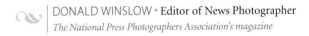

DONALD WINSLOW • Editor of News Photographer
The National Press Photographers Association's magazine

THE CALL

IN MY MIND'S EYE, I can still see the rolling sand hills of South Dakota on a beautiful, cool November night with the hint of sage in the air. That was more than 50 years ago. I had been teaching for three years at St. Francis Indian Mission on the Rosebud Sioux Reservation and I was perplexed.

What was I going to do with my life? I wanted to be a Jesuit but what kind? I had merely survived the three years of studying philosophy that preceded my assignment to St. Francis so that ruled out continuing in theology or philosophy. While I enjoyed teaching and coaching seventh and eighth grades at our Native American boarding school, I couldn't see doing it for life.

I loved riding horses and working on the mission ranch, but there weren't many Jesuit cattlemen. I liked hunting deer and pheasant, but that didn't take me anywhere either.

As I walked alone on that pivotal evening, I thought about photography. During my first week on the reservation, one of the other priests asked if I would be interested in learning photography to help with the mission's new fundraising campaign. I enjoyed that experience with photography so much that I kept at it and even began rolling my own film and printing the results in the darkroom at the school. Also that year my good friend, Dick Hauser, S.J. and I started the school's first annual, so I also got a taste of doing photography layouts.

But was photography the answer? After two years, I had only taken one marginally good photograph. It didn't seem to be going anywhere. Then I had an "Aha!" moment. It was like a voice speaking from deep within: "Stay with photography. It's the first thing you loved doing. Don't worry if it takes 10 years."

Today we call those types of moments "the voice of the Spirit speaking deep inside one's heart." I had found my vocation in photography within my vocation as a Jesuit.

During the summers of my Rosebud teaching experience, I studied at Marquette University with a photography instructor who taught me how to read and edit the contents of a photograph. That was a profound experience in my development. He also hired me to photograph for his publication, giving me the confidence to continue on.

While I was studying theology at St. Mary's and St. Louis University between 1965 and 1969, several of my fellow seminarians and I traveled to Omaha to give retreats at Creighton University. That's when I met the founder of the Department of Fine and Performing Arts, Lee Lubbers S.J. He asked me to exhibit my photographs in the university gallery. It was my first exhibit, although today I'd be embarrassed to show those images. Lee also invited me to come back to photograph the Omaha Ballet's production of "Nutcracker." Lee opened the doors for me to teach photography classes at Creighton.

I taught half-time and worked half-time in campus ministry at Creighton. After that year I knew that I wanted to teach photography full-time. Happily in 1970 Creighton offered me a job, splitting the courses between Fine Arts and Journalism. I've been at Creighton ever since.

> I loved riding horses and working on the mission ranch but there weren't many Jesuit cattlemen. I liked hunting deer and pheasant but that didn't take me anywhere either.

Looking back, I marvel at where the Spirit has led me since that night in South Dakota. Now before I make a picture, I often pray silently for my subjects. Perhaps they even sense my prayers. I want to respect them as a son or daughter of our common Father. Prayer has been as much a part of this journey as my omnipresent camera.

I have been blessed to have lived this journey. My dual identity as Jesuit and photographer has given me access to people who would never otherwise allow their picture to be taken. I have photographed life in an Alaskan village for National Geographic and captured both my mother's death from cancer and the birth of a child of close friends.

I was the official photographer in Rome for the election of a new Jesuit superior general. And I have returned many times to the reservations, producing two major photo books on Native American peoples. Every year I photograph children in their dance regalia for fundraising calendars for two Native American Catholic schools in Nebraska and South Dakota.

I have traveled to nearly 40 countries, often photographing the victims of wars and violence. I have been to refugee camps throughout Asia and Africa, photographed child soldiers in Angola, land mine victims in Sarajevo, and photographed fellow Jesuits ministering to the poor and disadvantaged in many parts of the world.

I invite you to share my 50-year journey as a priest-photographer, hopefully marveling at the beauty of God's people as I have. The book is arranged both chronologically and thematically to capture my major projects. I've tried to select the best from thousands of photos in my archive that tell these stories.

Above all, I thank the Spirit who quietly whispered that life-changing night in western South Dakota, "Stay with the photography." It's been 50 years and counting – and I am still listening to the voice of that Spirit.

MYRTIS WALKING EAGLE · *In Soldier Creek, South Dakota, Jesuits celebrate Christmas Mass with the Lakota people on the Rosebud Indian Reservation. This photo, for "Christmas in America," won first place as a Magazine Feature picture in the National Press Photographer's Pictures of the Year competition.*

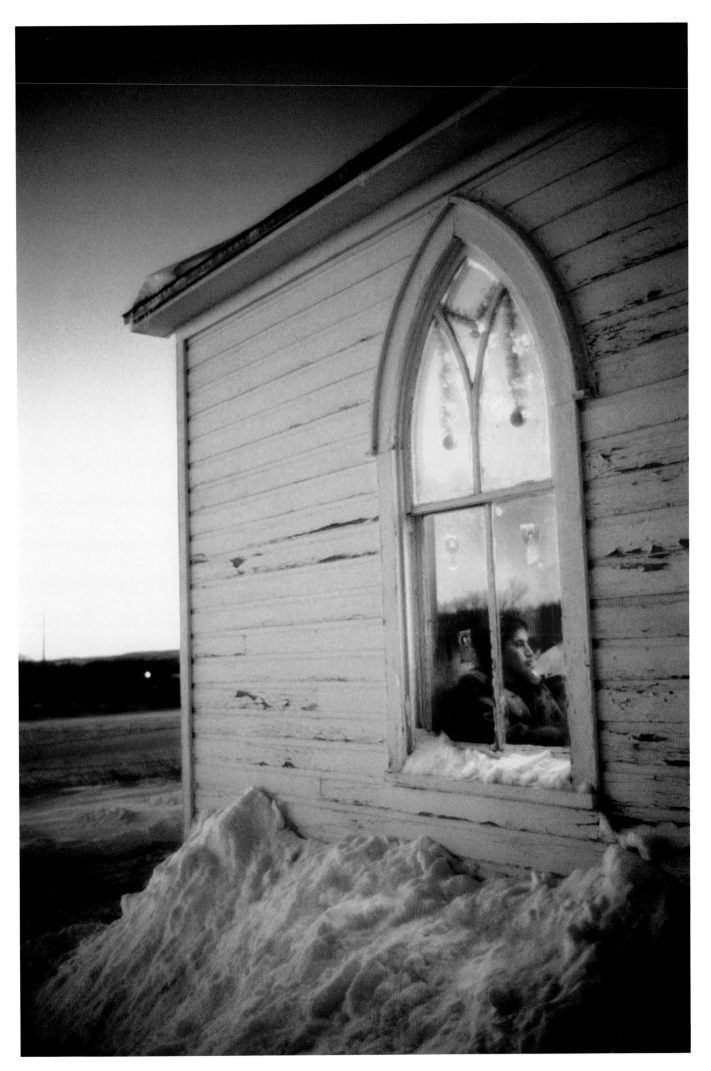

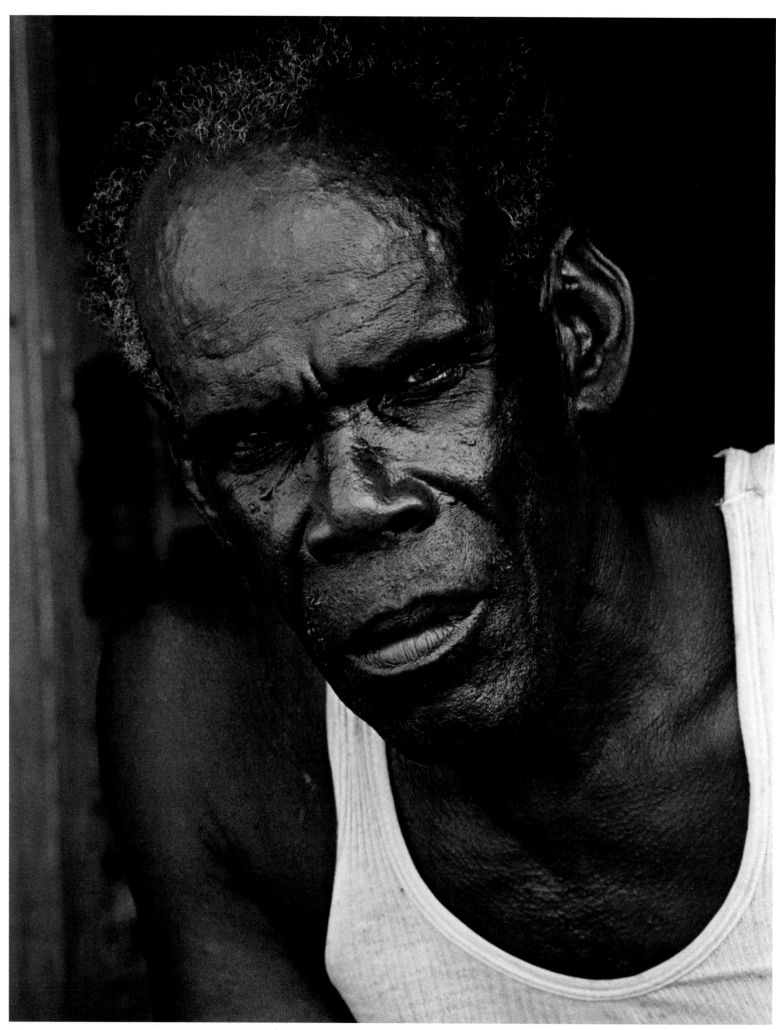

ORANGE WALK, BELIZE · *When I couldn't make a candid photograph of this man without him noticing, he graciously invited me to take his picture.*

IN THE BEGINNING

A FEW WEEKS BEFORE I ENTERED THE JESUITS at age 18 in 1955, I had planned to study chemical engineering at Notre Dame. I even had my dorm room assignment, but I could not shake the idea of a different future that I hadn't even mentioned to my parents.

I first confided the thought of entering the Jesuits to my Marquette High School counselor, Fr. William Fahey, S.J., and to my classmate Ed Mathie after he told me of his plans to join the Society of Jesus. The night of Ed's going away party, I could not sleep, thinking I should be joining the Jesuits too. The next morning, a Sunday, I called Father Fahey to discuss the idea. After two hours, he told me he thought I was ready to enter the Society. "Do you want to?" he asked. I said yes. Luckily, Father Fahey told my parents of my thoughts about joining the Jesuits. They were surprised but did not object.

On September 1, 1955, I entered the novitiate, the first stage of 13 years of Jesuit training, and never looked back. Today, Jesuits prefer men who have completed college and rigorous screening. But those were simpler times.

I grew up a timid, shy kid in Milwaukee who went to Catholic schools where my faith was nurtured. I chose Jesuit-run Marquette High School over another Catholic school because I was impressed with the esprit of its football team at a game my father and I attended. At Marquette High, I was deeply impressed with the Jesuit seminarians who taught us. A senior year retreat with a charismatic Jesuit planted the idea of the Society of Jesus.

Looking back, I'm a little amazed that I made it through the three years of studying philosophy in Latin. I was not a natural scholar like some of my classmates. But I wanted to be a Jesuit so I persevered through the seven years of study and spiritual training that preceded my life-changing, three-year teaching assignment to St. Francis Mission. There, on the Rosebud Reservation, the Spirit revealed my calling within a calling.

Today, more than 50 years later, I remain grateful for the decision to enter the Society as a kid just out of high school. A few words about Jesuit life may help put my adventures into perspective. From our founding by St. Ignatius of Loyola 500 years ago, we Jesuits have traveled worldwide on behalf of the Gospel. There are only a handful of places in the world where we do not serve, and Jesuits from anywhere immediately find community with their brothers of any nationality. We take vows of poverty, chastity, and obedience and live in community with fellow Jesuits, and we've always been active throughout the world.

The Society encourages us to "find God in all things," which encourages us to embrace our special talents as an integral component of our vocations. You'll find Jesuit doctors, lawyers, scientists, artists and architects in addition to professors and pastors. While we are an amazingly diverse group. We share the essentials, such as a deep faith, love of God, and a dedication to serving the poor and the marginalized.

> The Society encourages us to "find God in all things," and to embrace our special talents as an integral component of our vocations.

After my ordination in 1968 I discovered what kind of Jesuit photographer I would become. I went to Belize at the request of a classmate who had taught at Jesuit-run St. John's College. I slung a Leica camera around my neck, a Nikon over my shoulder, took in the street scenes that unfolded before me, and spontaneously shot photographs of people, imagining myself a National Geographic photographer on assignment.

I loved interacting with the people and found they trusted me to make their photographs because I was a Jesuit, and accompanied by Jesuits who had worked there for years.

The Third World experience felt somehow familiar, not unlike being on the reservation. Looking at my earliest pictures, I see the genesis of my mature self and realize how crucial this brief adventure was in shaping my vision. I began to understand that capturing scenes of ordinary life with a small camera suited my impatient nature, far more than lugging a huge view camera out to a location and waiting for the perfect picture.

In the summer of 1969 I built fiberglass darkroom sinks in the former medical library in Creighton's Fine Arts Department. That fall I expected to teach two photography courses and work in campus ministry – but the dean, Fr. Thomas McKenney S.J., had no budget for the darkroom plumbing and electrical outlets. He wanted me to teach Educational Psychology because I had a master's degree in the subject. I told him this would be boring, that I hadn't given it any thought in six years, and that I would rather leave Creighton and obtain an M.F.A. in photography. A week later somehow he found the darkroom money, and I stayed to teach photography in the Fine Arts and Journalism Departments.

So it was established: I would be a professor of photography at Creighton. But what kind? Over the next few years I focused on determining if I would be a fine arts photographer, primarily concerned with subjective expression and the more formal elements of light, tonal values, and composition, or a photojournalist documenting events around the world. Photojournalists often choose subjects that reveal what is inside their hearts, which is the route I chose.

I took advantage of the flexibility being a Jesuit allows by attending workshops, and meeting some of the nation's top photographers. That first summer I rode a motorcycle from Omaha to California for a Jesuit Institute on the Arts at Santa Clara University. My Jesuit superior must have approved this unconventional request with a patient sigh. I wanted to photograph the West from this vantage point – even though it meant crossing the mountains on the bike and riding 600 desert miles in one day. At Santa Clara, I experimented with abstract photography, spending a week taking pictures of a patch of tar in a street, doing what I thought was "art."

The following summer I attended a University of Oregon landscape photography course, crossing the state looking for photographs during the week and helping out at a local parish on weekends. In Oregon I learned how to run a critique session, which improved my teaching. We studied the photographs and darkroom techniques of the legendary nature photographer Ansel Adams. I became a much better photographic printer as I adopted some of his darkroom methods.

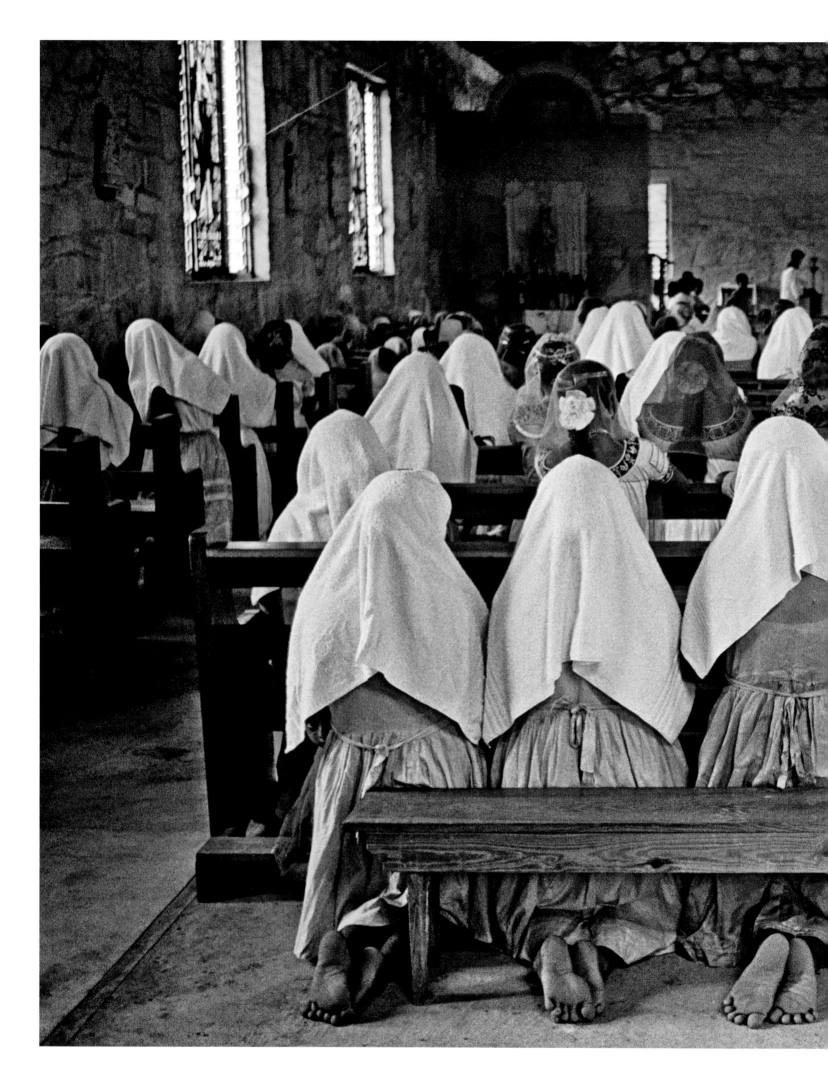

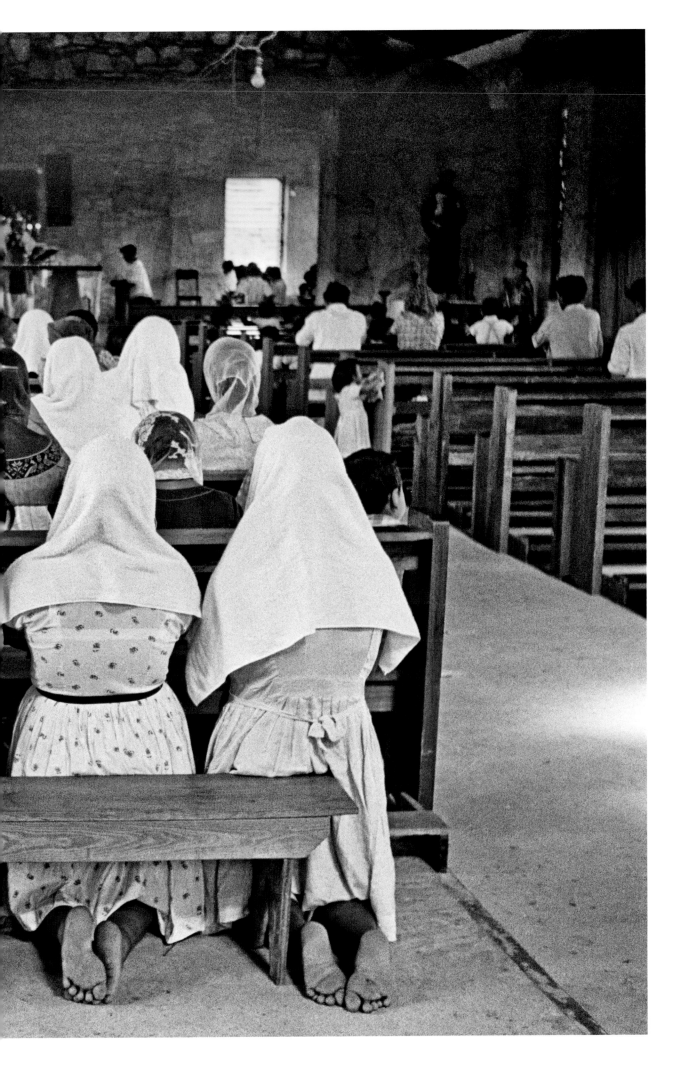

SAN ANTONIO, BELIZE

The Mayan Indian people gather for their Jesuit pastor's Mass on a Sunday morning. Many of the women use Cannon towels as their veils.

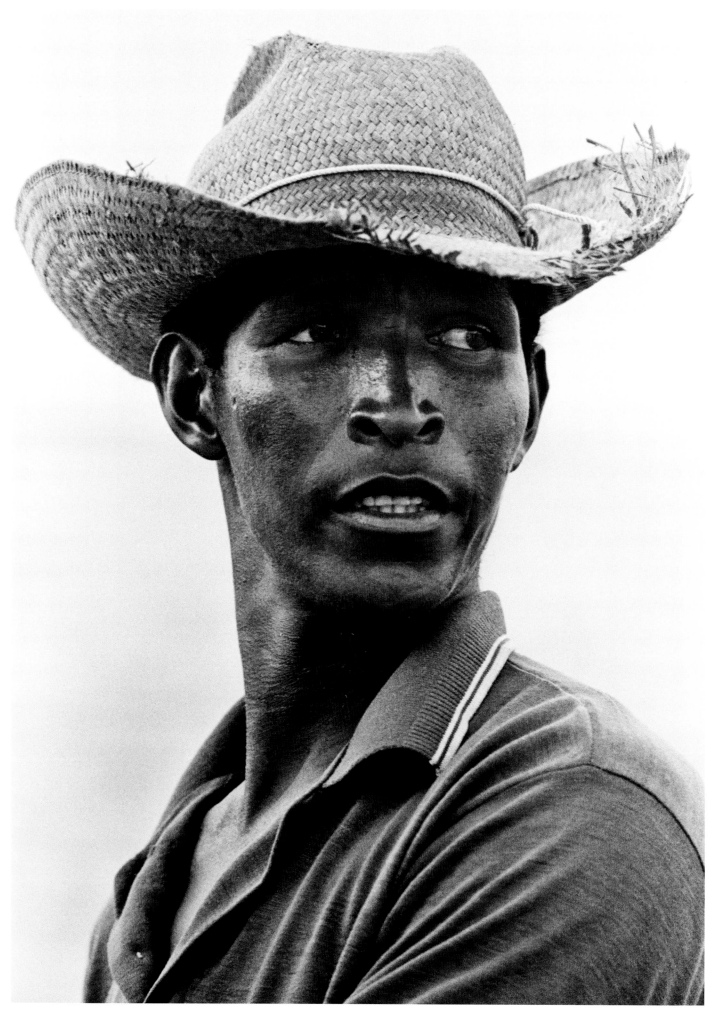

BELIZE · *In the wharfside market a fisherman cutting his catch of fish responds to a customer.*

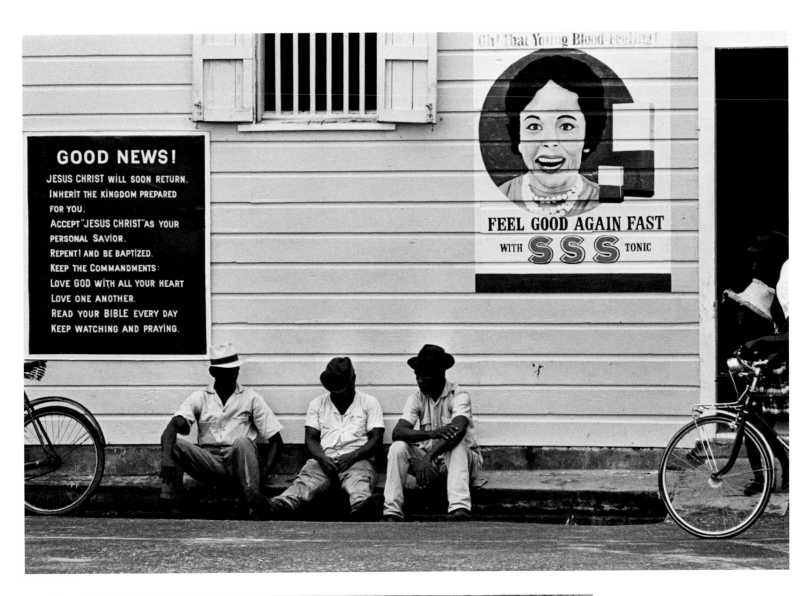

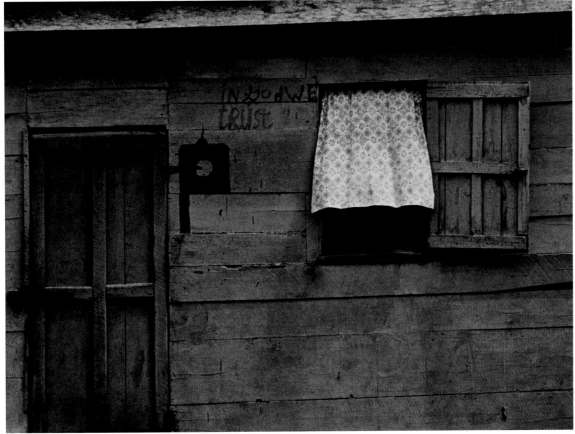

BELIZE
Unaware of the conflicting messages on the wall behind them, men sat outside of a pharmacy in Belize.

BELIZE COUNTRYSIDE
I was riding out to a remote village, standing in a pick-up truck's bed behind the cab, when I saw this out of the corner of my eye. I pounded on the top of the cab hoping to stop so I could make this photograph. I wondered: "Does 'In God We Trust' refer to their faith in God or the U.S. dollar?"

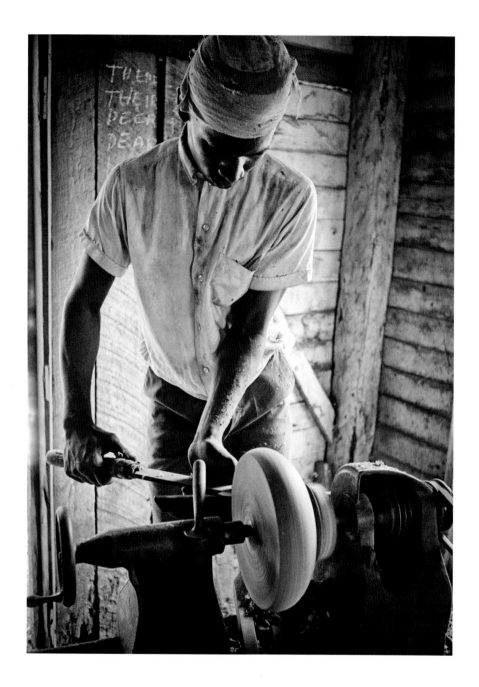

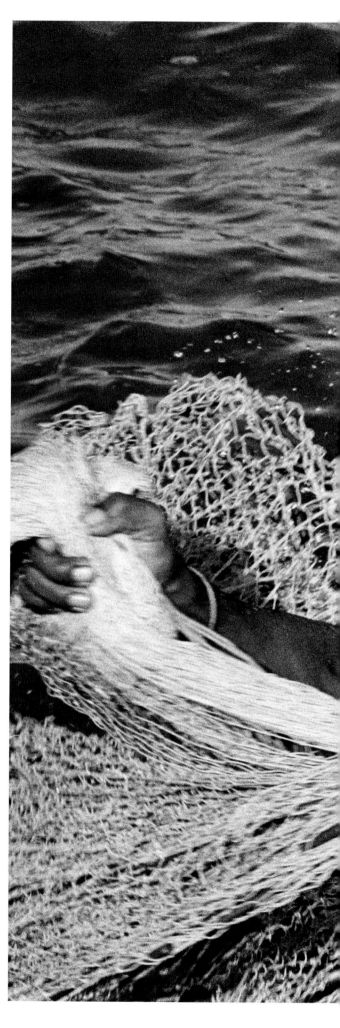

COROZAL

*A man begins working
a mahogany bowl
on his lathe.*

*Along the shore a
man casts his nets
for minnows or
small bait.*

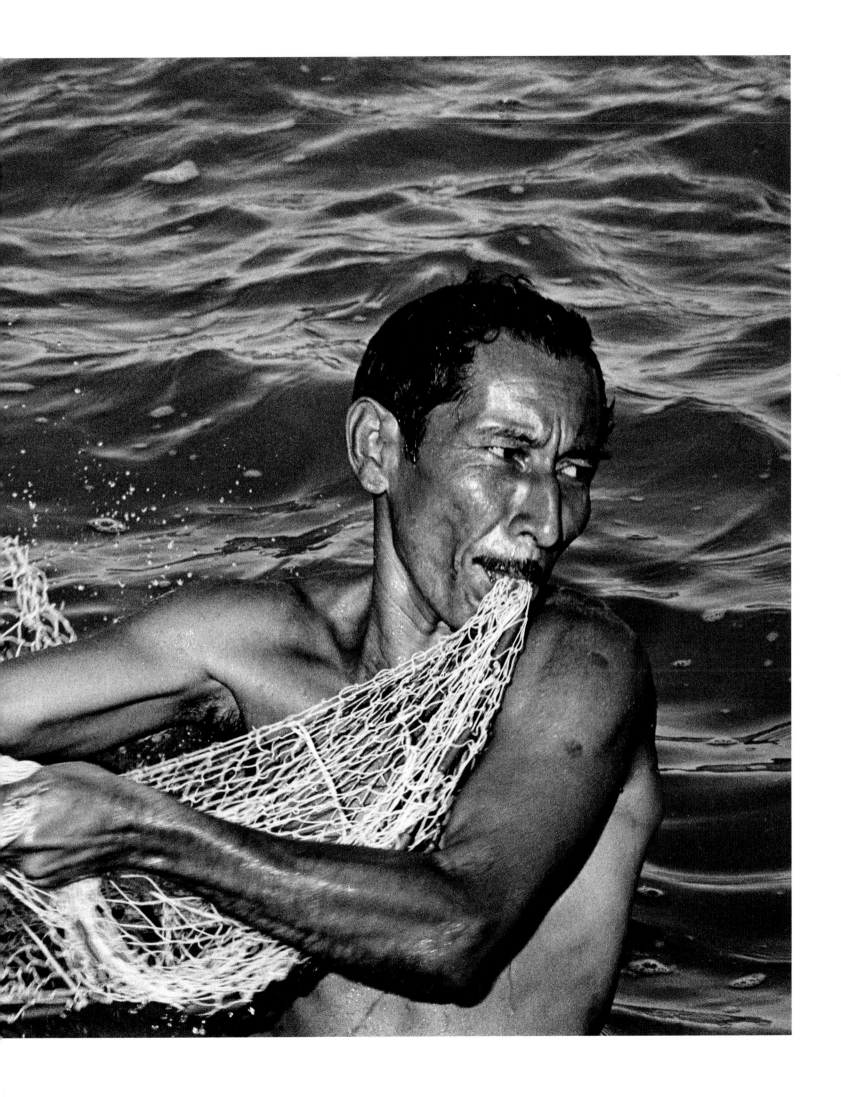

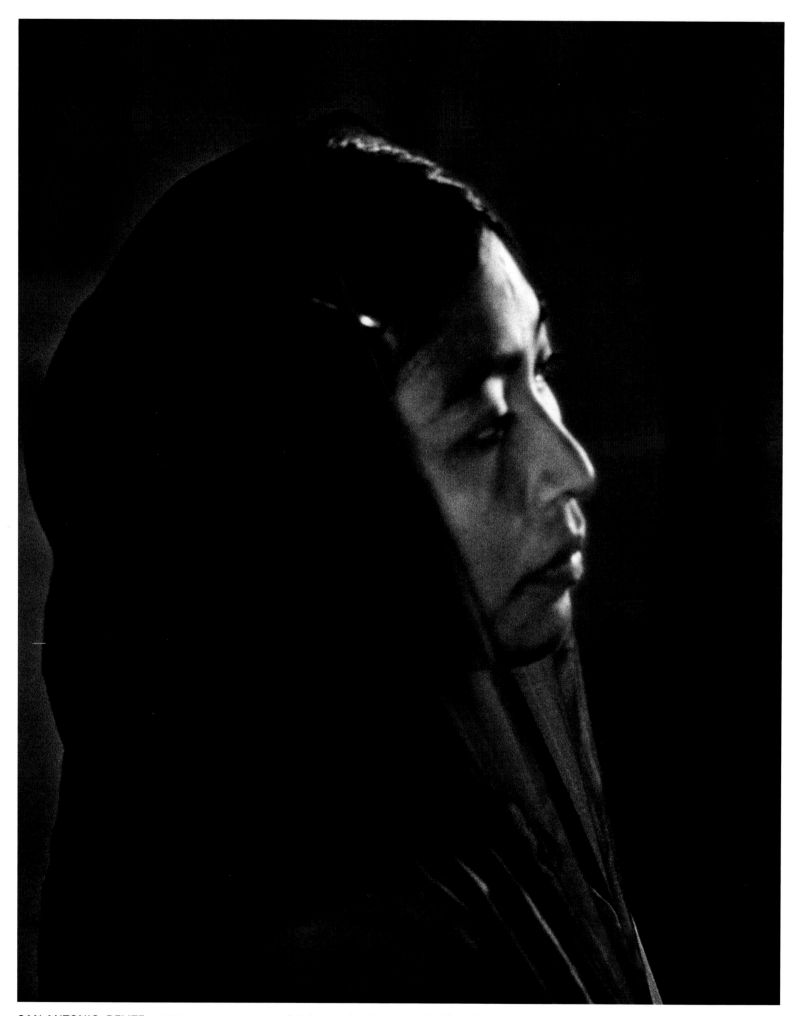

SAN ANTONIO, BELIZE · *A Mayan woman attends Mass at the San Antonio Church.*

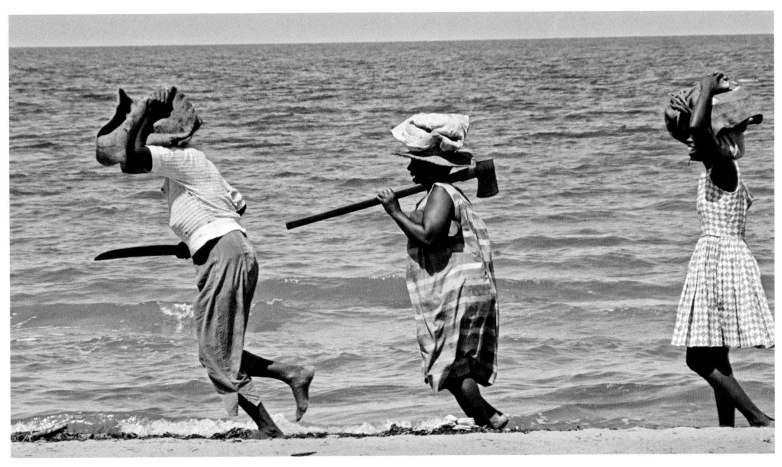

COROZAL · *One of those spontaneous moments that delight most photographers.*

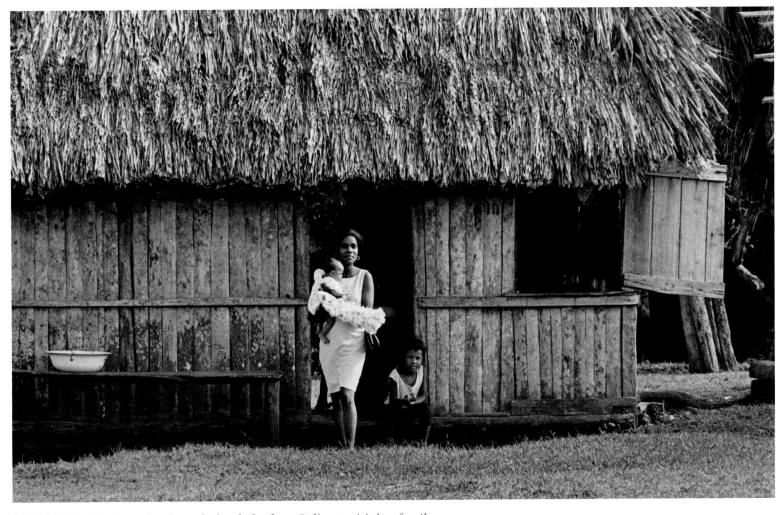

RURAL VILLAGE · *A mother brought her baby from Belize to visit her family.*

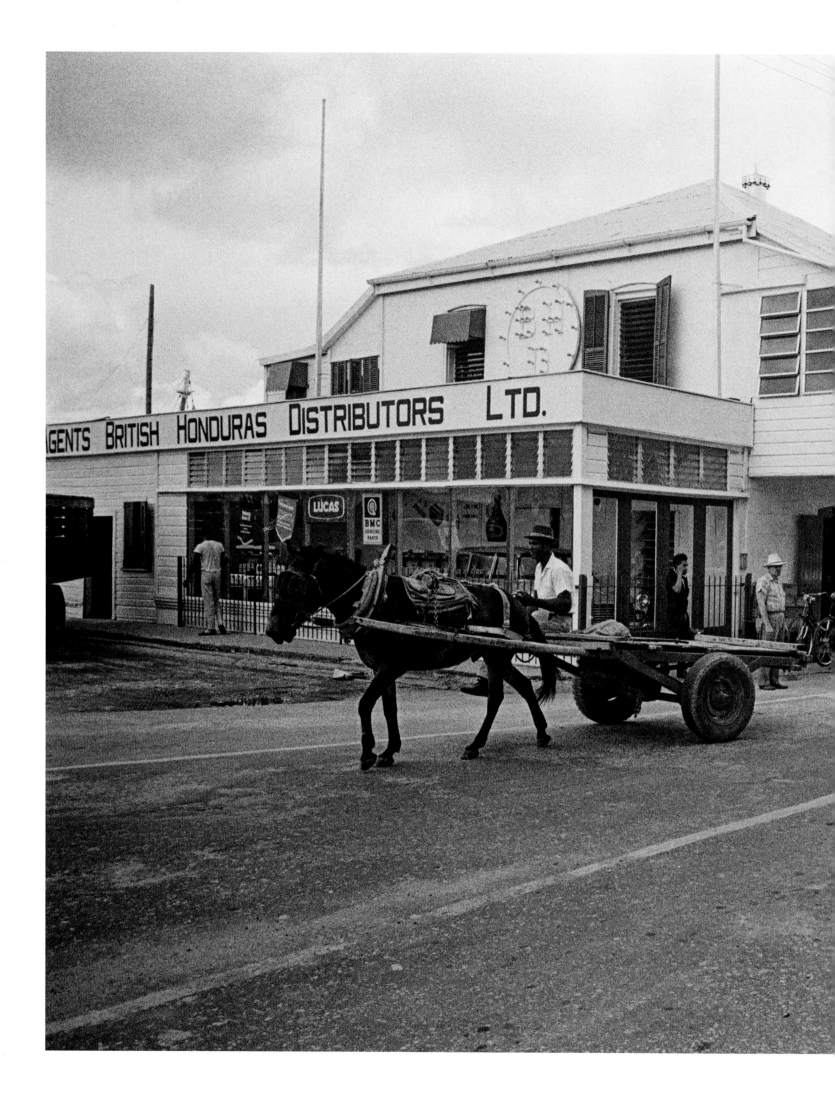

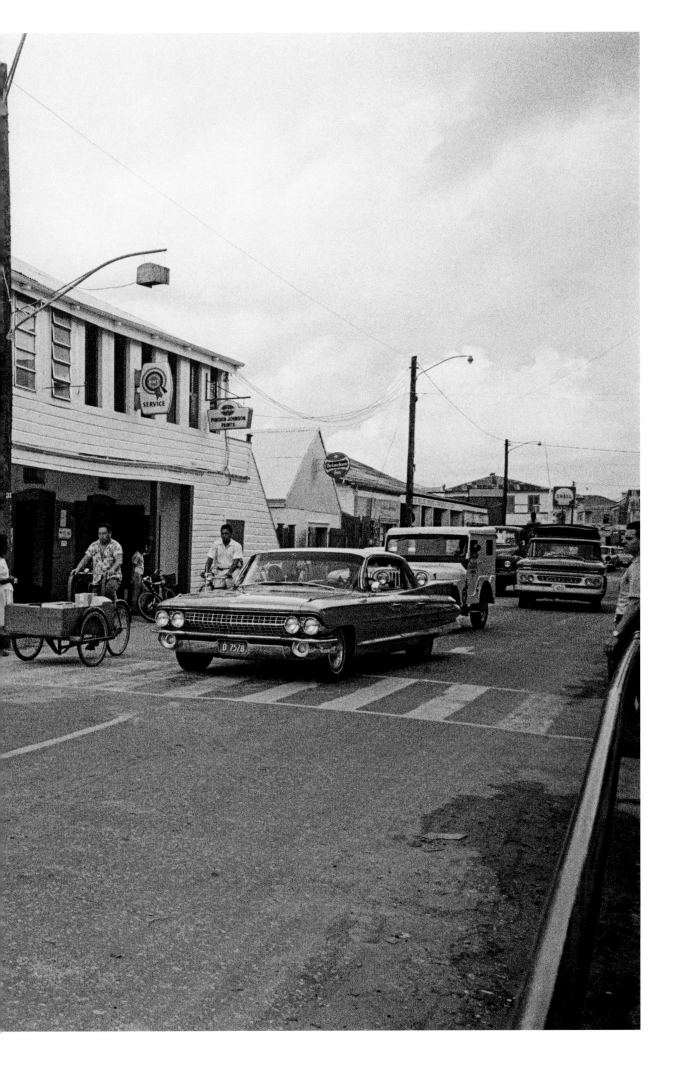

BELIZE MAIN INTERSECTION

The contrasts one notices when traveling are a constant prompt to make images. It's what gives a photographer his or her point of view. Here the disparity in modes of transportation drew my attention.

NATIVE AMERICANS

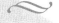

THE 1973 LAKOTA SIOUX OCCUPATION OF WOUNDED KNEE, SOUTH DAKOTA, MADE ME REALIZE THAT I HAD NOT SEEN ANY IN-DEPTH PHOTOGRAPHIC COVERAGE OF NATIVE AMERICANS. WHY NOT RETURN AND DEPICT THE LIVES OF MY FORMER STUDENTS, IN THE PLACE WHERE I FIRST EXPERIENCED THE CALL TO BE A JESUIT PHOTOGRAPHER? IT WAS THE BEGINNING OF A JOURNEY THAT WOULD EVENTUALLY LEAD TO THE BOOKS "CRYING FOR A VISION" AND "VISION QUEST," AND TWO MAJOR ASSIGNMENTS FOR NATIONAL GEOGRAPHIC MAGAZINE ABOUT ALASKA'S NATIVE PEOPLE.

IN 1997, THE NATIONAL PRESS PHOTOGRAPHERS ASSOCIATION PRESENTED ME WITH THE KODAK CRYSTAL EAGLE AWARD FOR IMPACT IN PHOTOJOURNALISM — ONE OF THE NPPA'S HIGHEST AWARDS — FOR MY WORK WITH NATIVE AMERICANS.

GORDON SWIFT HAWK · *The 'Red Power' sticker was a hint of the rising Native pride across America's reservations.*

CRYING FOR A VISION

NATIVE PEOPLES

In 1974 I moved to Spring Creek, a Lakota village on the Rosebud Indian Reservation, when Creighton gave me a year's leave of absence. I knew many of the 150 residents because I had been their teacher a decade earlier. I assisted the village's Jesuit parish priest but my primary job was to fit into the village and photograph the residents as they went about their lives — not unlike W. Eugene Smith did in his Spanish Village story published in LIFE magazine.

> I could use my God-given artistic talent to give visibility to the sufferings and joys of peoples who are invisible to much of the world.

I settled in and started making pictures, only leaving for a summer of tertianship, the final stage of Jesuit spiritual training. Once again, I relied on the trust that the people had in the Jesuits who had worked with those families for over a century. I felt like I was standing on their shoulders.

I think my students remembered me fondly because we had won two basketball championships with me as their coach. I began making what I thought were family photographs. I always repaid their kindness by giving them copies of the photographs I was making in those days before one-hour photo and digital cameras.

At the end of my year's stay, I printed and mounted 18 black-and-white photographs and submitted them to major museums in New York City. Cornell Capa of the International Center of Photography accepted them for exhibit but insisted the exhibit open in New York. However, the Mid-America Arts Alliance in Kansas City that had obtained funding from the National Endowment for the Arts also wanted to premiere the exhibit. It opened in Kansas City.

The exhibit entitled, "Crying for a Vision," toured museums throughout the country, and was published as a book. It formed the basis for a special section in a newspaper in Worthington, Minnesota. The publishers of the Worthington Globe submitted it for a Pulitzer Prize, and urged me to apply for the World Understanding Award, a prestigious national honor from the National Press Photographers Association. It not only won a Special Recognition Award but I was invited to speak at the awards ceremony at the University of Missouri, that in turn led to my participation in the National Press Photographers Association's Flying Short Course - a six-city photography seminar.

Each step on this journey opened new professional doors, but this was less important to me than the realization that "Crying for a Vision" had brought me full circle from the night on the prairie where the Spirit had first called me to be a Jesuit photographer.

Now I began to more fully understand that summons and the unique opportunities it offered me to fulfill my Jesuit vocation. I could use my God-given artistic talent to give visibility to the sufferings and joys of peoples who are invisible to much of the world. It has become a mission for the rest of my life, and my way of heeding the Society's mandate to its members to be men for others in solidarity for and with the poor.

The photographs in this section trace a journey of self-discovery from my initial trip to Belize through "Crying for a Vision." On a more personal level, the book and exhibit helped me attain academic tenure and I later assumed the role of chairman of Creighton's Fine and Performing Arts Department.

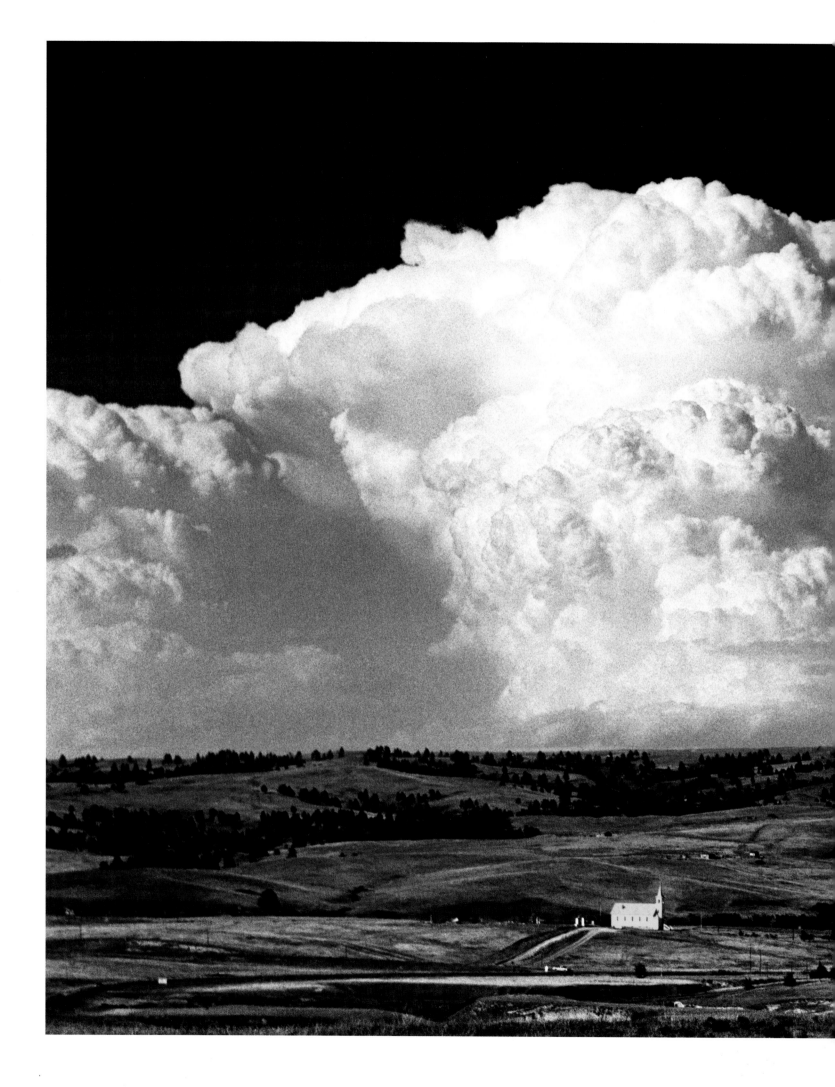

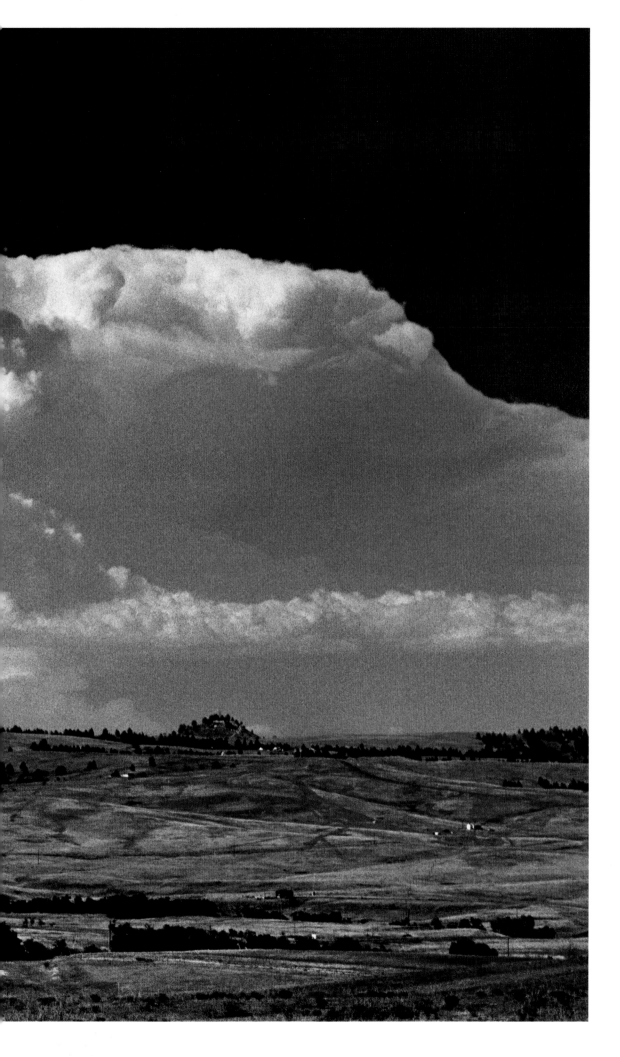

WOUNDED KNEE, SOUTH DAKOTA

When I saw these thunderclouds rising over the landscape of the Pine Ridge Indian Reservation, I sensed there was a storm coming with the Native people.

This site, where Big Foot's people were massacred in 1890, was an incredible symbol for the Lakota whose anger was rising after so many years of broken promises.

When Native activists occupied this burial site in 1973, the subsequent standoff with federal marshals lasted 71 days, and the church burned to the ground six months later.

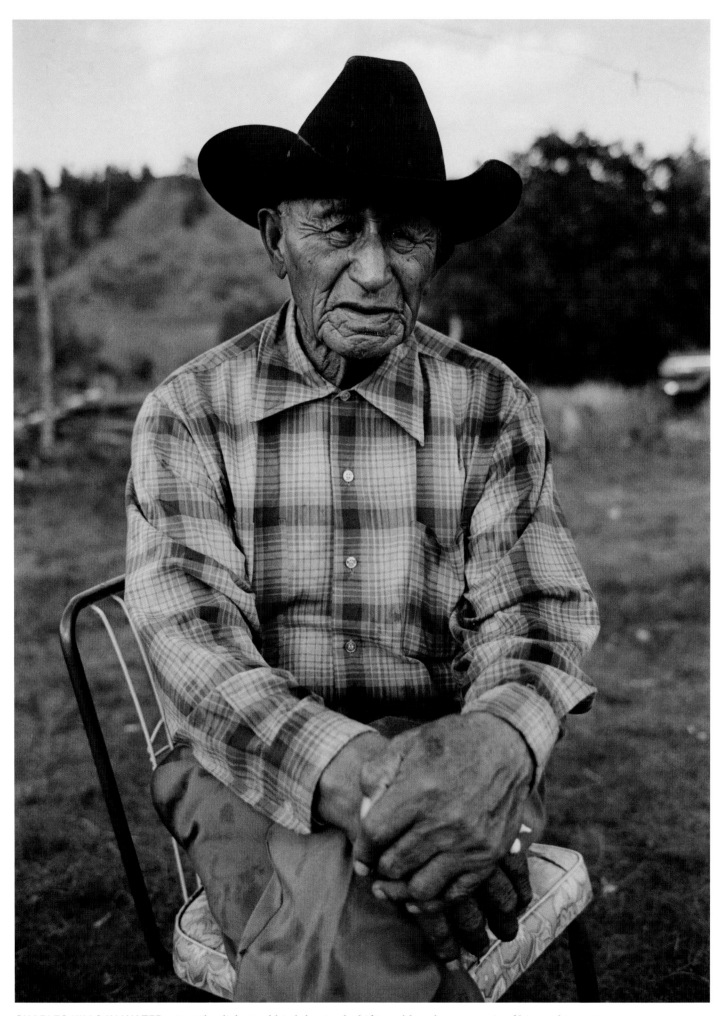

CHARLES KILLS IN WATER · *On Charlie's 83rd birthday I asked if I could make a portrait of him at his party.*

CAROLINE KILLS IN WATER · *As I sat with people, I often pulled out my Leica and asked if I could make a portrait.*

EAGER TO BE CHILDREN

Everybody falls in love with the children on Native American reservations, and I was no different. They have the freedom of their horses, recalling traditions of life on the open plains.

Here, Kenny Kills in Sight, Wendall White Eyes, "Yogi Bear" Left Hand Bull, Rafael Kills In Sight and Brian Left Hand Bull go for a ride on a Saturday afternoon. This is the age they are allowed to explore life before the disillusionment of adult life on the reservation sets in.

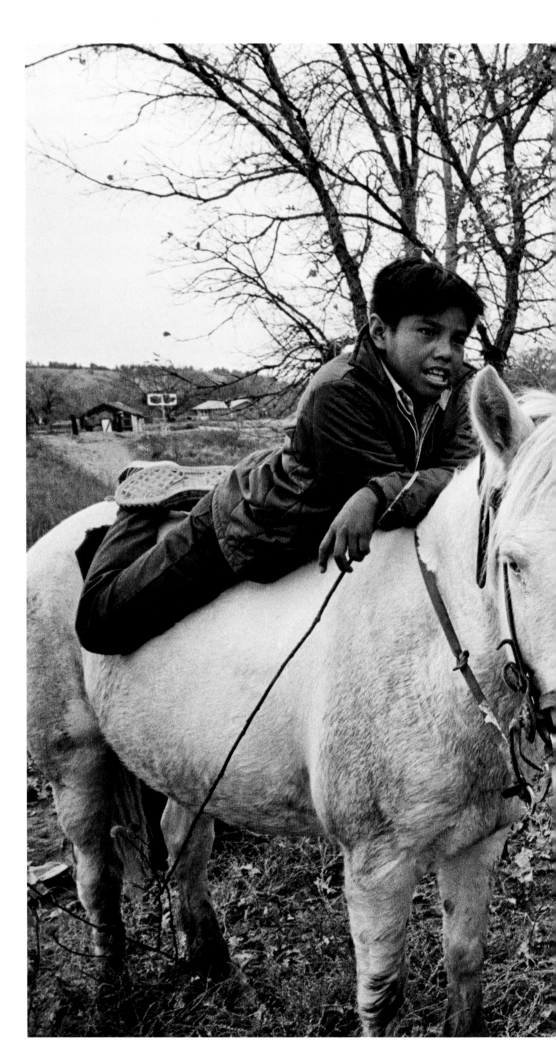

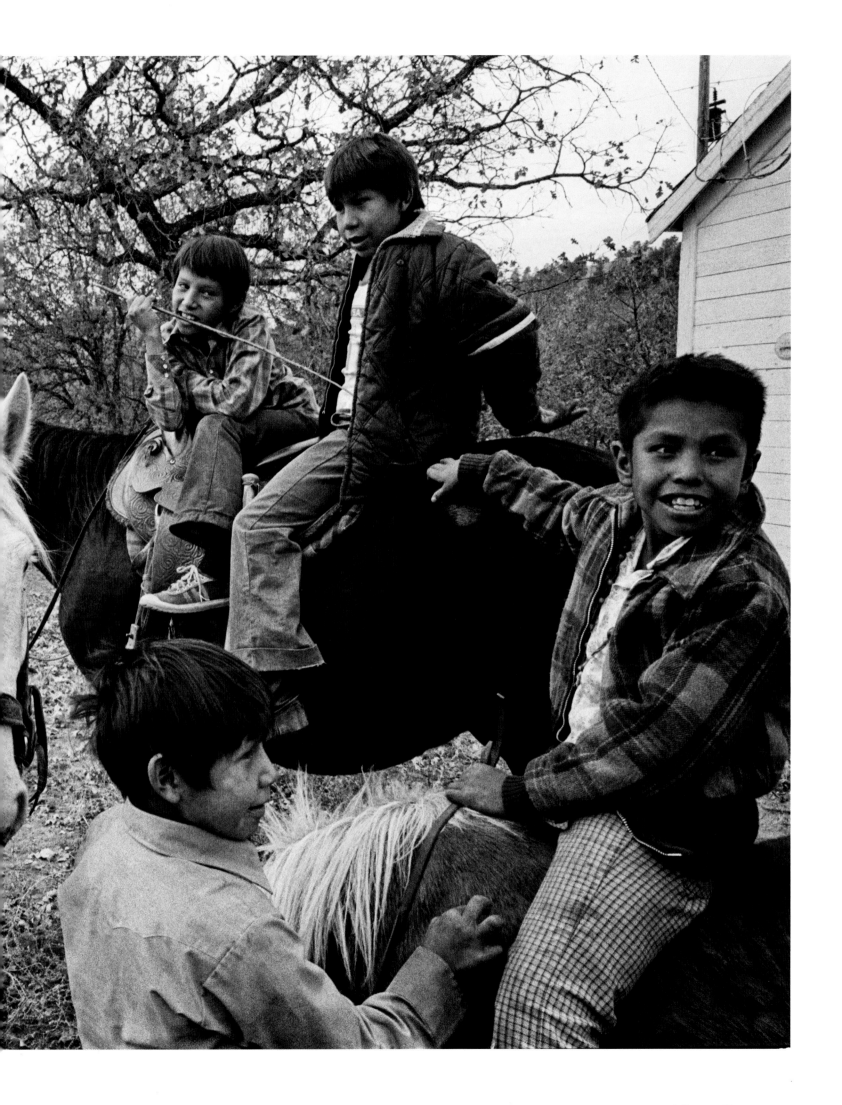

REALITY OF GROWING UP

Morris Kills In Sight, Glenford Walking Eagle, Ambrose, Sylvan and Daniel White Hat called themselves the Wiwila Wakpa Wicokini, the Spring Creek Re-awakening, and had hopes to reinvigorate their community.

Morris (holding the air rifle), who years earlier was on my winning basketball team, had come home from Vietnam and would often show me photos of his combat weapon with notches on the stock of his rifle, telling me he killed 14 people in the war.

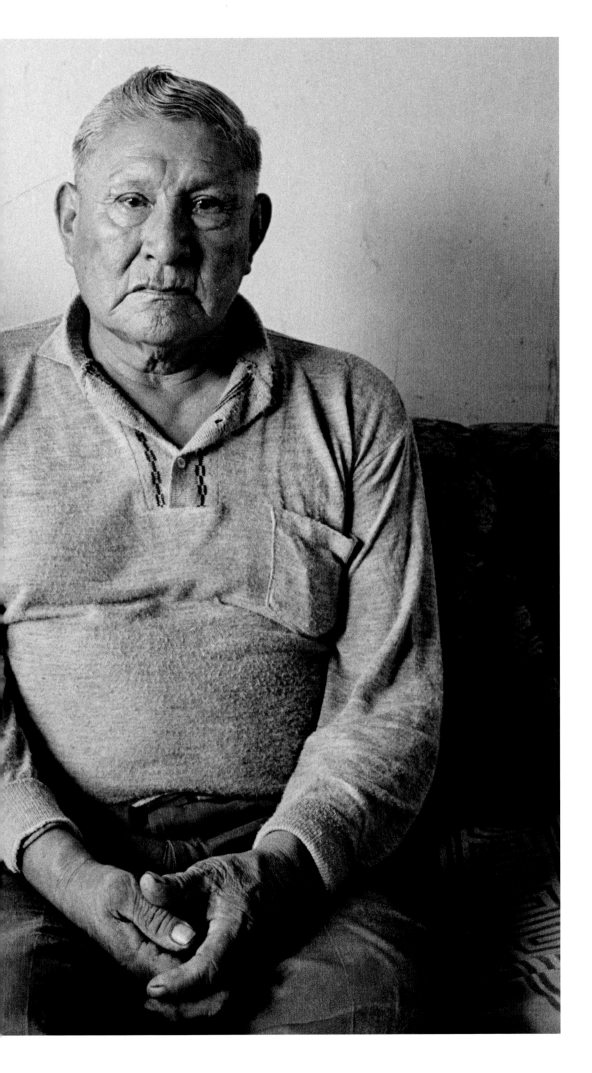

NOAH AND EMILY
KILLS IN SIGHT

Noah and Emily were perhaps my closest friends in Spring Creek. I don't think this photograph portrays their personalities well. Noah was a Lakota storyteller with a great sense of humor. However, I do think it acts as a metaphor, conveying what has happened to the Indian people. I don't know where the sadness on their faces comes from. I think they are reacting to me.

For some reason on that day I was especially saddened by what happened to the people and how much they have suffered. Somehow, I feel Noah and Emily had sensed this and were asserting, "Yes, that is true; that's how it is."

Noah confirmed that when I gave him a book. He said: "What you say there is true."

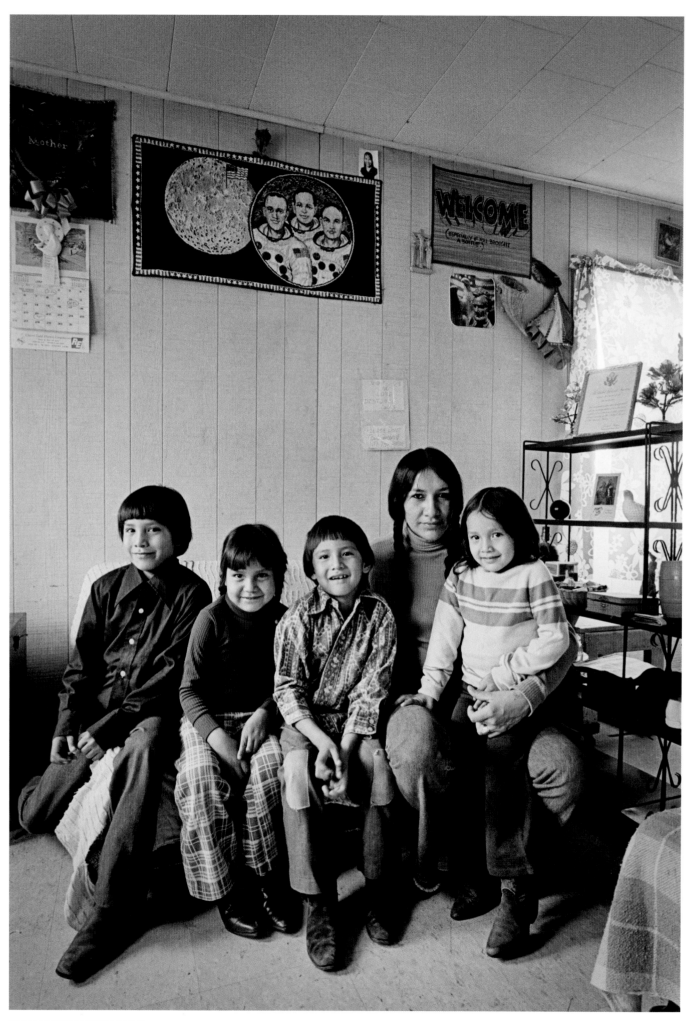

THE WHITE HAT FAMILY · *Anna Rose, Tyrone, Camille, Marlon and J.J. White Hat pose for a portrait in their home.*

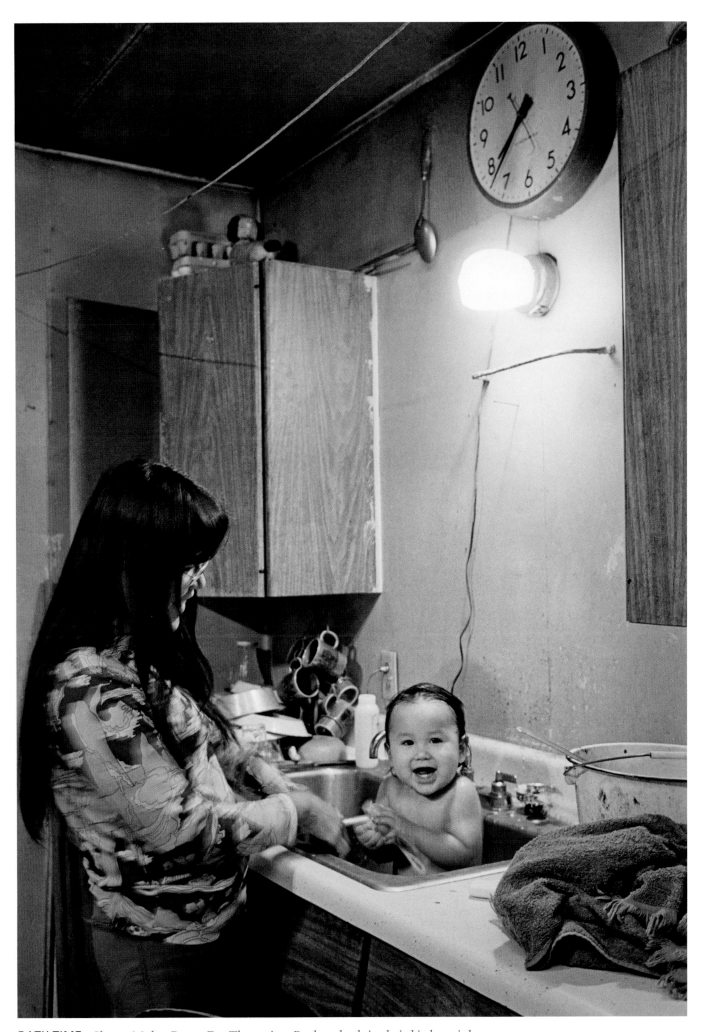

BATH TIME · *Sherry Makes Room For Them gives Rocky a bath in their kitchen sink.*

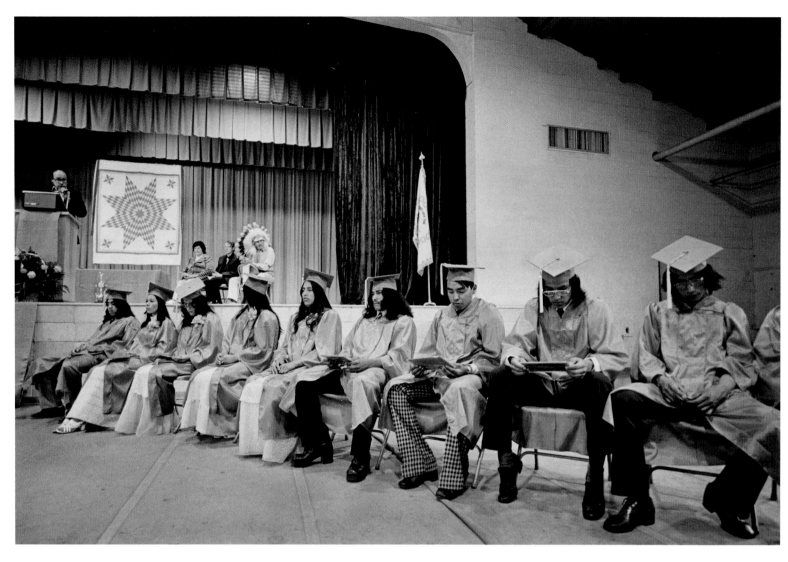

GRADUATION DAY

On what is usually nothing but a joyous occasion, graduation on the Rosebud Indian Reservation was both happy and sad. Parents celebrated, but only one-third of those who started as high school freshmen graduated. The graduates themselves knew their future would be bleak. At that time, only 23 percent went on to college, and unemployment was at 80 percent.

ABRAHAM KILLS IN SIGHT

In the reservation's cemetery, Abraham prayed before a crucifix. "I pray for all the people," he told me. "I pray that they may have strength and find peace. I pray with many words. I am sure God hears at least one of them."

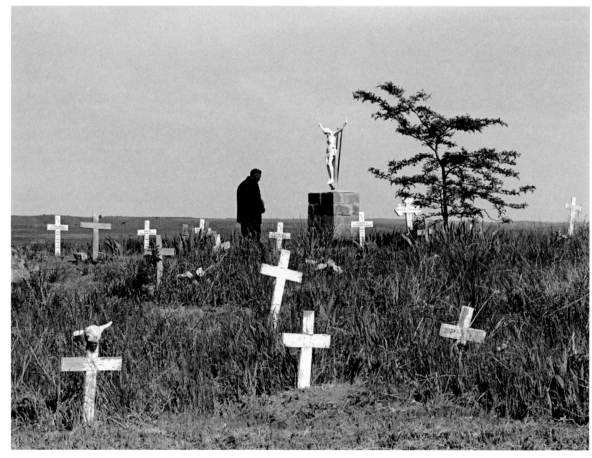

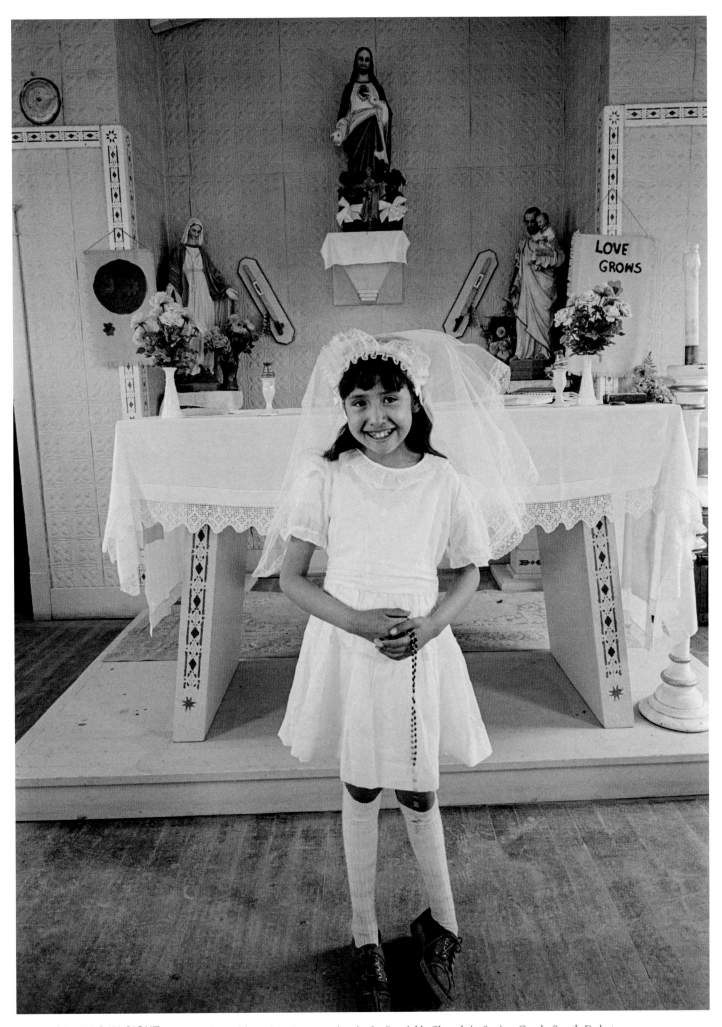

ELEANOR KILLS IN SIGHT · *She celebrated her First Communion in St. Patrick's Church in Spring Creek, South Dakota.*

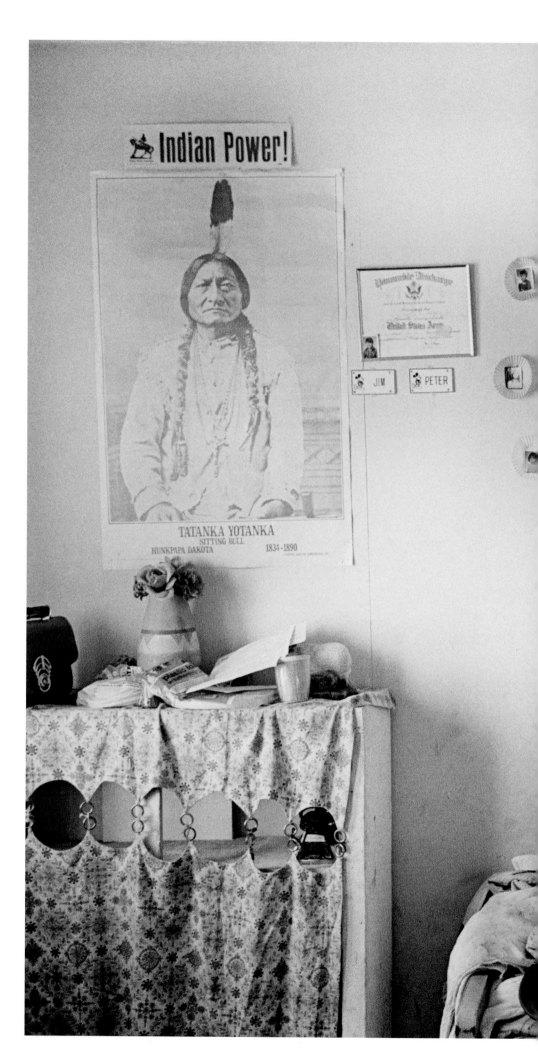

PETER SWIFT HAWK'S HOME

The walls of Peter's home are adorned with Indian Power icons and the photograph I made of their family. Before the years of one-hour photo shops, I loved giving prints to the people I photographed.

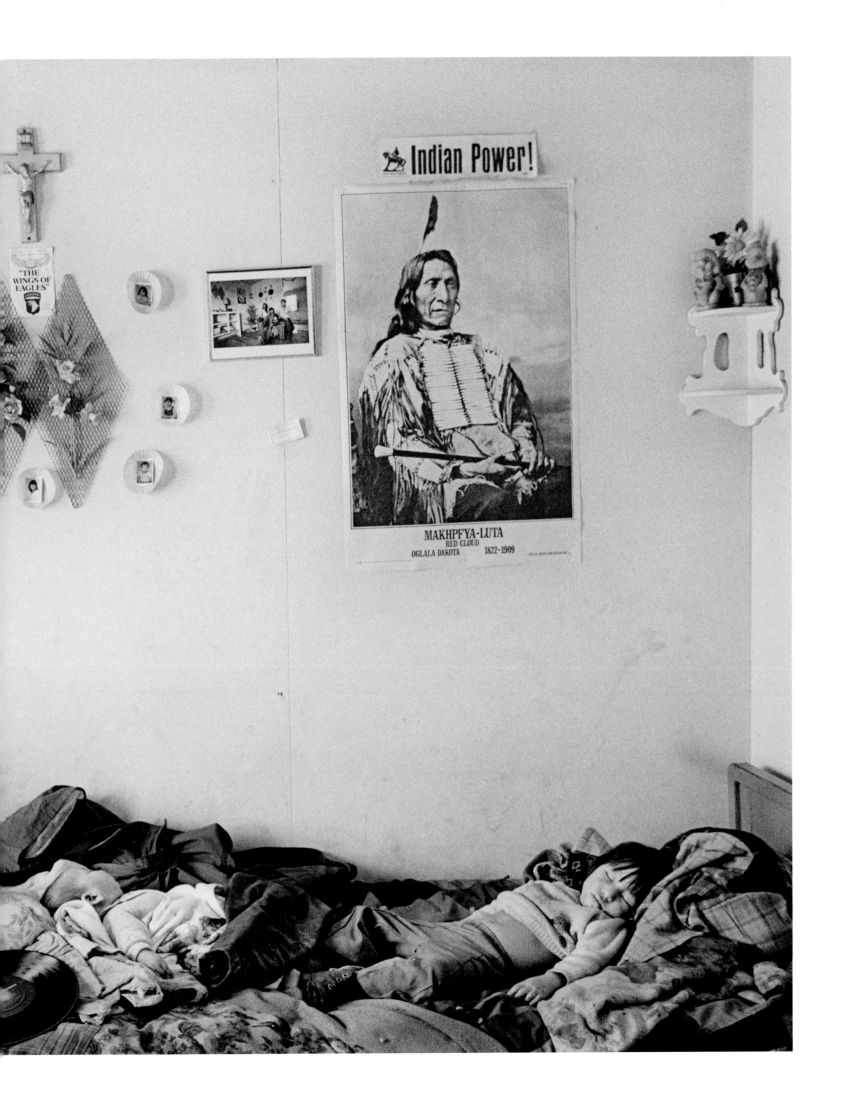

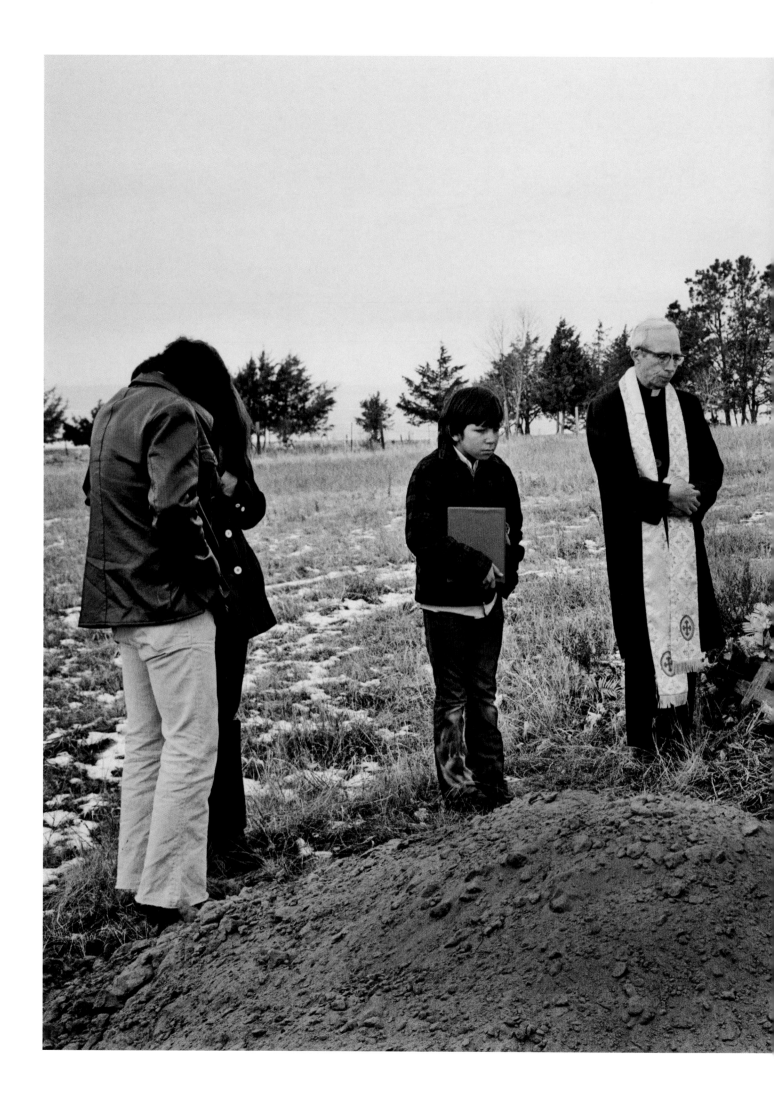

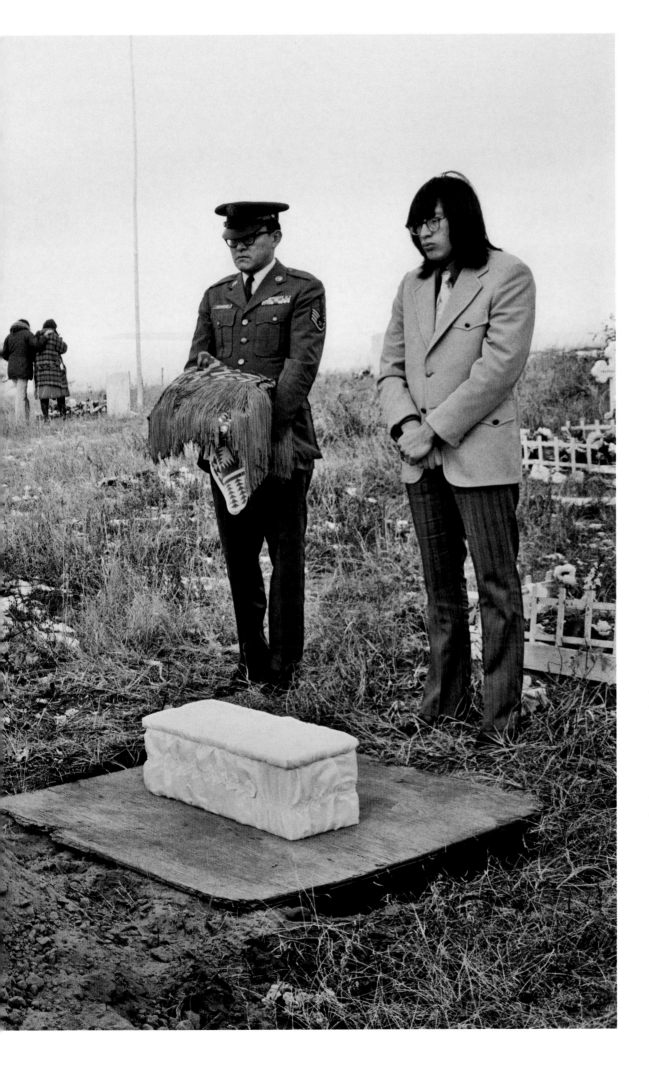

SPRING CREEK CEMETERY

Jack Menard and Linda Kills in Sight bury their month-old daughter who died of crib death, which was common on the reservation. Fr. Richard Jones, S.J., their beloved pastor for many years, leads the graveside ceremony.

HARVEY WALKING EAGLE'S WAKE

I asked Freddie to pose with his father's World War II medals that would be buried with him. Harvey Walking Eagle was shot and killed in Spring Creek while I was in Saint Francis, ten miles away. When I heard the news I rushed down to the scene.

Harvey was a close friend. I was conflicted between being a photographer and being a pastor. I decided not to photograph until the police asked me to help document the crime because their camera wasn't working. It almost made me sick.

Afterwards, I could not bring myself to photograph the sorrowing victims as a photojournalist might. I was just too close to them all.

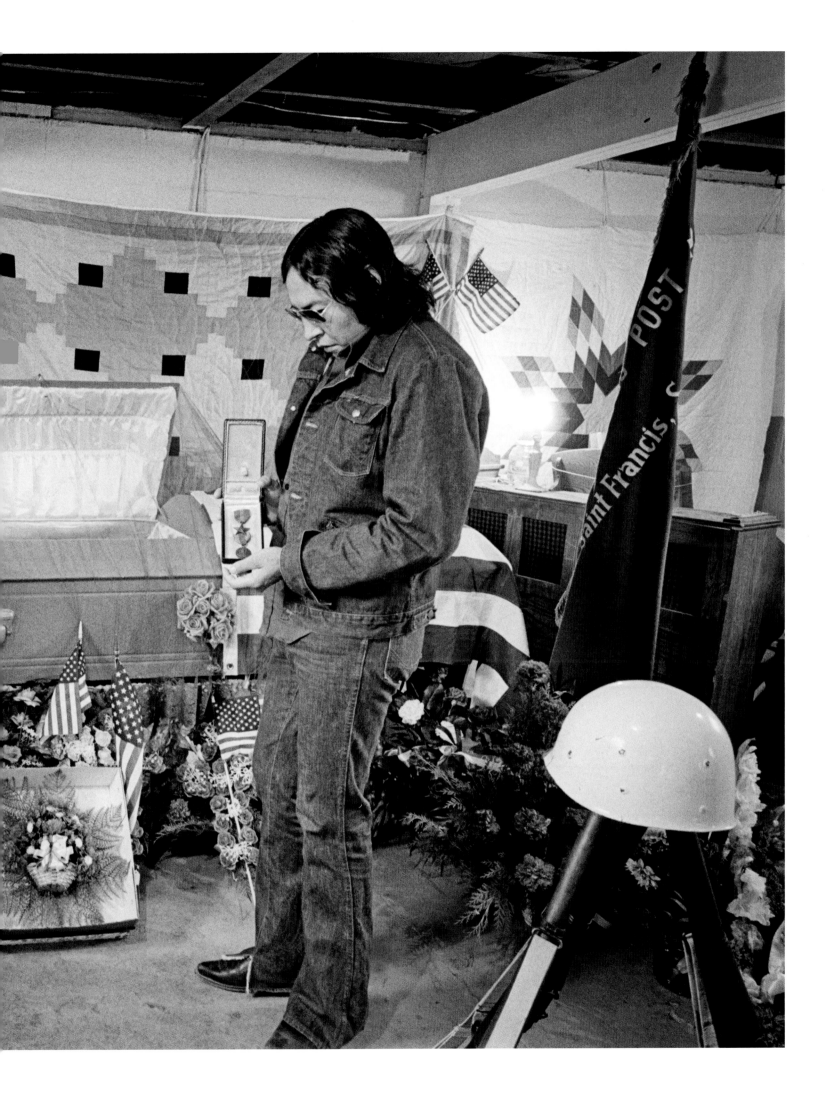

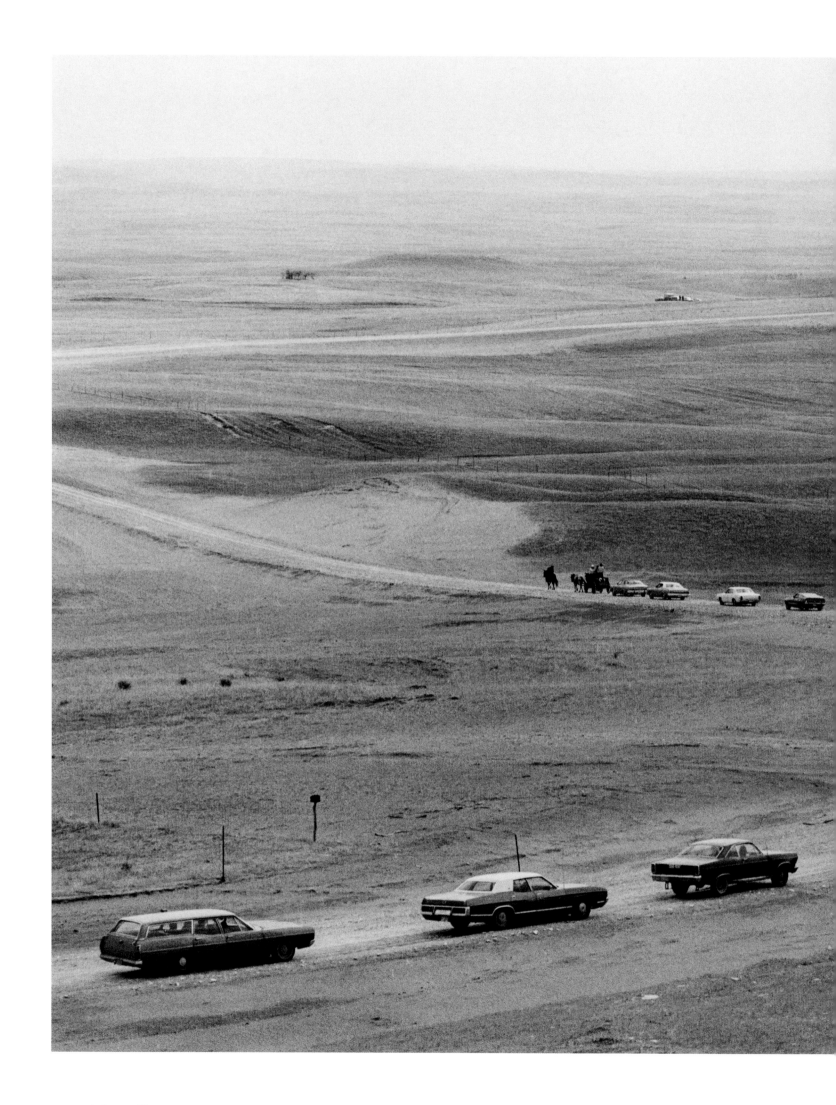

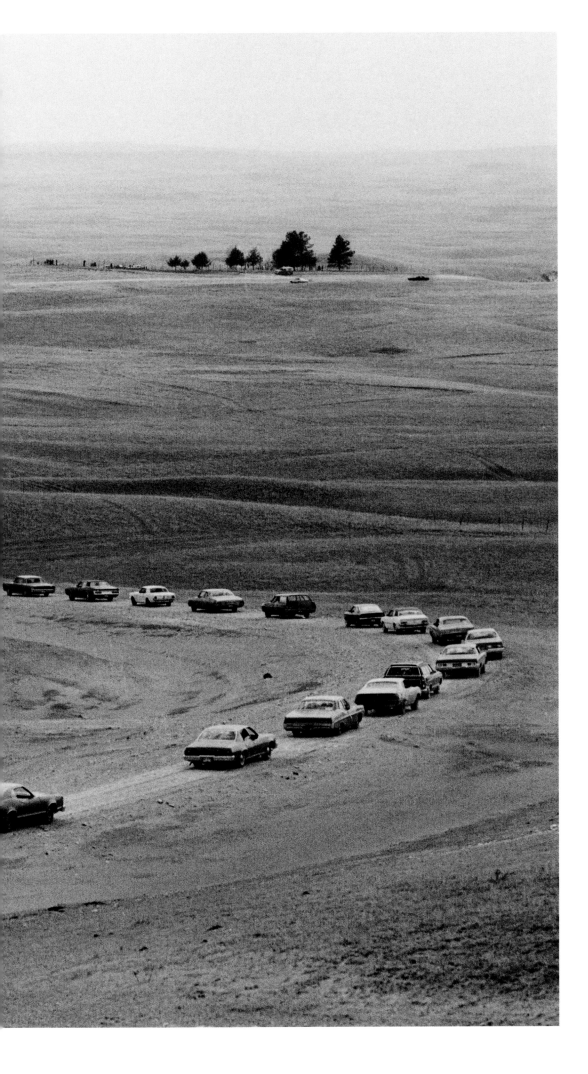

SPRING CREEK CEMETERY

Harvey Walking Eagle's funeral procession, led by a horse-drawn wagon carrying his casket, wound its way across the open plains of the reservation destined for the cemetery.

He was loved for his great sense of "Lakota" humor. Before he was killed he had promised to give me a tour of the sacred places on the reservation. Without Harvey, I never got to see the places that meant so much to him.

THE YUPIK ESKIMOS

NATIVE PEOPLES

ALTHOUGH MY PHOTOGRAPHIC ESSAYS documenting the lives of northern Alaska's Yupik people and the Athapascans of the northern Yukon appeared in National Geographic back in 1984 and 1991 respectively, people today still want to know if I'm involved with the magazine. The essays had that much impact on my career. Photographers took special interest in the Yupik piece because it was the first major story Geographic had published for some time in black-and-white instead of color.

At the time the magazine's estimated readership was something like 36 million worldwide, a mind-boggling outreach for a guy from Milwaukee who had decided to become a photographer in an almost desperate search for a vocation within a vocation. Both of these stories were very much an outgrowth of that life-changing night on the South Dakota prairie.

The idea of documenting the lives of Alaska's native people took root while I was finishing work on "Crying for a Vision" and realized that I needed a new project. "What next?" I asked myself one day, standing near the old Philosophy Annex on campus. "Why don't I go to Alaska!" Not only had I always wanted to go to Alaska, I could adapt the "Crying for a Vision" model to a new setting, combining ministry to people in a village with photographing their daily lives.

Because Jesuits staffed many parishes in rural Alaska, finding a welcoming village would be fairly easy. I was also inspired by a Jesuit photographer from Santa Clara University, Fr. Bernard Hubbard, S.J., known as the Glacier Priest who spent summers taking pictures in Alaska then returning to lecture on his work. Fortuitously, after "Crying for a Vision" appeared, the University of Missouri invited me to lecture at its annual photography workshop. My colleagues at the workshop included a National Geographic editor who urged me to pursue the Alaska assignment for the magazine.

After receiving a contract and being granted a leave from Creighton, I headed to Toksook Bay, west of Bethel, Alaska, to spend the summer of 1980 and the spring of 1981 in the village of 300 people. The gear included equipment for an on-site darkroom that I would use to make prints to give to the people that I had photographed. This was a wonderful method of repaying their kindness just as it had been on the Rosebud Indian Reservation.

Prior to leaving Omaha, I teamed up with a Jesuit writer and colleague, Brad Reynolds, S.J., who had been to Toksook Bay many times and truly loved the people. Brad agreed to write the story. I remember outlining our coverage at an Omaha restaurant at which diners could "scribble" with crayons on paper tablecloths.

When I arrived in Toksook Bay, I discovered that most of the men were absent from the village because they spent their summers on the Bering Sea catching salmon. I joined them in Bristol Bay for a week, living with a Yupik crew on their commercial fishing boat to document their work. At dinner, they opened a box of dried herring covered with blue mold.

And they slept in bunks in front of the boat's diesel engines. I ate the herring dipped in seal oil, but found that I could not sleep in the bunks because of the heat and diesel smell, so I moved to the deck and focused on the horizon to avoid seasickness. After a fascinating week with them I returned to the village, helped out at the parish, and photographed women and children as they collected food for the winter.

After teaching the fall semester at Creighton, I returned to the village in January and settled in for winter, adjusting to winds howling off the Bering Sea and temperatures of 10 to 30 degrees below zero. Sunrise was at 9:30 or 10 a.m. When the men went on their winter hunting and fishing expeditions, I often accompanied them. I was struck by the constant politeness of these joyful people who would rather say "maybe" to an idea they didn't like rather than "no."

The people still subsist off the land and sea, hunting geese, seal, walrus and fishing for herring and salmon, but face problems like earning enough money to pay for gas and oil to heat their homes. Some modern changes were popular, like the construction of a high school that gave the village a community meeting room.

Upon my return to Omaha in the summer of 1981, I reviewed over 300 rolls of film, working through the National Geographic's elaborate editing process. Each photograph had to present new visual information, adding to the story with no repeats. Only the best photographs survived, a rigorous process that taught me to be ruthless in picture selection and editing. The magazine delayed publication of the story until 1984 and then used only 11 photographs of the hundreds I had shot. However, I was pleased with the outcome and the attention that publishing in the National Geographic carried.

Sometimes people ask why I continued to shoot in black-and-white long after many photographers shifted to color, something I did not do until the late 1990's. There were several reasons. Philosophically, I liked working in black-and-white because it revealed the bare bones of my subjects. However, black-and-white had other more practical advantages. At that time it was far less expensive, and easier than color film to shoot and process. Also, I taught black-and-white photography in my classes because that was the norm for newspapers in the 1980's. So I was comfortable working in this medium. I finally shifted to color when technological improvements cut costs and made it easier to shoot and print quality work. And, as a friend reminded me, I could always print a black-and-white photograph from a color negative – but not vice versa.

> The people still subsist off the land and sea, hunting geese, seal, walrus and fishing for herring and salmon, but face problems like earning enough money to pay for gas and oil to heat their homes.

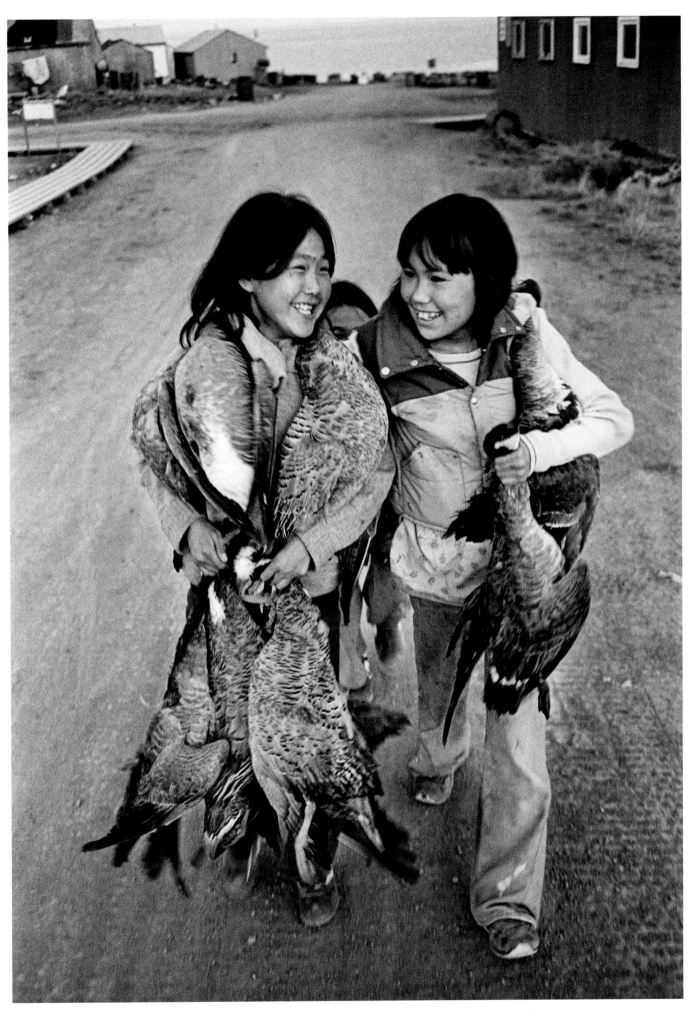

TOKSOOK BAY, ALASKA · *Anna Asuluk and Darleen Morgan, along with shy Lucy Asuluk (center), carry geese that were shot by Anna's father. They will share the bounty with friends and neighbors who do not have a hunter in the family.*

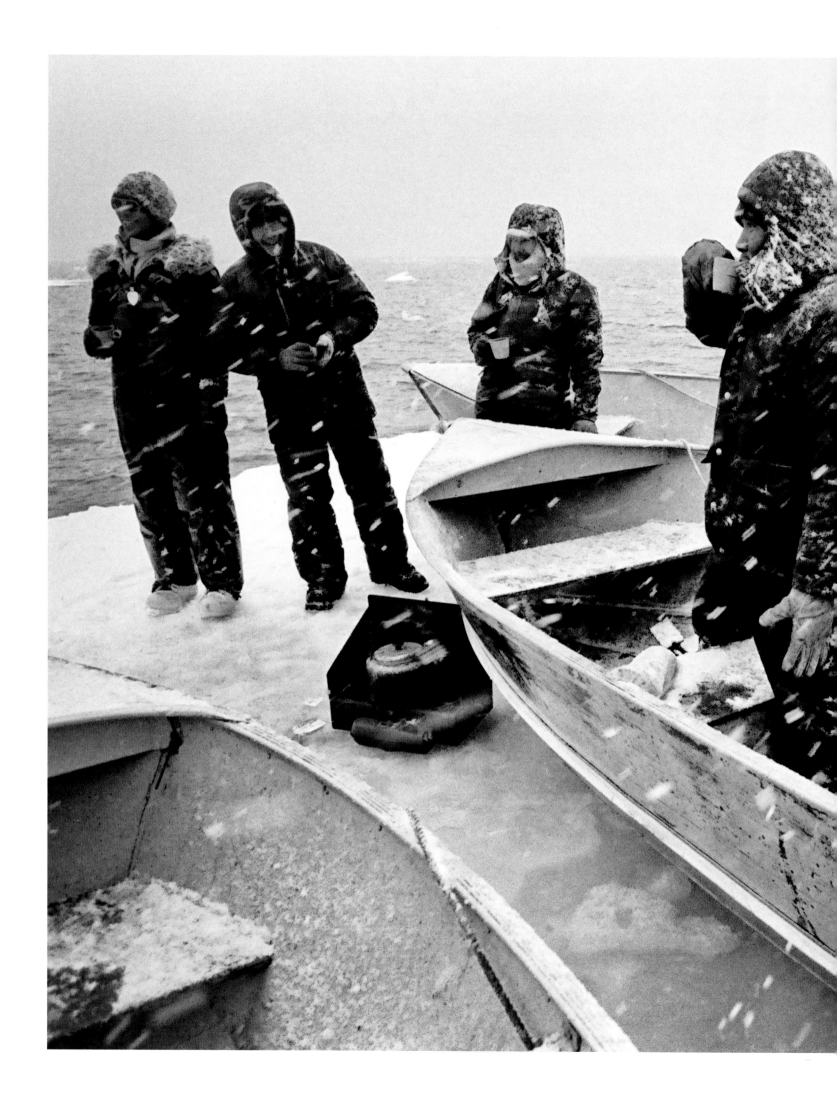

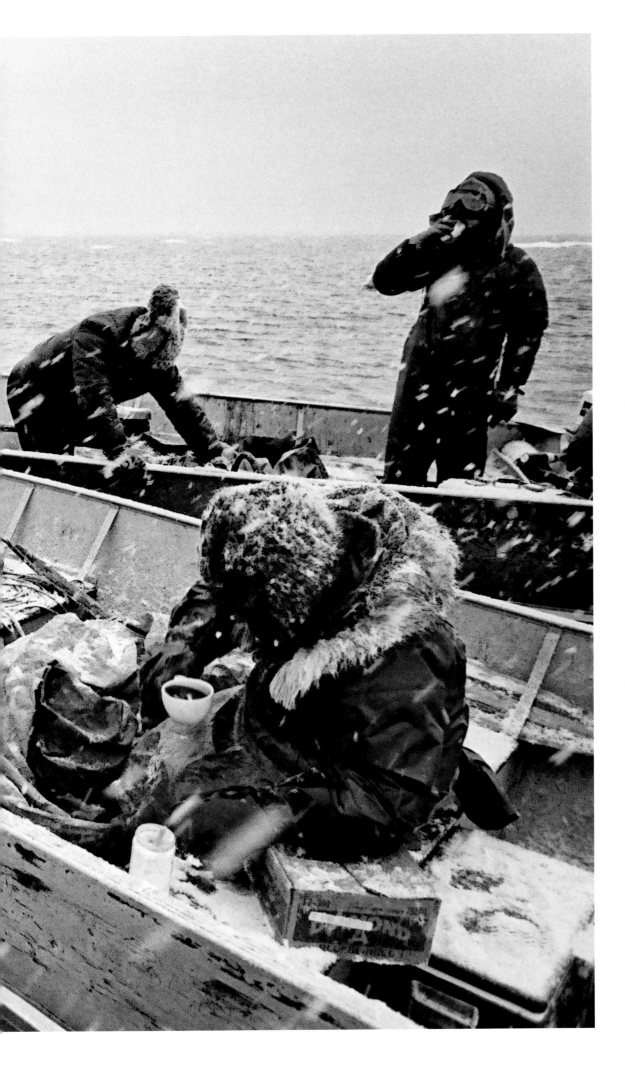

TEA BREAK

Toksook hunters gather on an ice floe for a tea break while seal hunting on the Bering Sea. They shared 'steak of the north' -Spam- on a Pilot cracker with their tea. In a thick fog miles into the Bering Sea, I had no idea how these men were going to find their way back to shore.

Once the seals have been caught, they use the skins for clothing, dry the meat on their roofs in the summer sun, and use the oil for cooking. Each table in the community has a peanut butter jar of seal oil to use as a condiment: to dip dried herring - another staple food for the Yupik people.

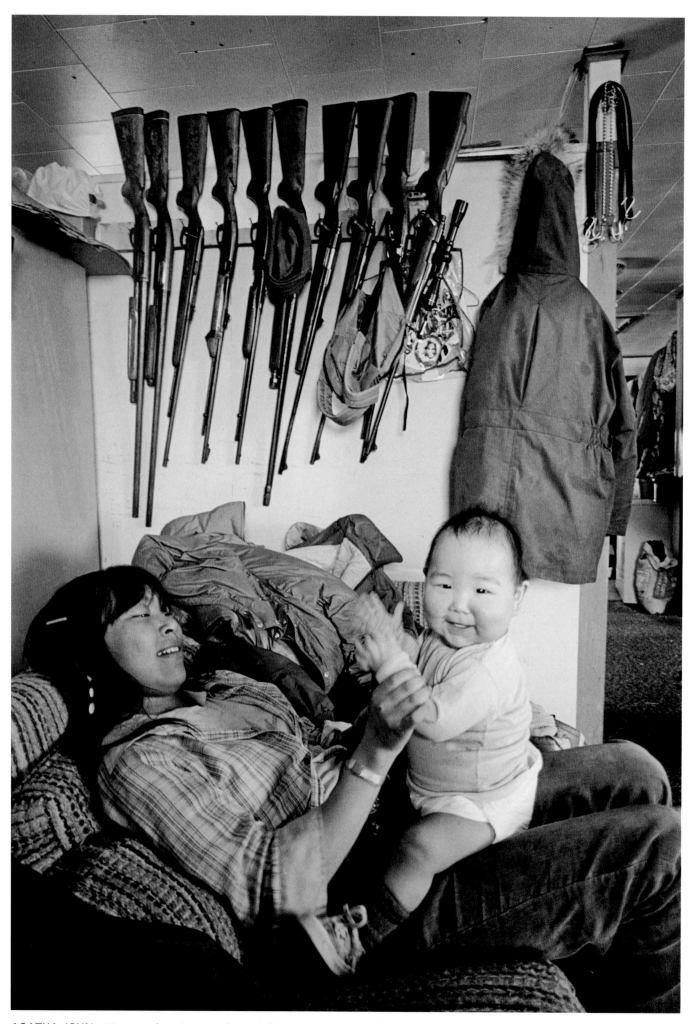

AGATHA JOHN · *Vernon plays Pat-a-cake with his aunt Agatha in their living room fully equipped for the hunting season.*

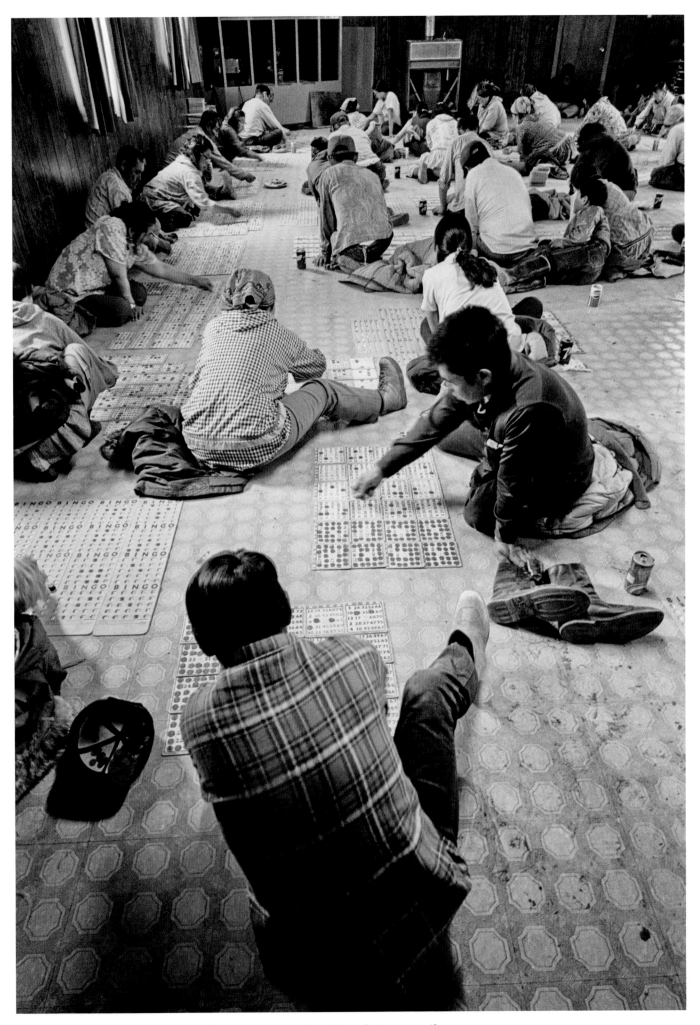

BINGO · *Weekly bingo brings in half the income for the Toksook city council.*

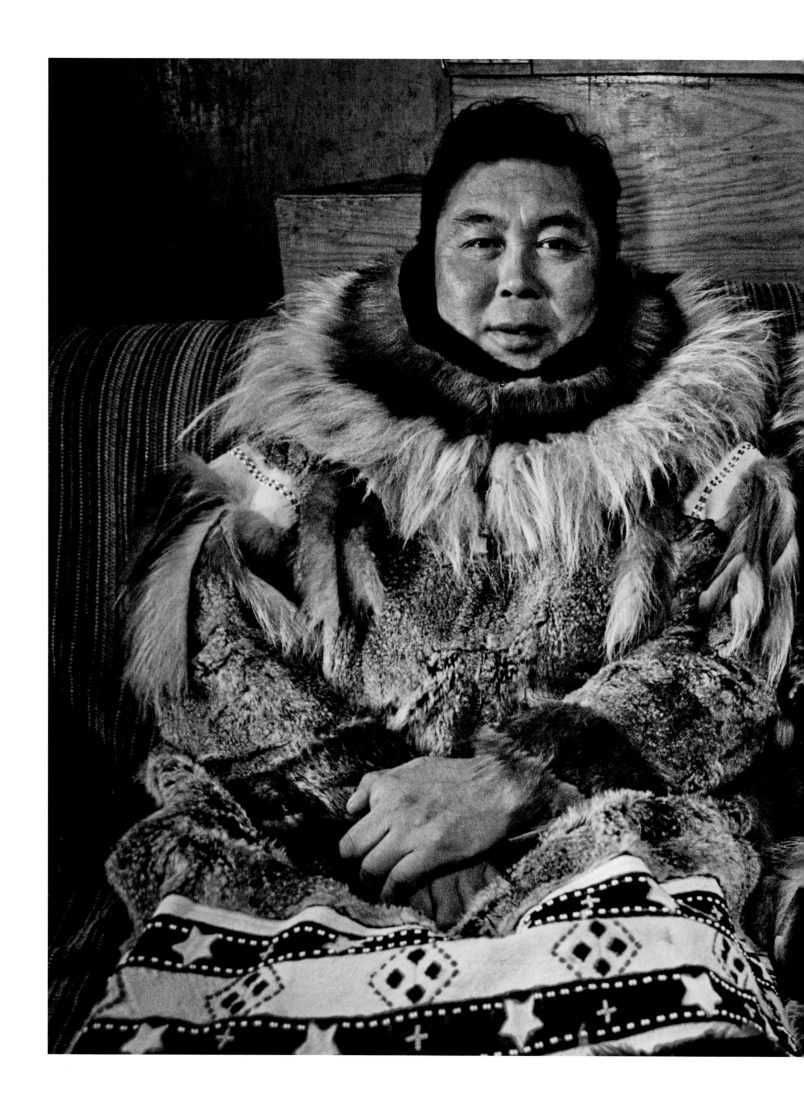

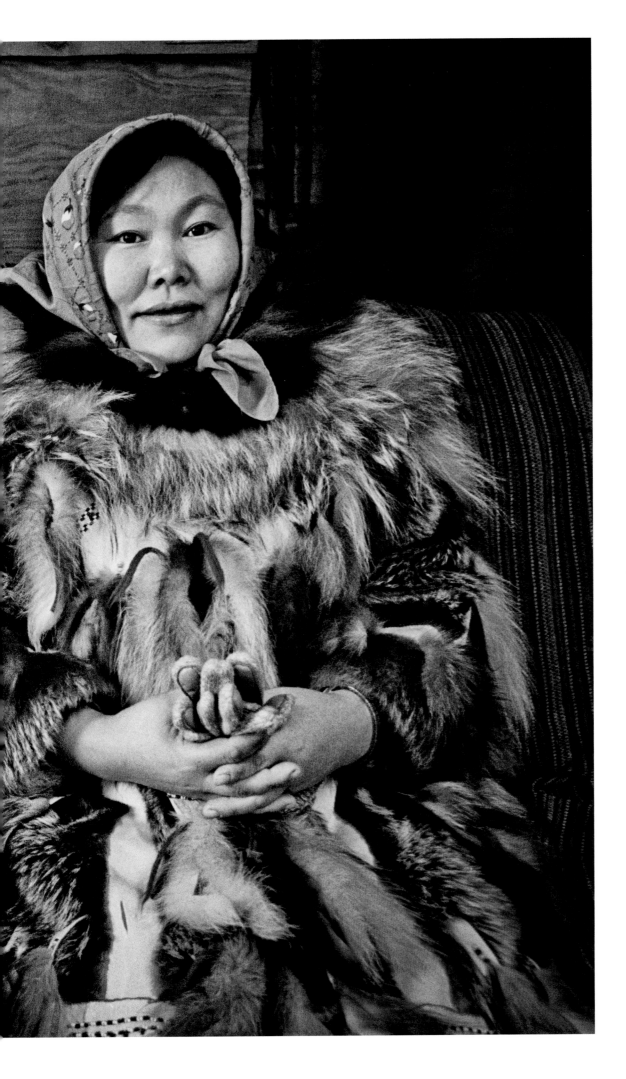

NICK AND LAURA THERCHIK

Wearing the handiwork of Laura's sewing, this couple's mountain-squirrel parkas kept them warm one winter morning. The couple was attending Mass in Saint Peter the Fisherman's Roman Catholic Church. With the heater broken, it was so cold that the holy water froze.

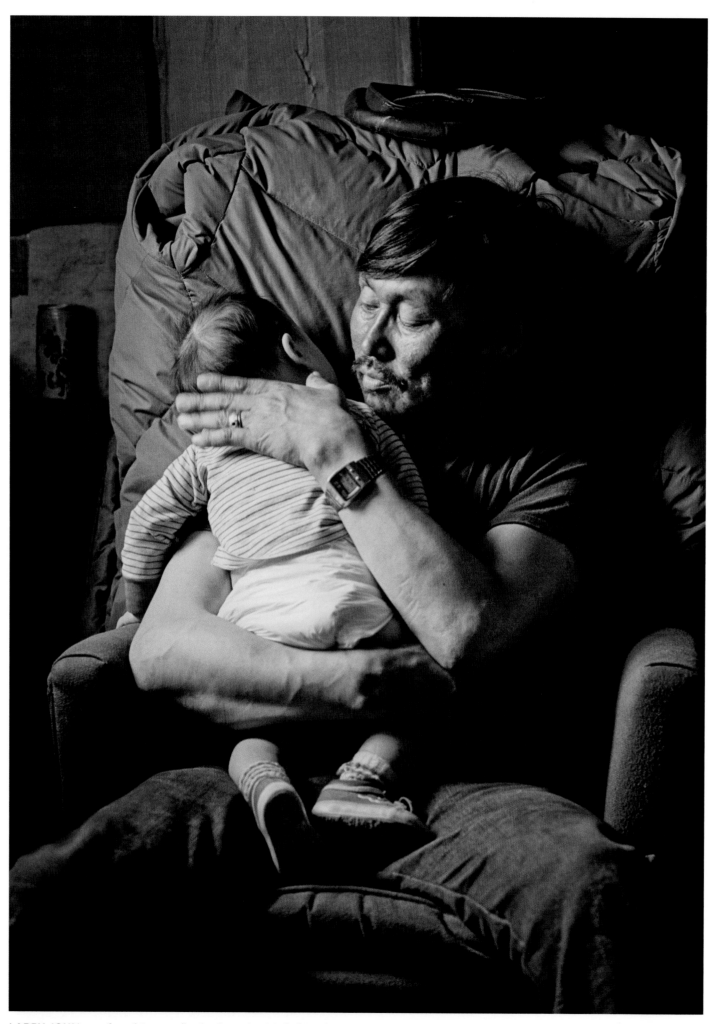

LARRY JOHN *comforts his son who had meningitis before chartering a flight to a Public Health hospital about 100 miles east.*

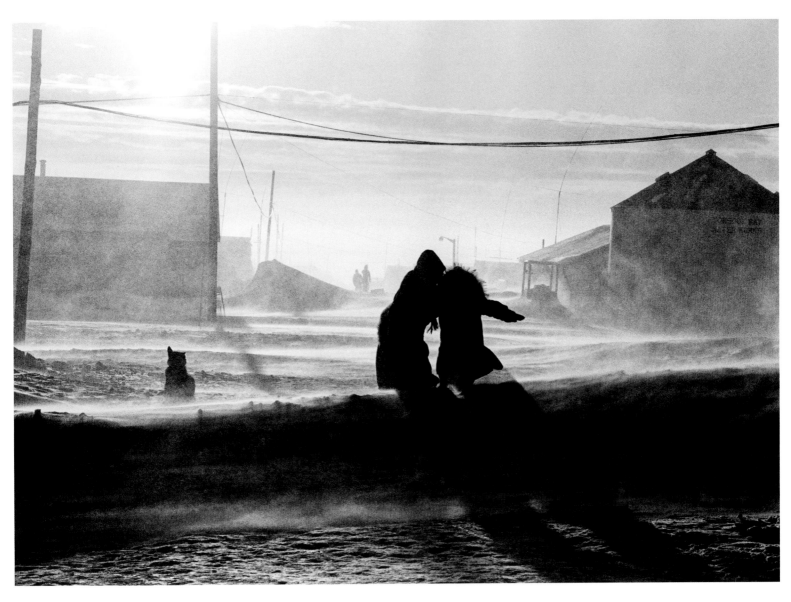

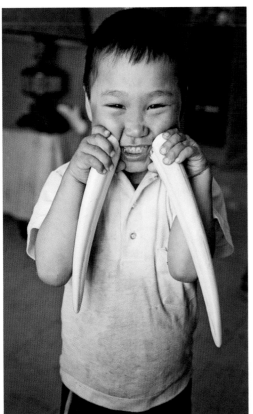

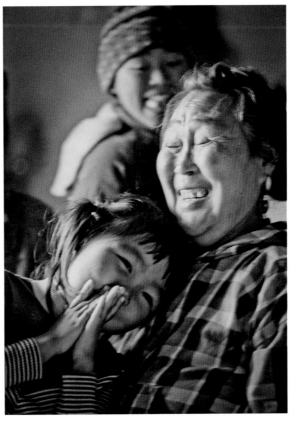

GROWING UP

Children in the frozen communities of Alaska still behave like other children. They walk to school in the mornings, but here they do it in temperatures of minus 20 degrees Fahrenheit and winds up to 70 miles per hour.

Fritzie Nevak plays with real walrus ivory tusks for his make-believe fangs instead of plastic replicas. His father carves the ivory into fine jewelry.

Grandmother Therchik enjoys a moment with her grandchildren. In tribal society, kinship is all-important.

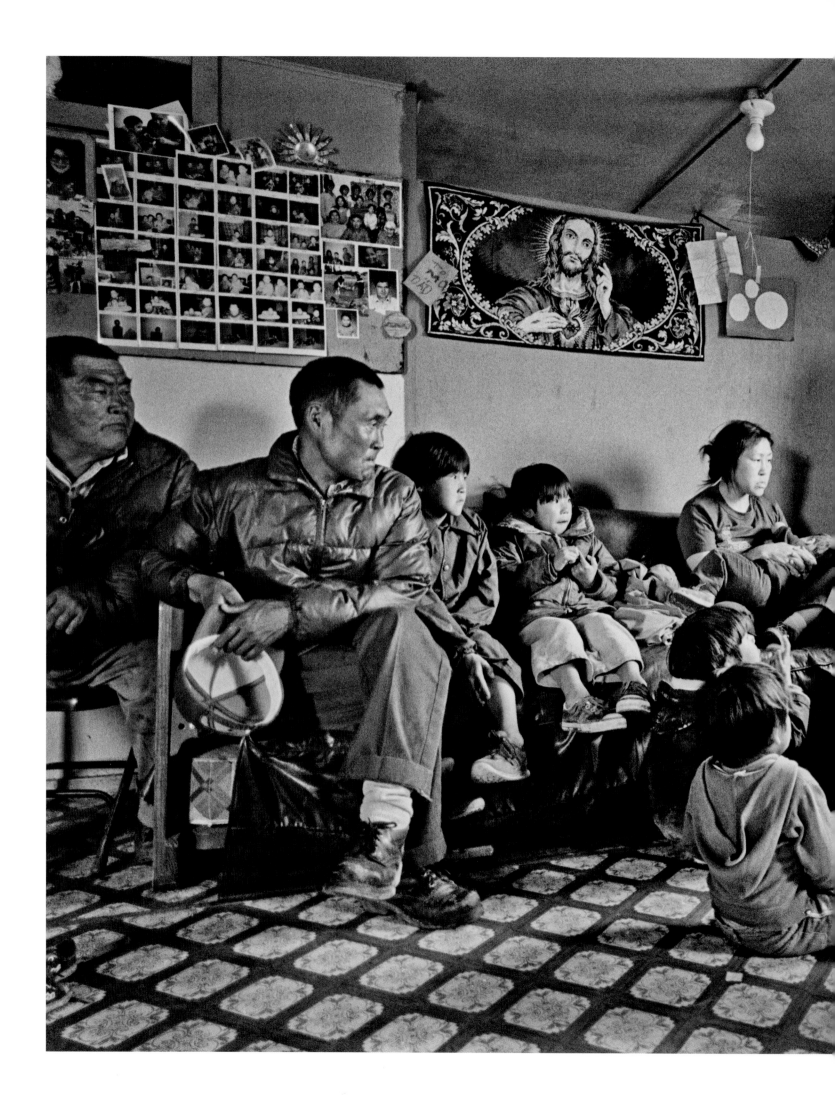

TV TIME

Simeon Julius and John Alirkar spend a few minutes watching Snow White with Larry John's family. A few days prior the television tower blew over, leaving video cassettes as the only option. Storekeeper Larry John had 140 tapes at that point, making his house popular when people were unable to get local channels.

I always enjoyed sitting on the floor of this home with Larry's family after Sunday Mass, when he cooked one of his marvelous king salmon. He was considered to be one of the best fishermen on the island.

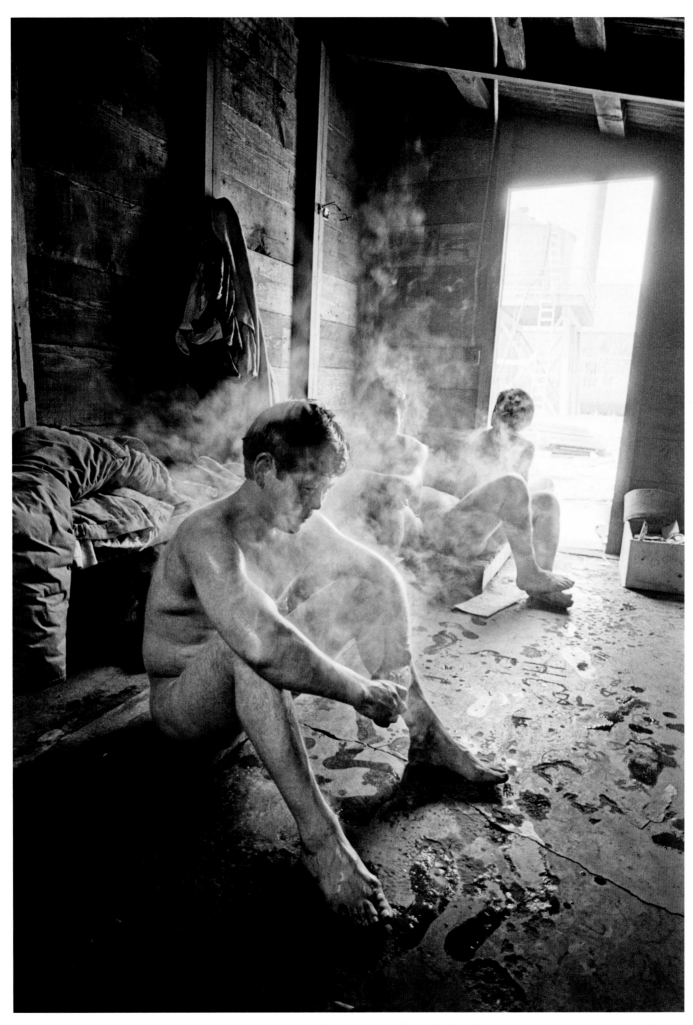

CLARK'S POINT · *Nick Chanar enjoys a communal steam bath known as "maki" after three days at sea in Bristol Bay, Alaska.*

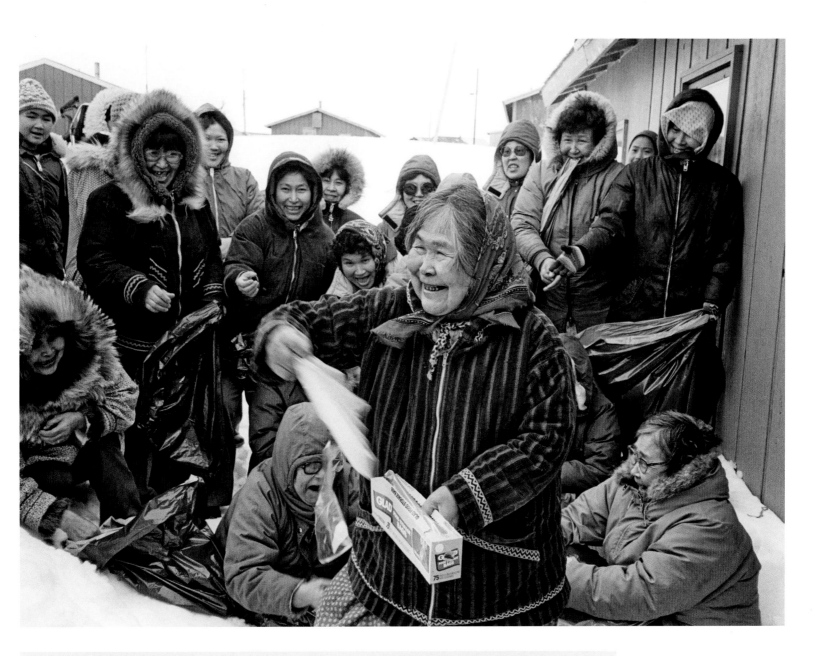

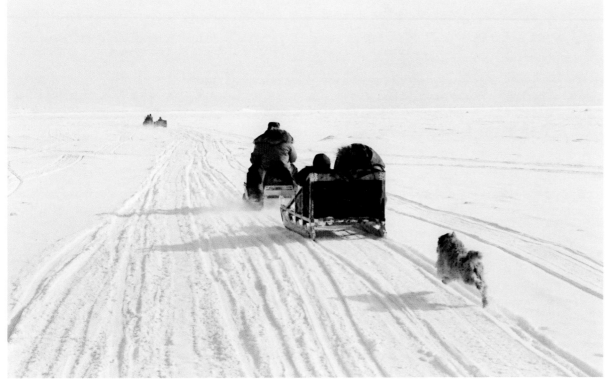

COMMUNAL LIFE
The women laughed at my expense as Francis Usugan questioned my manhood in Yupik. In their culture, only women attend a seal party at which the first large seal of the hunting season is shared.

The Sipary family dog chases the family 'station wagon' as they head 45 miles to the east for a religious rally.

BEN CHAGLUAK

Ben wanted a home of his own for him and his wife - away from his in-laws - and towed this house from the old fishing camp at Umkumiut to Toksook a few miles away on 55-gallon drums for floatation.

His father and fellow founders of the town did much the same thing 20 years earlier when they moved across to Nelson Island from Nightmute. In the winter, people were able to move their homes over the ice, letting dog teams do the manual labor.

Government-built housing later doubled the number of homes for the 65 families in the community.

THE ATHAPASCANS

NATIVE PEOPLES

THE SUCCESS OF MY PROJECT with the Yupik Eskimos led to a second major Geographic story, this one depicting the lives of the Athapascans who lived along the Yukon River. Through careful research I found that no one had yet told their story. Again, working with Brad, I spent the summer of 1987 with the Athapascans. I took another leave of absence from Creighton which allowed me to return in spring semester of 1988, and complete the photography during a week in spring of 1989.

The Athapascans reminded me of my Sioux friends as they faced many of the same challenges, including poverty and high rates of alcoholism. One of my more memorable adventures was driving a snowmobile for 50 miles in subzero temperatures to photograph a fur trapper who was checking mink traps. At one point he asked me how my feet were doing. I responded: "I think they are blocks of ice." He had me remove my socks and shoes and defrost my feet by placing them on his belly. Then he gave me straw-lined moose-hide mukluks that kept my feet warm and dry. Finally, after four or five hours, we arrived at his log hunting cabin. There he sent me down to the river to chop a hole in the three-foot ice to get water. During the three days we spent in the lodge the menu included beaver, bear, caribou, and even pickled beaver's feet prepared by my host's mother. Each day I photographed him making another 30-mile loop to check his traps.

> At one point he asked me how my feet were doing. I responded: "I think they are blocks of ice."

Once I gained more skill, I enjoyed driving a snowmobile. After the trapping expedition, the Athapascans were astonished when I drove alone 90 miles down the snow-covered frozen Yukon River trailing a sled with bags and camera equipment. I took up residence in Kaltag, a fishing town that the Jesuits served for years. The previous Jesuit pastor, Fr. Jim Sebesta, S.J., had started a fishing association, which got the price of the major local source of cash, salmon roe for caviar, raised from a dollar a pound to $5 a pound. This was more than an economic improvement, it was a justice issue.

Brad and I had long discussions about which stories would best depict the lives of the Athapascans. We covered a gold miner because he was a rarity, and showed a mother giving a Saturday night bath to her children. My research indicated every issue of the Geographic on Alaska carried a bathing photograph. Since there was no running water families had to carry water to their houses. We showed native children learning about urban life during a summer program in Fairbanks, and a baseball game that started at midnight during the summer solstice, when the sun never sets.

Some of the tragedies I encountered reminded me of life on the Rosebud Reservation. A mother who had lost four children to fetal alcohol syndrome told her story. A fifth child had lived but had been permanently damaged. My fur trapper friend was terribly burned in an airplane crash but lived to tell many the story of his rehabilitation. We depicted the death of a man who drowned trying to recover an outboard motor.

I returned to Alaska in the spring of 1989 specifically to photograph the Stick Dance, a ritual in which participants dress up in the clothing of someone who has died and they become that person. They are invited to village homes to say farewell – a way of processing grief in an area where so many people die suddenly due to accidents and weather.

A follow-up project for Geographic confronted me with my first significant failure as a photojournalist. The magazine asked me to shoot photographs on all 15 Sioux reservations in North America for a somewhat wide-ranging story on native life, a project I could only work on during summers and breaks during the school year. It didn't work.

Not only was I exhausted from spending every break traveling to reservations, I had no time to settle into a village and build trust. I learned that doing an assignment for National Geographic was a full-time job that could not be squeezed into a crammed teaching schedule. In addition, the Geographic wanted a more positive story while my photographs depicted people struggling with alcoholism, massive unemployment, and other serious problems. This disconnect prompted the magazine's editor to ask me to return for "happier" pictures. I declined, as I was exhausted. The story made it all the way to the layout phase, but it was eventually killed.

I felt like a total failure. But I learned that my major photographic projects could succeed only when I took time off from teaching and had a chance to build relationships and immerse myself in the lives of people. I had to focus exclusively on the work at hand, free of outside demands and commitments, to tell their stories with my cameras. It was a lesson I took to heart after the Athapascan story, during my next major project with Native Americans.

KAREN ESMAILKA · *One of the few women in her village able to perform the ancient Athapaskan songs, Karen hopes to pass them on to her daughter, Whitney. In remote villages like hers, such traditions are in danger of being forgotten.*

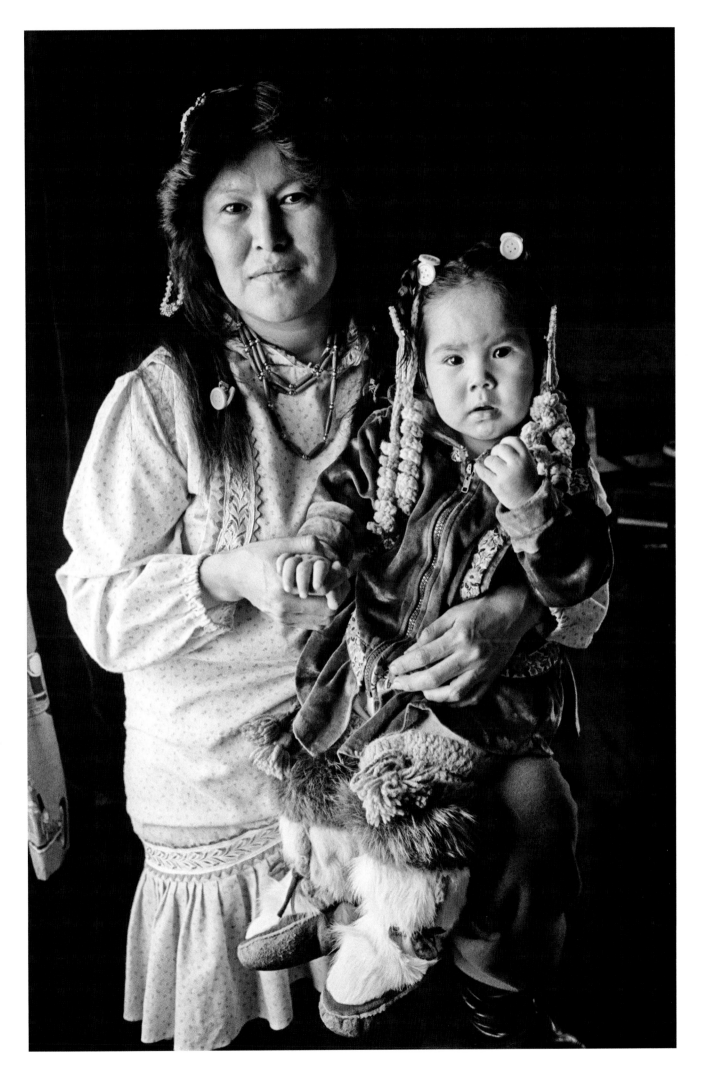

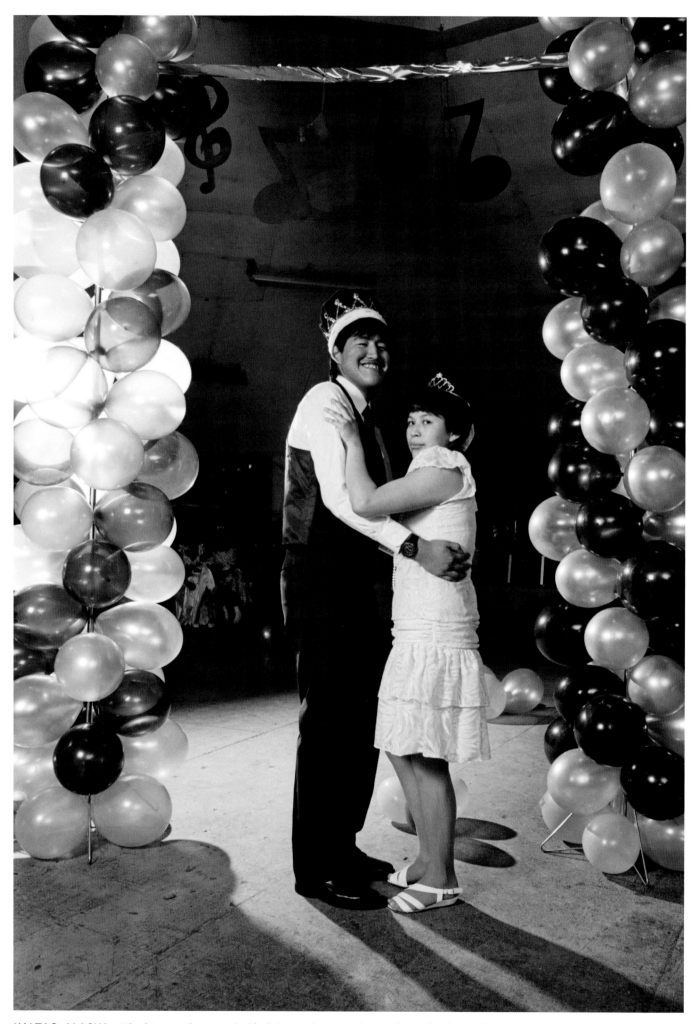

KALTAG, ALASKA · *The king and queen, half of the graduating class, take to the dance floor at Kaltag's high school prom.*

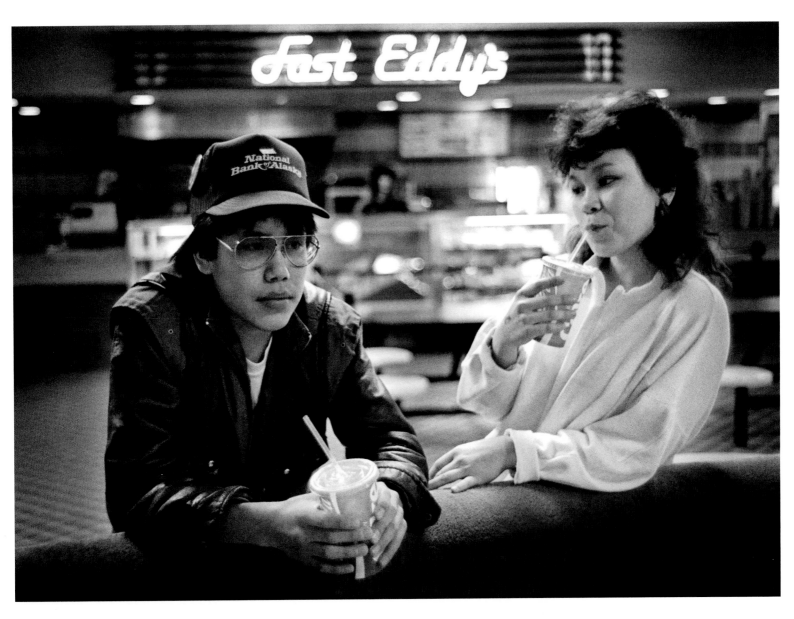

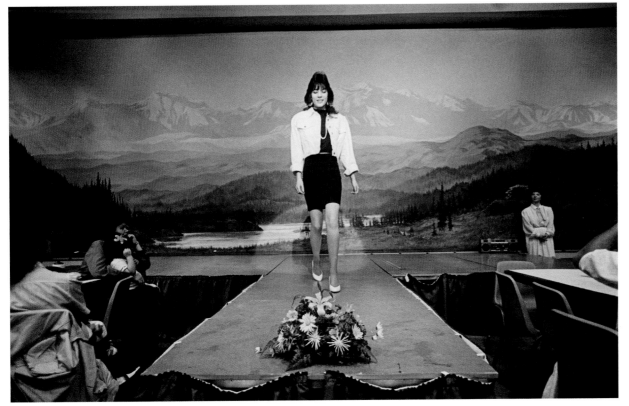

SURVIVING THE CITY

To prepare rural students for a transition to city life, they received instructions on opening bank accounts and applying for jobs. Joe Wright and Stephanie Alexander met at a roller skating rink in Fairbanks, Alaska, on a "Urban Survival" school trip.

The local J.C. Penney's donated clothing for an urban fashion show in Fairbanks for young people to try on city clothes, completely foreign to what they wear in the "bush."

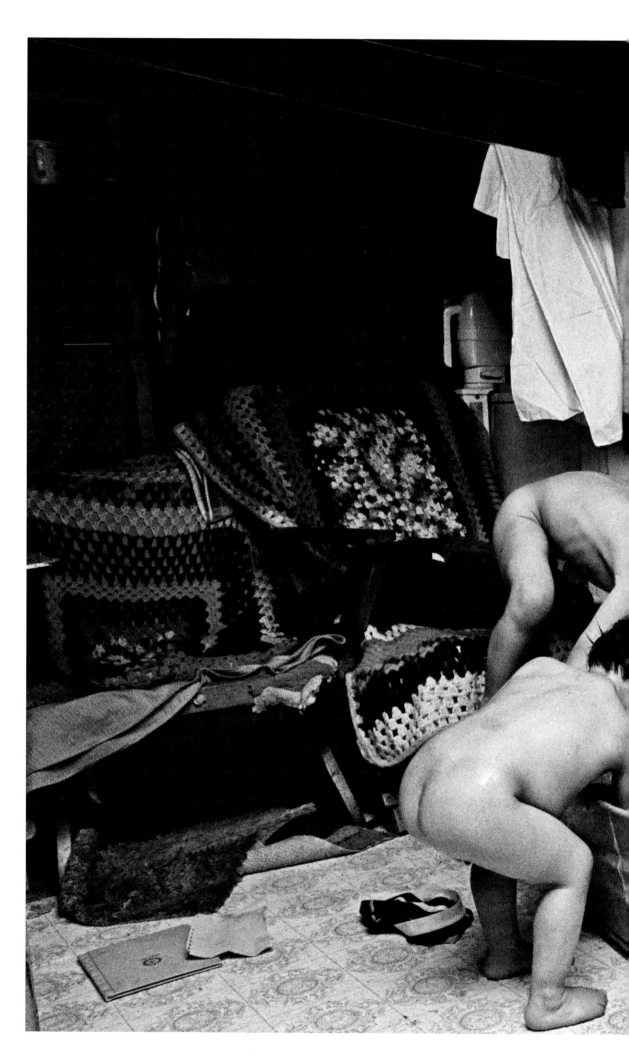

JOANN PITKA
scrubs her three sons in the shared bath water her husband hand-carried from the river. There was no running water in Kaltag, Alaska, along the Yukon River. The heating oil they relied on to warm the house was shipped by barge during the summer months.

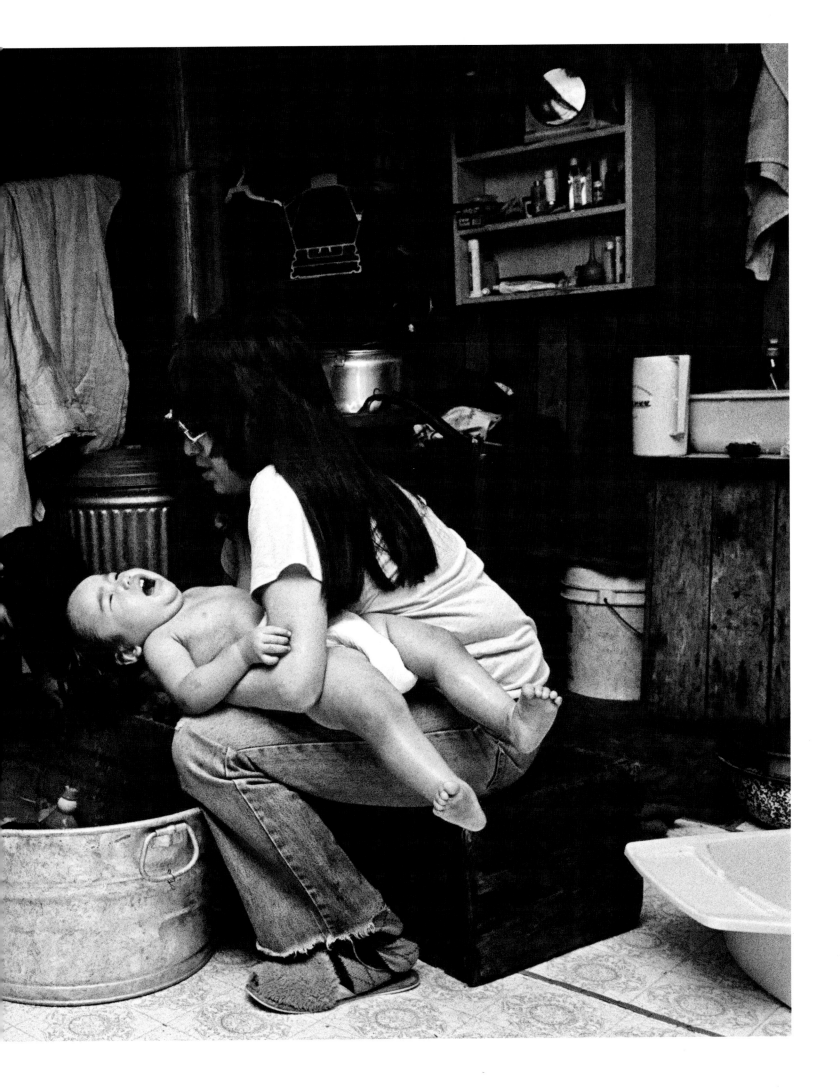

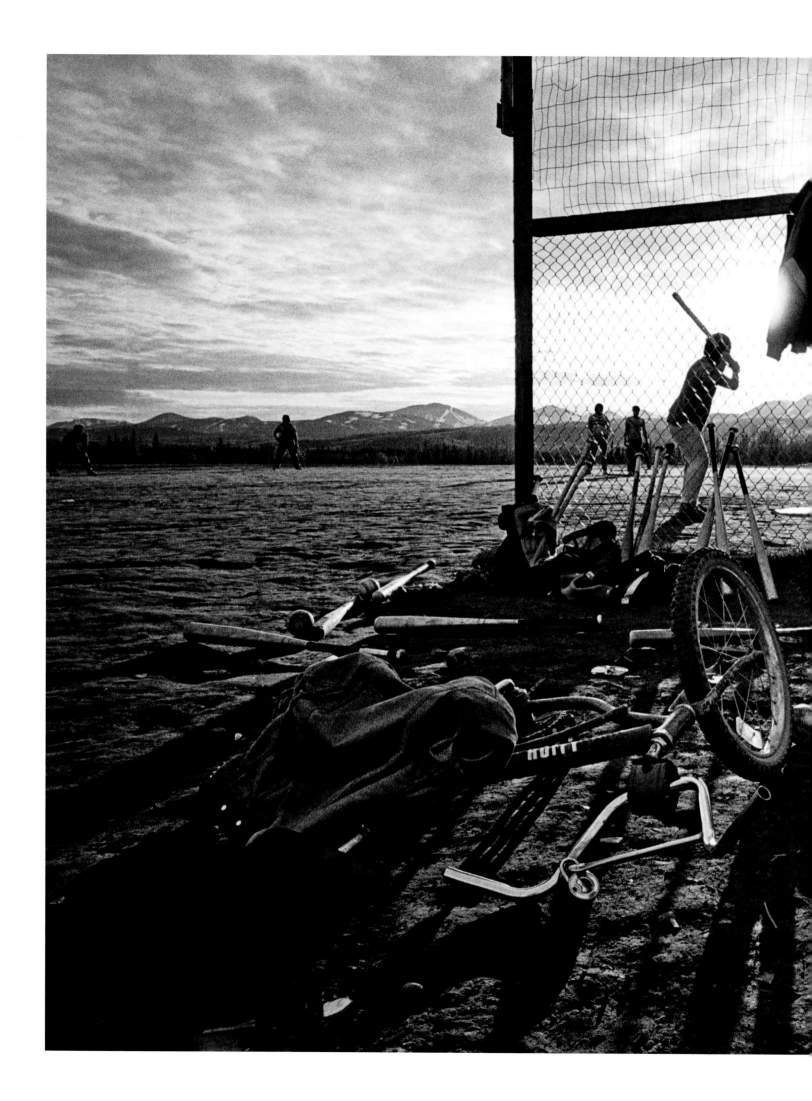

MIDNIGHT BASEBALL

Athapascans in Kaltag play night baseball under the midnight sun during the summer solstice when there is only about an hour of twilight between 1 and 2 a.m.

People soak up the sun while they can, rarely sleeping and surviving on cat naps during these bright and warm months.

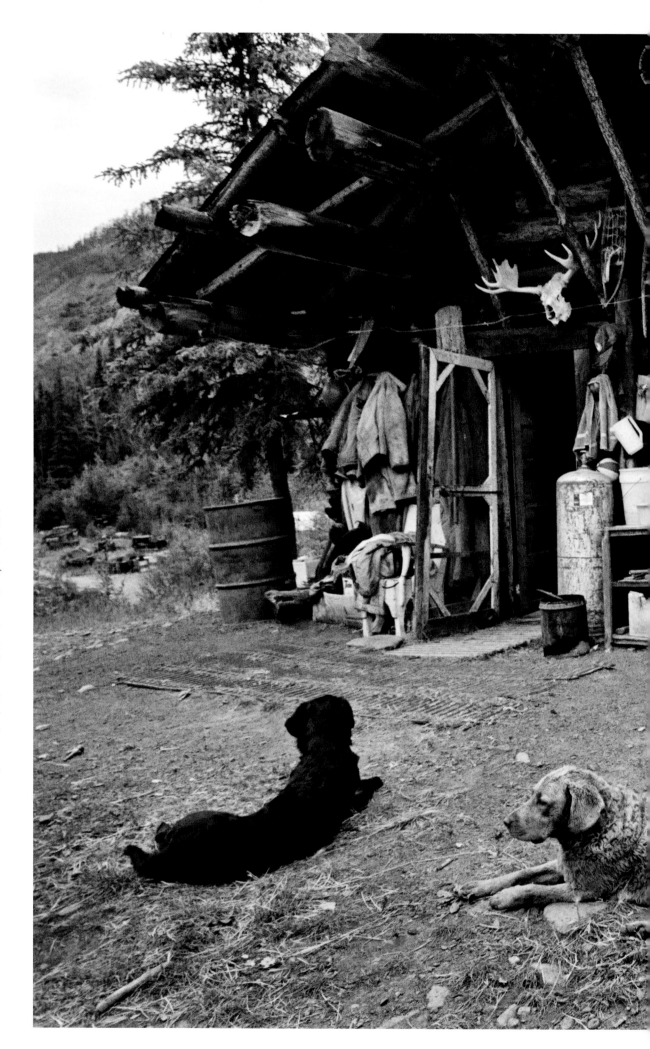

RAMPART, ALASKA

I wasn't getting any good photographs of their gold mining all day. So when Bill Carlo asked me if I wanted to see some gold, I almost said, no, because I knew what gold looked like. He went into his cabin and retrieved a pan of gold, emerging with a smile as his granddaughter dug through looking for the largest nuggets.

"I dig just enough gold to pay my bills," he said, holding a pan worth about $10,000 from his mine.

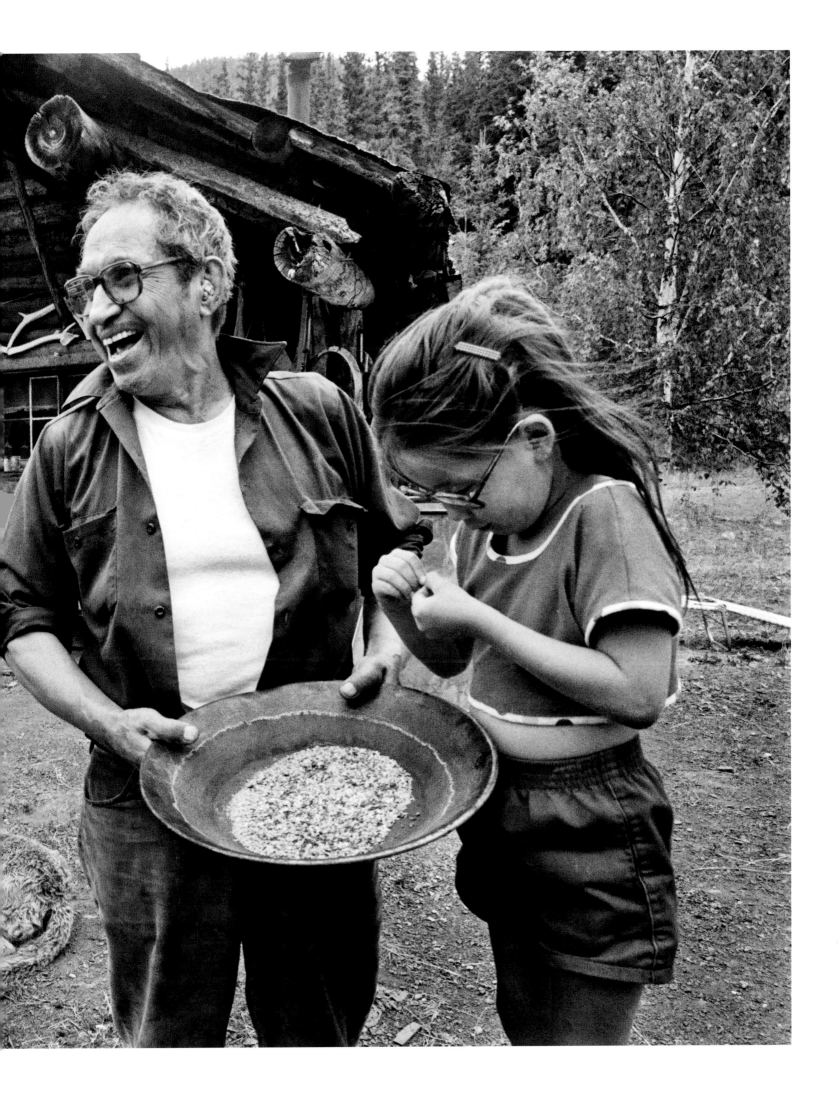

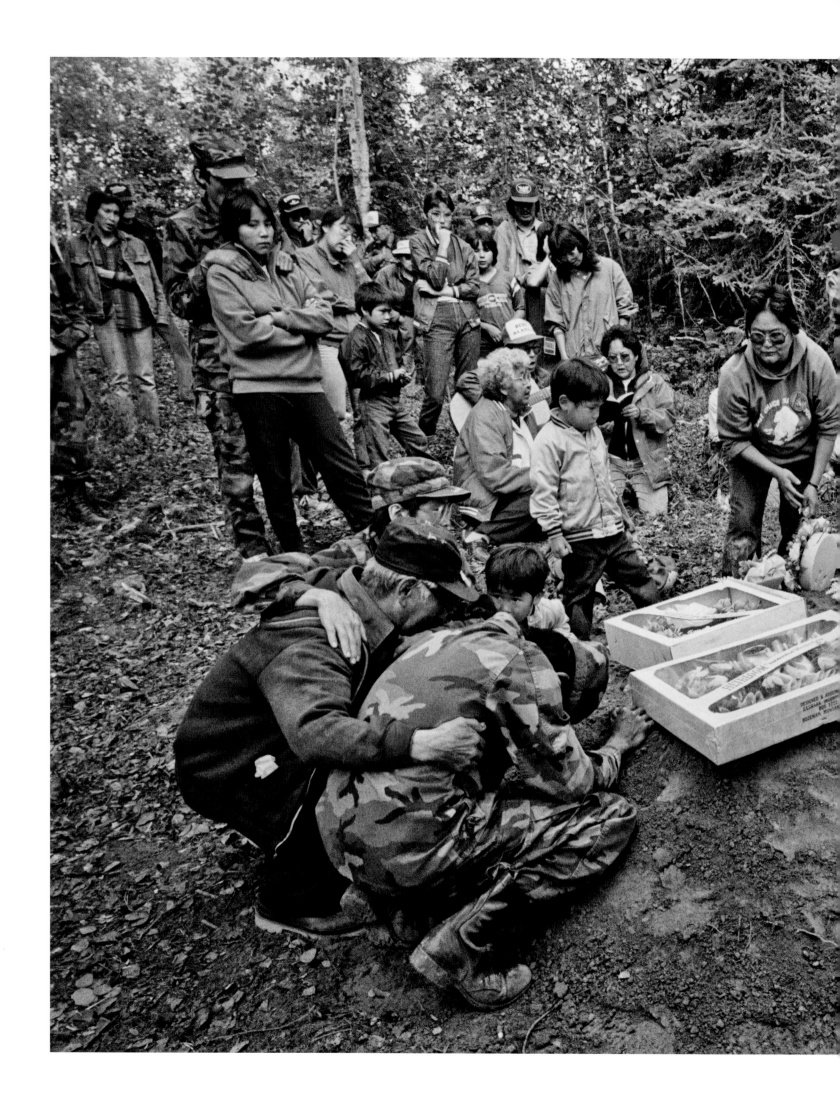

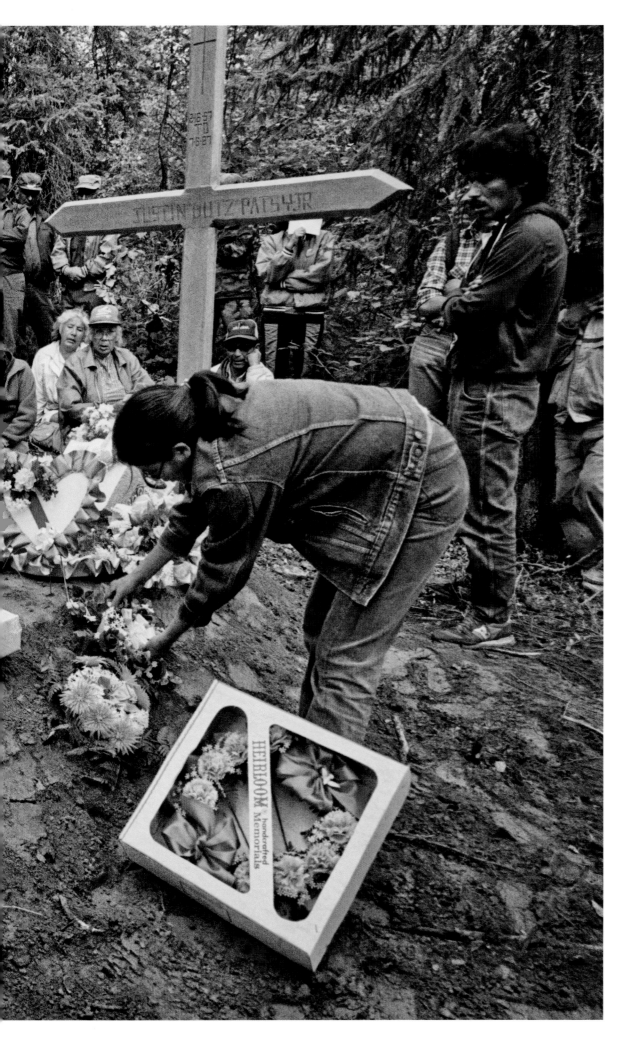

NULATO, ALASKA

A funeral service was held for National Guardsman Justin Patsy surrounded by friends and family. Justin drowned in the Yukon trying to retrieve the motor when it fell off his boat.

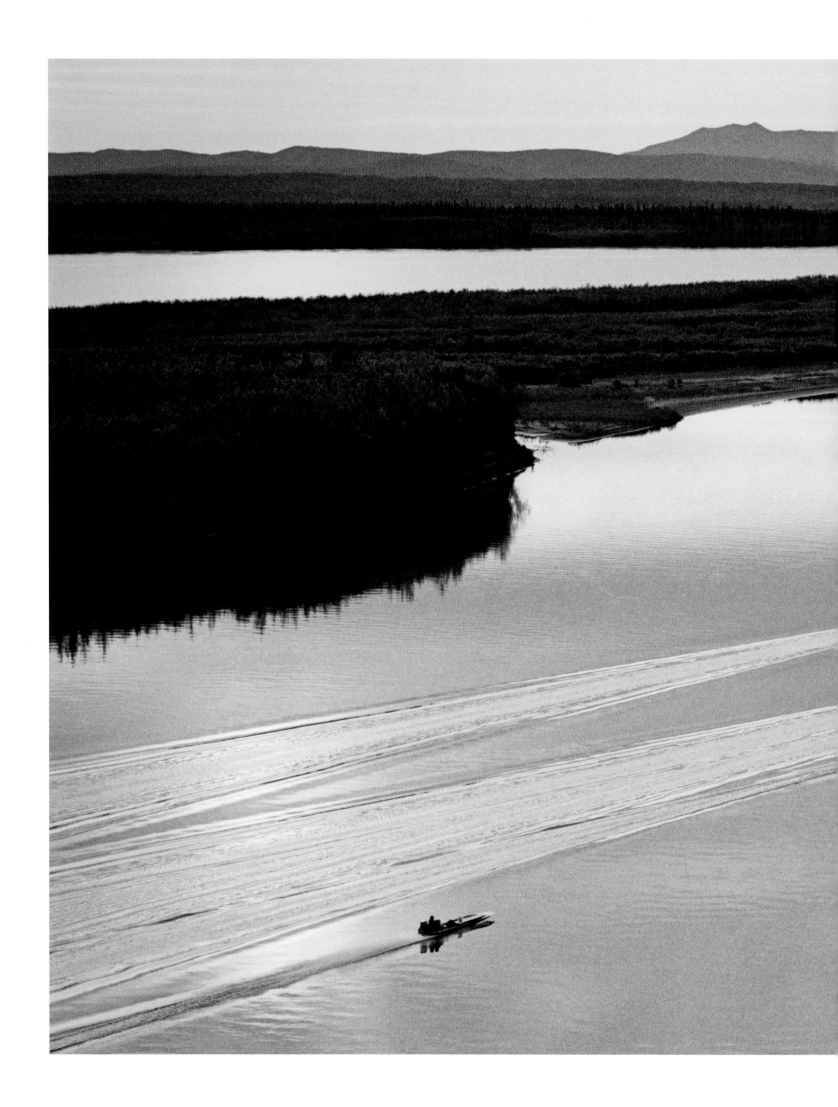

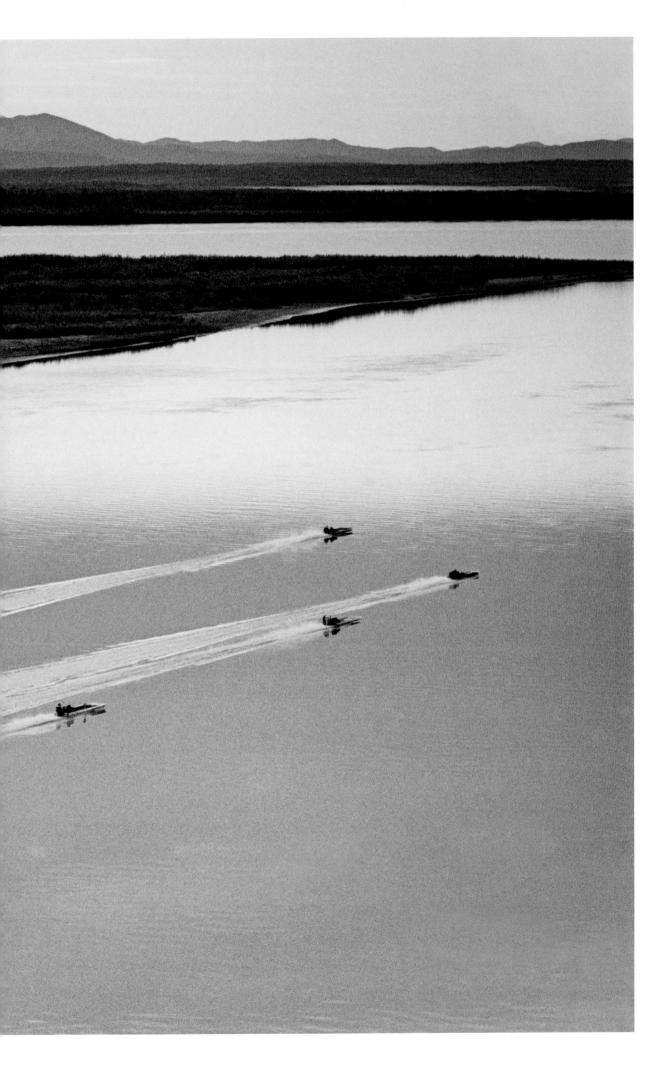

YUKON RIVER RACE

I persuaded a friend to take me up in his Super Cub airplane to photograph the return leg of the 400-mile race up the Yukon between Galena and Fairbanks. I liked the visual pun: They looked like the F-15 fighter jets based in Galena.

I kept asking him to go slower so I could make my photograph. He finally said, "If we go any slower, we'll stall."

STICK DANCE

Men gathered in the village of Nulato before the traditional Stick Dance ceremony. Every two years or so, to commemorate the lives of loved ones who had died, the village would hold a Stick Dance.

For an entire year a close friend of the deceased would participate in meals and receive a new set of clothes made by the family.

On the day of the ceremony he or she would visit friends and relatives, taking on the name of the person who had died to say goodbye on his or her behalf.

After the ceremony there was a large potluck dinner on the floor the length of the hall. Everyone knew who the best cooks in town were, and they made a beeline for those dishes.

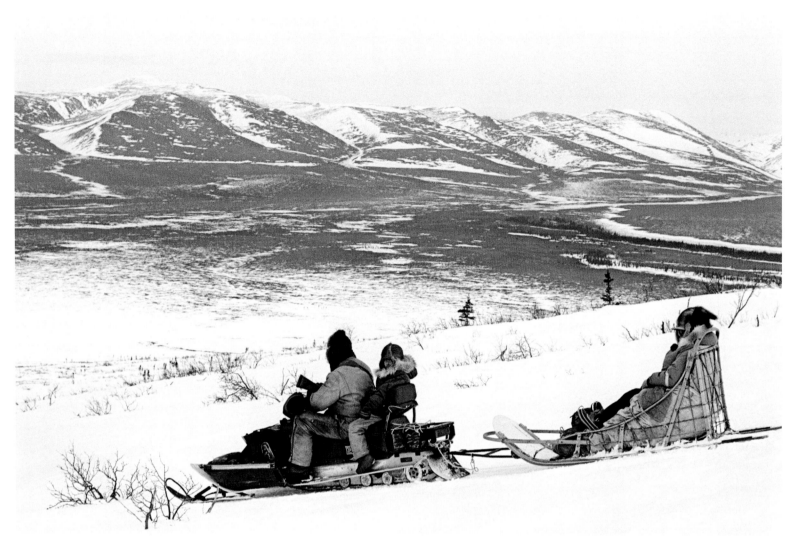

MODES OF TRAVEL

Whether it is by dogsled, snowmobile or boat, the people of these small villages have found the best way for the season to get in and out of town. Wilson Sam takes his family on a 90-mile trip to Selawick Hot Springs north of the Arctic Circle.

But some transportation brings more harm to the community than good. Bootleggers risk $500 fines to bring alcohol to these "dry" communities, doubling the price of the goods for their trouble.

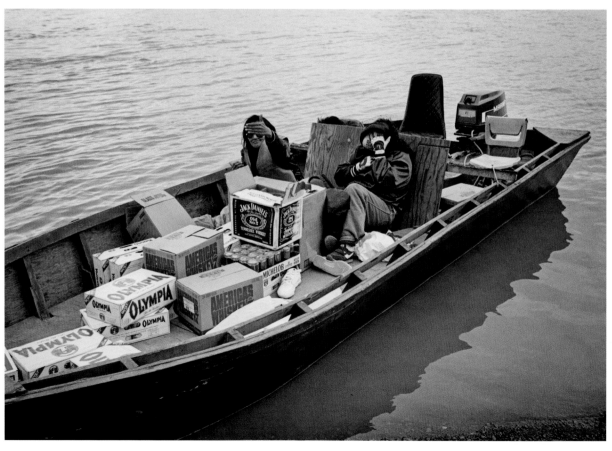

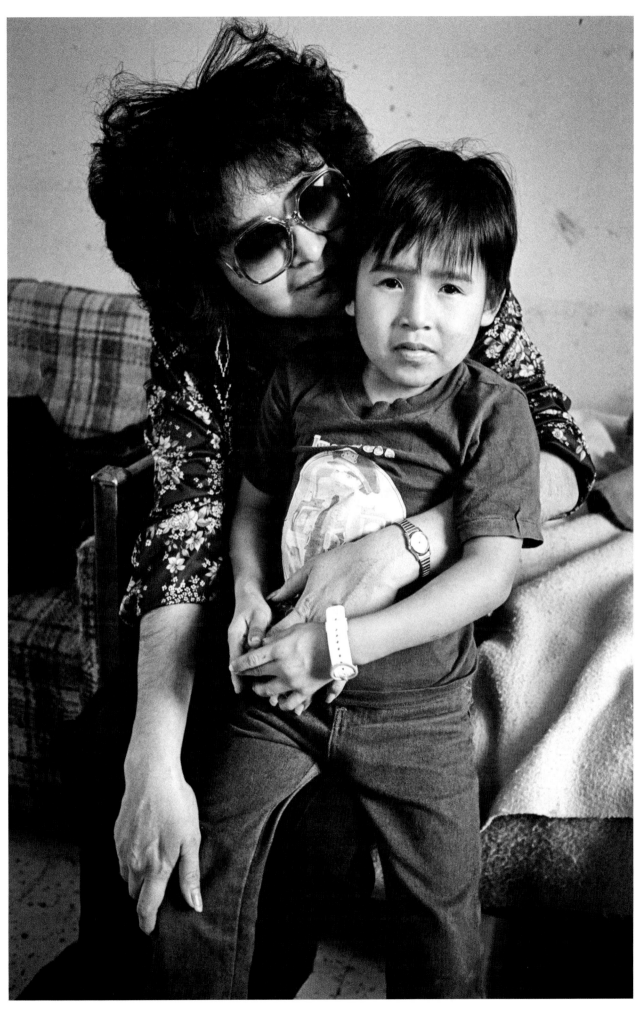

PAULINE GEORGE *lost four of her children to fetal alcohol syndrome. Now in recovery, she wanted her story told so other women wouldn't make the same mistake. Her son, Kelsey, was born with lung damage due to alcoholism.*

ROGER HUNTINGTON

*considers himself lucky to be
alive after his plane crashed in
the bush. In order to survive he
tore off his burning clothes and
hiked seven miles to find help,
all in zero-dregree weather.*

*He wore a plastic mask and
body suit to help the skin grafts
heal. Before his life-changing
flight, he spent time at his
cabin, trapping and
skinning marten.*

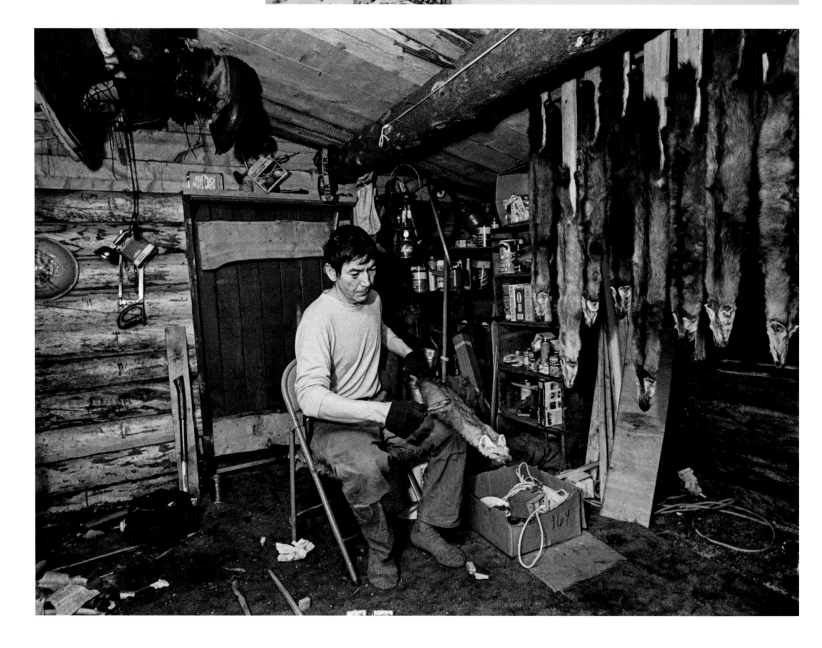

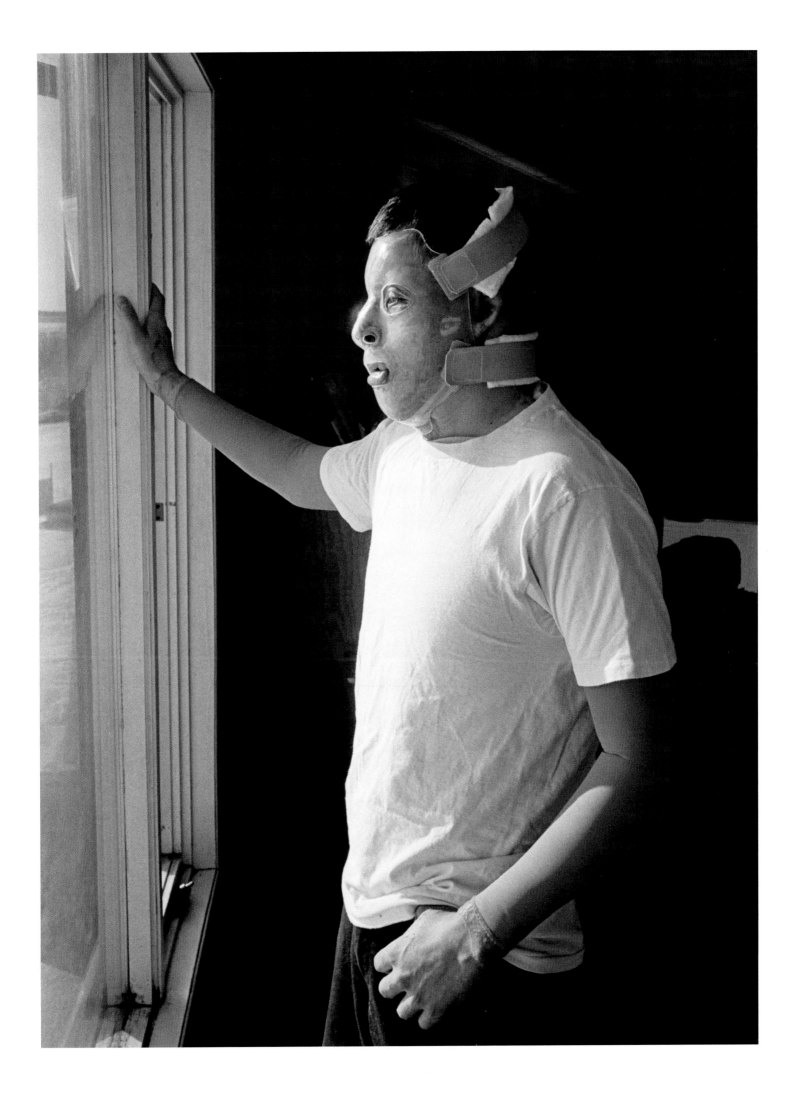

MOONRISE OVER RUBY

A full moon shone like daylight on the small Athapascan village of Ruby, Alaska. At the time, 200 people lived there but the fox prints in the snow show signs of the many other creatures who make their home on the Alaskan tundra where it can reach 35 degrees below zero Fahrenheit.

During the gold rush era at the turn of the last century, Ruby was home to 10,000 people, mostly white settlers coming to make their fortunes off the land.

VISION QUEST

NATIVE PEOPLES

IN 1990 AS I HELPED JUDGE 30,000 PICTURES for the National Press Photographers Association's Pictures of the Year contest at the University of Missouri, I realized how different my work was and maybe why NPPA had awarded my work. My inner voice began prompting me to return to the Sioux and tell the story of the revival of hope and pride in heritage that was developing on the reservations. The signs included the growth of traditional Native American religion.

How should I proceed to tell this important story? The late Brian Lanker's wonderful book, "I Dream a World," which contains the portraits and stories of 75 African American women who changed our country, became my model for translating the sweeping social change on the reservations into images and stories. But I had never interviewed my photography subjects as Lanker did. Nor would I be settling into a single village where my subjects first built trust with me as a priest.

I flew to Oregon in 1991, to seek advice from Lanker and he generously taught me what he had learned: never try to interview and photograph a subject on the same day and always do the interview first. A good interview would lay the groundwork for a successful portrait by allowing me to discover who this person was and what environmental elements would convey their message.

This project would require funding and at least a year off from teaching. By this time I had become involved in the "A Day in the Life Of ..." projects. On the way home from the "Day in the Life of Italy" shoot, a Kodak representative said he was sure the company would back the project. At Creighton, my dean suggested a two-year leave so he could hire a substitute for me. I spent 1991-93 interviewing and photographing members of the Sioux nation for the project that became the book, "Vision Quest: Men, Women & Sacred Sites of the Sioux Nation."

The success of the book depended on identifying subjects who conveyed their new pride in their Native American heritage and who would be credible to both their own people and outsiders. I needed to go beyond people who had made headlines such as Olympic Gold Medalist Billy Mills and Russell Means of the American Indian Movement although they were important. Tim Giago, a newspaper publisher and syndicated writer; Albert White Hat, a Lakota language teacher and spiritual leader; and Charlotte Black Elk, of the Pine Ridge Reservation suggested many of my subjects. They were all known for their deep understanding of Native American culture.

Giago suggested James Holy Eagle, 102, who told the story of the Wounded Knee massacre three times during our interview. As I made his picture, which appears on the cover of "Vision Quest," I knew my project was going to succeed. I began shooting in black-and-white but colleagues at the Missouri Photo Workshop advised switching to color because native peoples had always been photographed in black and white. The color portraits would symbolize the new spirit of contemporary Native Americans. I concurred, although it meant re-shooting some subjects in color.

As I visited Sioux reservations in five states and Canada, it occurred to me that I was revisiting the areas I had tried to cover for the Geographic article that was killed. Perhaps it was fortunate the article wasn't published. It was to have featured the return to native spirituality, but it also emphasized the tough realities the people still faced. Now with "Vision Quest" the people themselves could tell their own stories. I found that the rapport I formed during the interviews built trust and helped participants relax during the portraits. Shooting Polaroids first to show my subjects what I had in mind allowed me at times to get their feedback.

> Shooting Polaroids first to show my subjects what I had in mind allowed me at times to get their feedback.

When I was nearly finished with the project, I attended a Stanford Unversity workshop on book publishing where I learned that it's helpful to design a "dummy" or mock-up of a picture book to send to publishers. A National Geographic designer created my book dummy. I sent this mock-up to 18 publishers and received beautiful letters of rejection. However, the Stanford workshop director introduced me to the new head of Random House, an Italian who was interested in Native Americans. He sent my dummy to Crown Books, Random's photography book division.

When I didn't hear back, I tried again. I flew to New York City with what I felt was an impressive portfolio of 24 color 20" x 20" prints and a book dummy with live text. I met with Crown editors who contacted their marketing director in San Francisco, and she guaranteed that she could sell the book. The final product was almost identical to the mock-up I had given Crown. Major bookstores nationwide featured it during the 1994 holiday season. The Mid-America Arts Alliance sponsored traveling exhibits of the "Vision Quest" in 20 cities. Often long-term friends Albert White Hat or Duane Hollow Horn Bear accompanied me to exhibit sites. As I talked about photographing in another culture, they gave the Native American perspective on reviving their cultural identity.

I have declined suggestions for a follow-up book because it is time for Native American photographers to interpret their own culture to a broader audience. Income from books and prints created the Vision Quest Endowment Fund at Creighton University that provides scholarships for Native American students to attend Creighton and assists in other educational ventures.

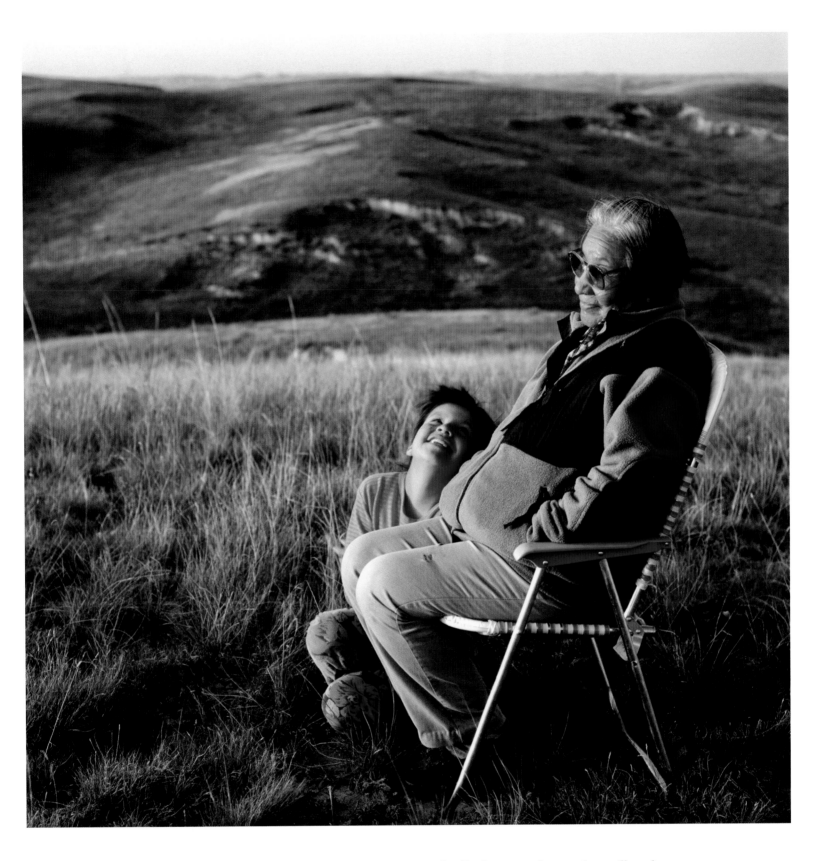

ALICE NEW HOLY · *Ever since she was a young girl, Alice has created porcupine quill work, a traditional Lakota art form. To complete the intricate works porcupine quills must be dyed and made into medicine wheels, breast plates, Pipes and other items used in Lakota ceremonies. In 1985 she was selected for a National Heritage fellowship Award by the National Endowment for the Arts. "I learned quilling from my Dad. He never did quill work but I guess he learned from my grandmother just by watching... They say if you're a true Indian the design of the pattern comes to you automatically. And you can never repeat your work. I have tried but I cannot repeat it."*

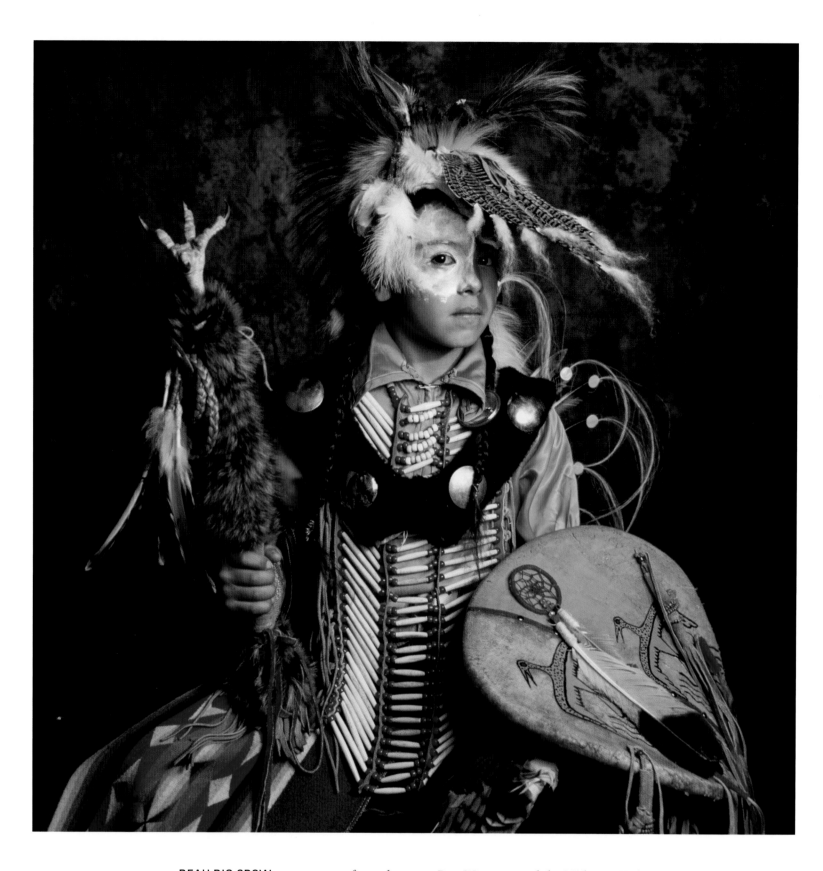

BEAU BIG CROW *competes as a fancy dancer at Pow Wows around the Midwest. He is originally from Oglala, South Dakota. The word for Pow Wow came from an Algonquin word for a gathering of medicine men and spiritual leaders in a curing ceremony (pauau). Pow Wows have expanded from district celebrations on individual reservations to huge intertribal gatherings that move on a nationwide Pow Wow circuit. New ideas of art and design as well as song and dance appear every season.*

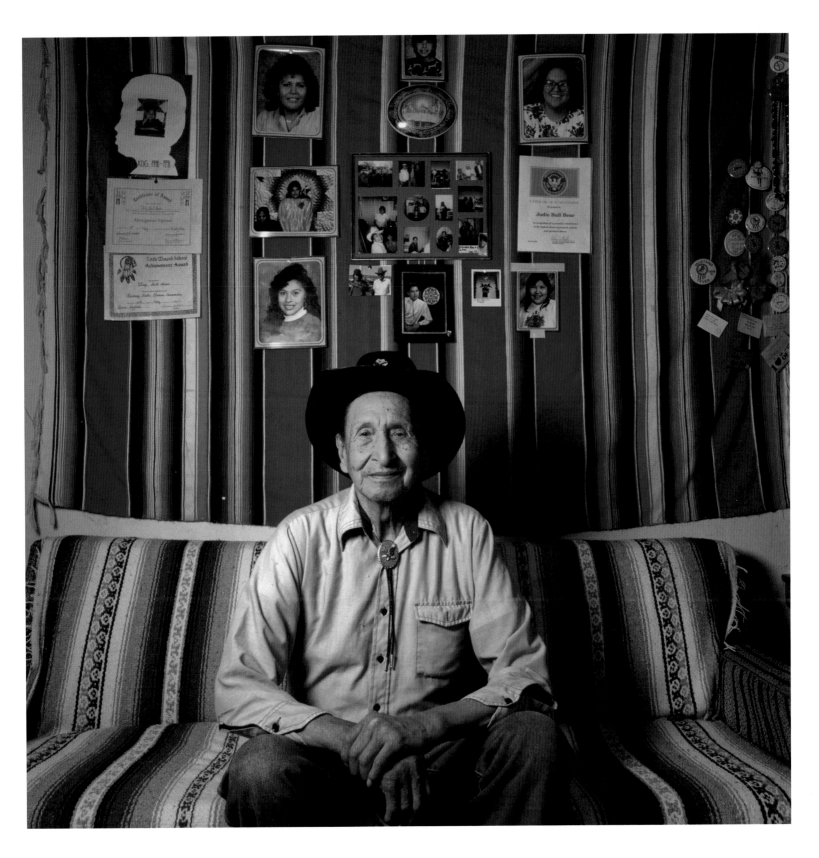

ROYAL BULL BEAR · *Descended from six generations of the Bull Bear family, Royal is chairman for life of the Grey Eagle Society, a group of elders who encourage the traditional way of life. Active in the foster grandparent program, he fights for treaty rights for his people. He is an unselfish worker for youth in schools and summer camps. "I believe the government will return the Black Hills. For over a hundred years we've fought for our treaty rights. The US government violated our treaty and took all our land, over 25 million acres. All we want is 1.2 million acres returned."*

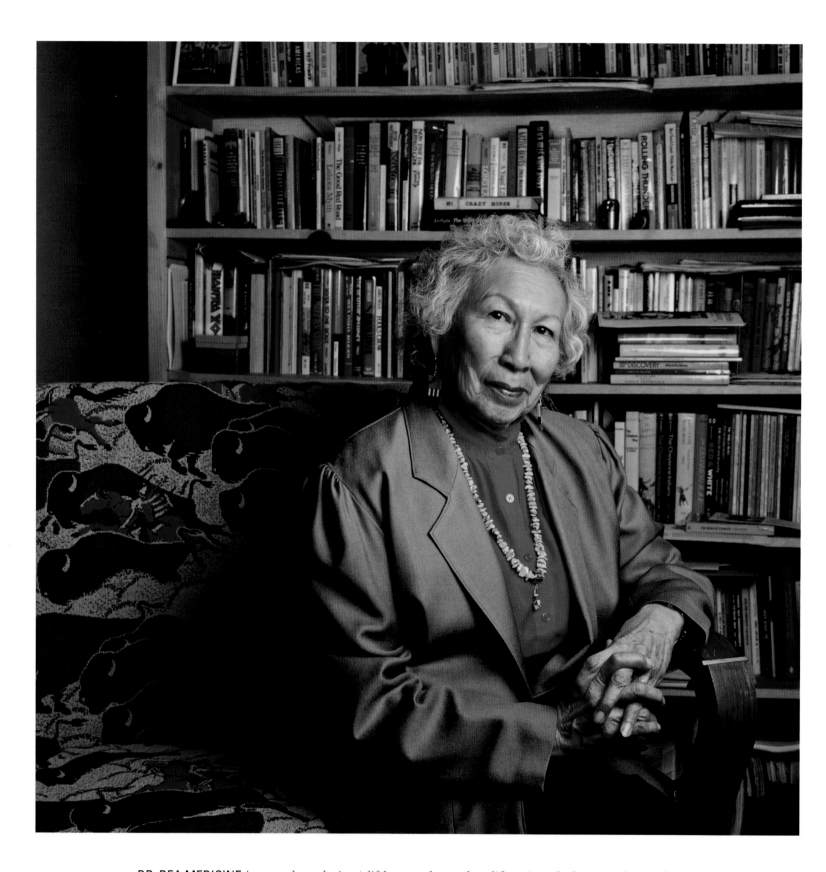

DR. BEA MEDICINE *is an anthropologist. A lifelong teacher and prolific writer, she has spent her professional life teaching at colleges and universities around the United States and Canada. She retired in 1988 but continued her research and writing on the Standing Rock Reservation where she was born. "When I was growing up and learning to read, there were signs on the stores: no Indians or dogs allowed. I got interested in anthropology because of the whole notion that we were different. We had a different language, and we had to learn to live in the white world... Yes, I have achieved a lot. I have a doctor of humane letters and a PhD, but these are things of my profession. My main interest though is living as a Lakota. I feel much more a part of the Lakota than the white man's world."*

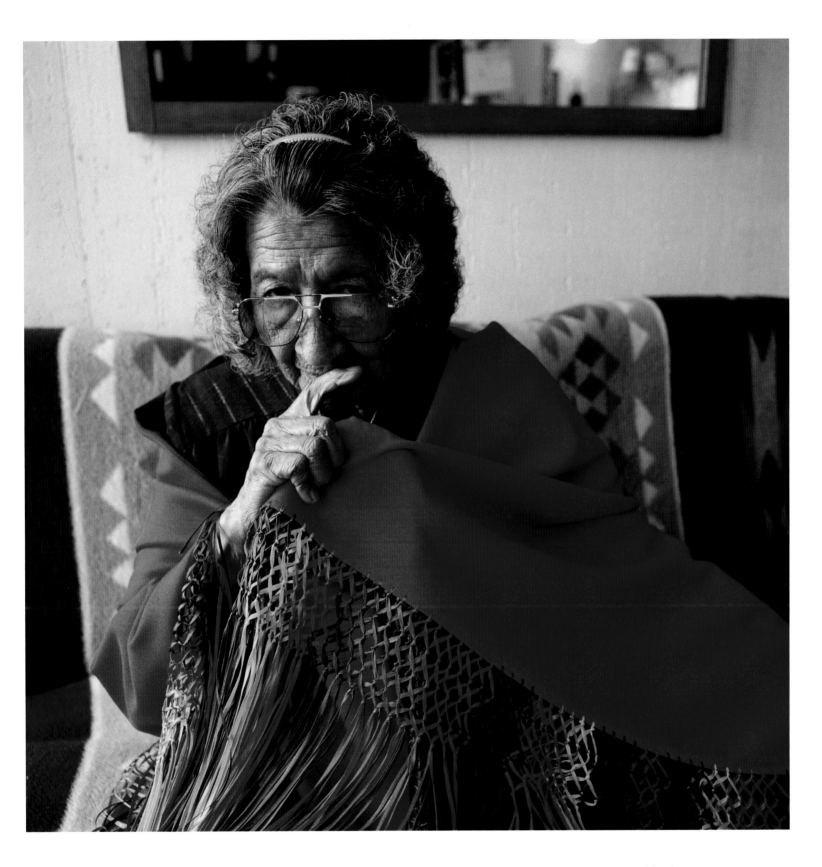

NELLIE MENARD · *Nellie Star Boy Menard is a Lakota. Her star quilts and shawls are known worldwide. Her first art award came at 16 from the Pendleton Company for designs in the Chief Joseph Blanket. Nellie began teaching arts and crafts in 1935. Her talents have touched generations of Native American children and teachers." I was never taught how to do Indian art. My grandmother was a rawhide painter and my mother did bead work and made star quilts... When I was a child I was very sick. I was bitten by a rattlesnake and couldn't walk for a long while... At 12 I was severely burned on the arm and contracted tuberculosis and spent a year in the hospital. I prayed that my arm would be saved and made promises to do my handiwork if I got well."*

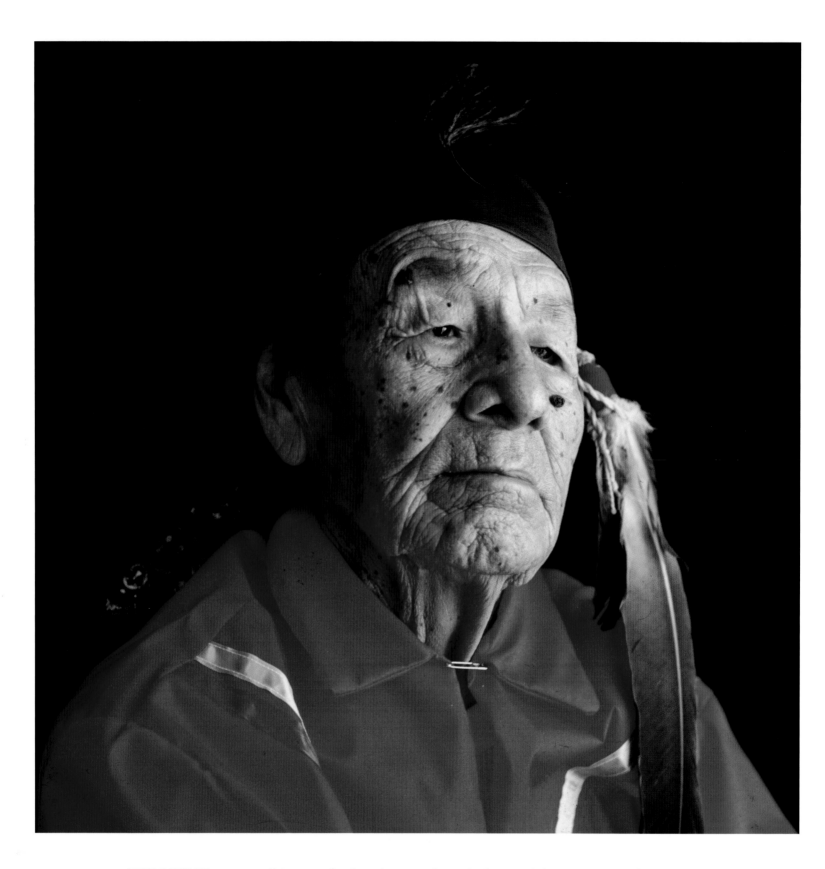

PETE CATCHES *was a medicine man for the Lakota people. He had a sacred dream in 1948. After years of avoiding the dream's message, he finally carried out the dream in a Sun Dance in 1964 which gave him many powers. In the intervening years, he served on the tribal council, was a member of the tribal police force and worked as a ranch hand. "My Indian name is Man That Carries Hot Coals In His Hands. I had a vision up on the hill and that vision became my name. It was on the third day of a fast in the summertime. I was weary, tired, hungry, thirsty... I see suddenly a man walking towards a huge blazing fire. He walked to the fire, knelt down. He raked some hot coals, picked it up in both hands and walked very slowly around the fire and everything dissolved. When he turned and walked slowly, I noticed I was looking at myself."*

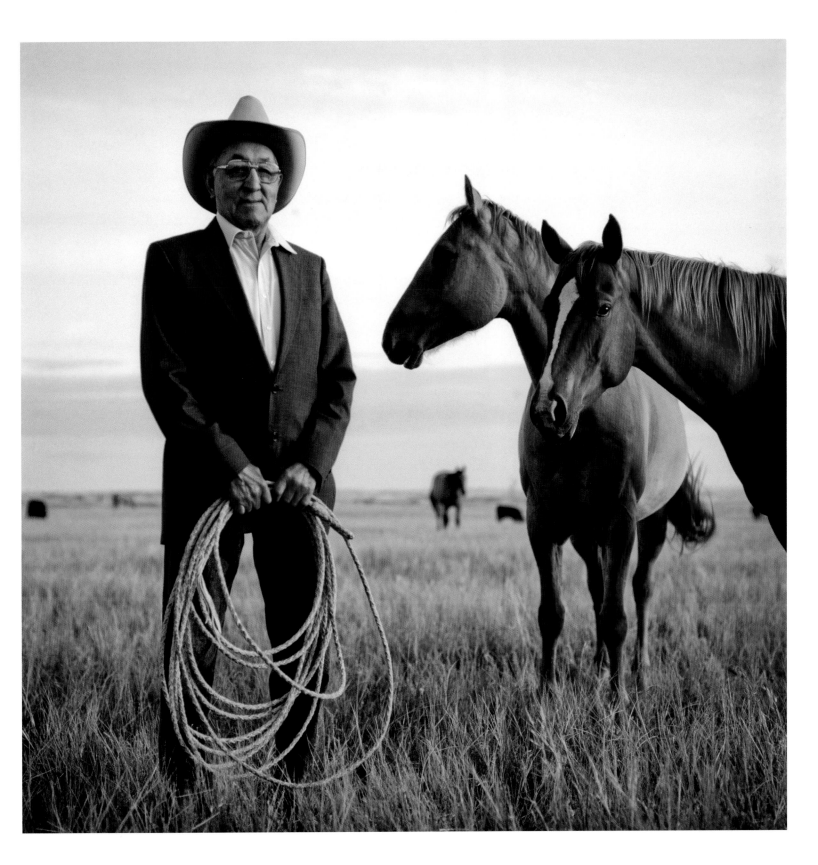

NORMAN HOLLOW *has been on the Ft. Peck Assiniboine Sioux tribal council for 47 years and tribal chairman for 12. One of his major accomplishments as tribal chairman was the 1973 establishment of the Assiniboine and Sioux (A&S) Manufacturing Company, a successful effort to bring industry and jobs to the reservation. He negotiated oil and gas rights on tribal lands and taxed the railroads that cross the reservation. In 1986 he was recognized as "Small Businessman of the Year" by the regional Small Business Administration. His avocation is raising quarter horses on his ranch near Ft. Kipp, Montana. "I lived a good, happy life and I've accomplished some of the goals I set out for myself. It's been a great challenge and there's been disappointments along the way, but the success ratio overrides the failures."*

JOE FLYING BYE *is a Dakota medicine man living in Little Eagle, South Dakota, on the Standing Rock Reservation. He learned his craft as a boy when he served as a guide for his blind grandfather, the holy man, Sun Dreamer. "I was born and raised among medicine men. I've seen what they do. I've seen my grandfather. He asked me to help him do things. He said, "Grandson, you're going to wear my white bonnet," meaning the white hair at old age. I walk in my grandfather's ways. Today I stand as a medicine man."*

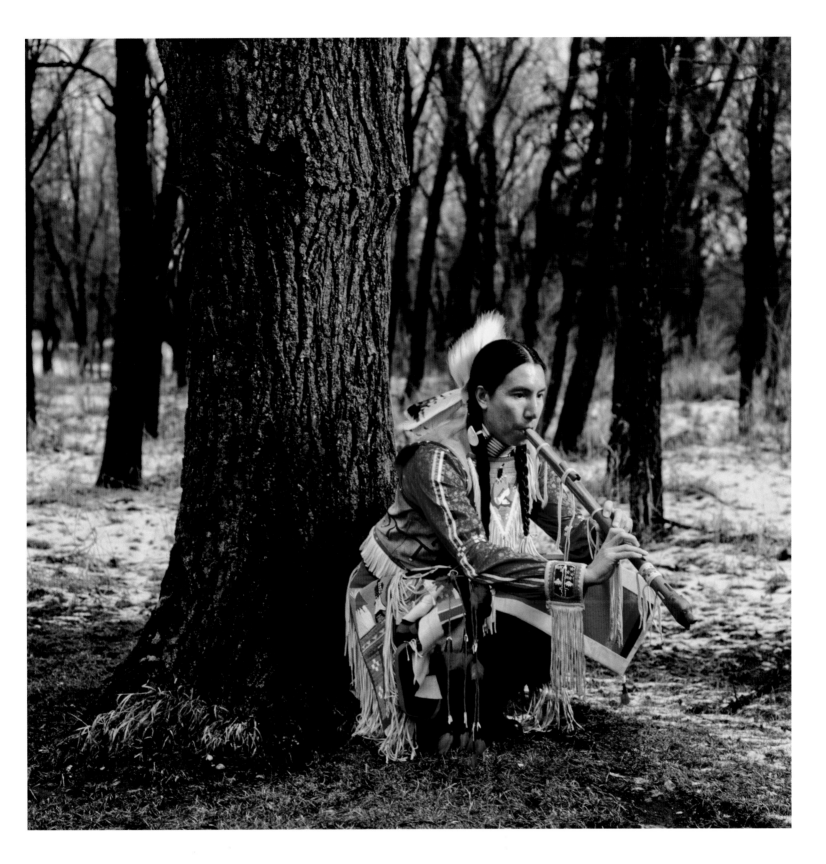

BRYAN CRAWFORD *is an Indian folk artist. He carves flutes and other wood work in the traditional way, plays flutes and eagle bone whistles, is a traditional dancer and paints both oils and watercolors. His diverse talents include making costumes and teaching nearly forgotten Indian children's games. He learned his many skills by talking to elders and studying traditional Indian ways. He performs and exhibits his works around the country. "When do I feel best about myself? When I'm with a bunch of other people and we're all doing something, whether it is a funeral service with my relatives or a Pow Wow with several hundred other dancers. When I perform on my own I feel so out of place. So when I feel more at home is with a lot of other Indian people."*

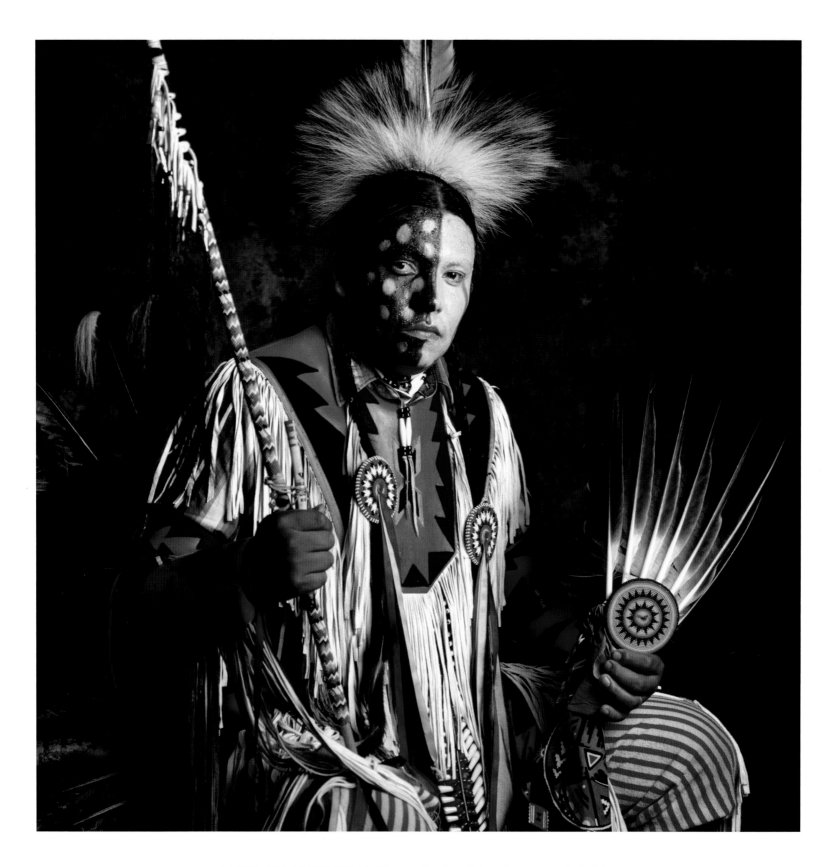

DANIEL STACEY MAKES GOOD · *Much of traditional ceremonial clothing came from the honors of the warriors. There were different ranks of honor based on what you had accomplished in battle. For instance, the highest honor went to a warrior who could strike an unwounded enemy with a hand or bow. This required bravery and skill to escape unharmed. The symbol for this honor would be a white-tipped feather from the tail of a golden eagle, erect in his hair.*

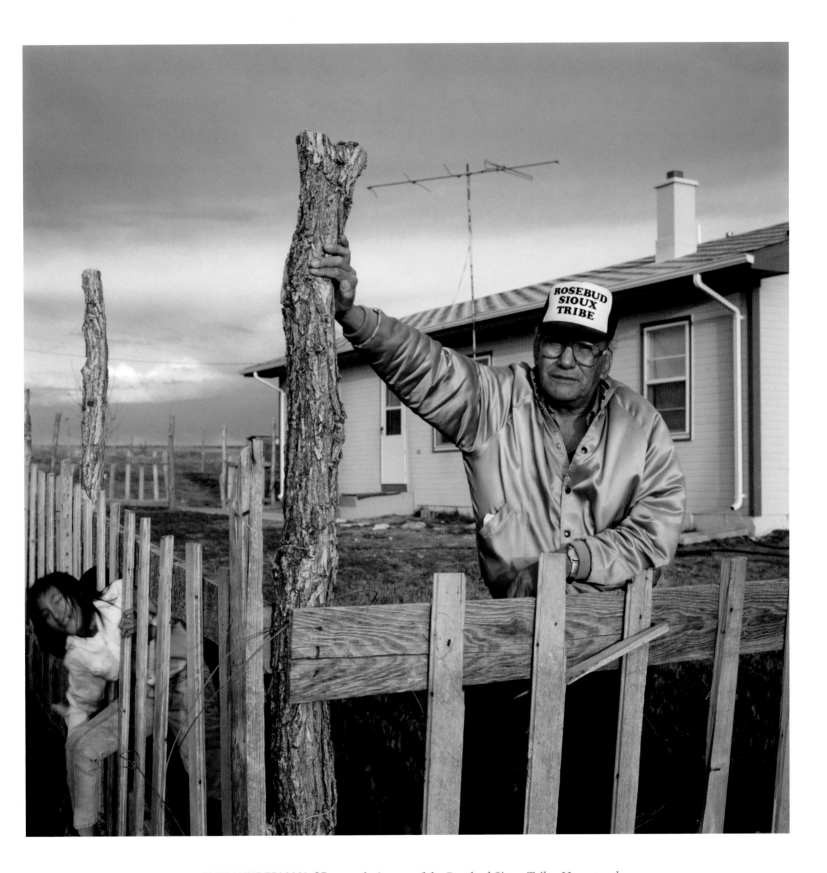

ALEX LUNDERMAN, SR. *was chairman of the Rosebud Sioux Tribe. He entered tribal politics only after he had a vision in 1979 calling him to leadership for his people. His dream is that the tribe will someday be a sovereign nation. "South Dakota is the only state in the union that fights Indians. It's because there are nine reservations here. We're getting bigger. We're going to control the vote and put a governor in there of our own. But when that happens, we won't treat them like they've treated us."*

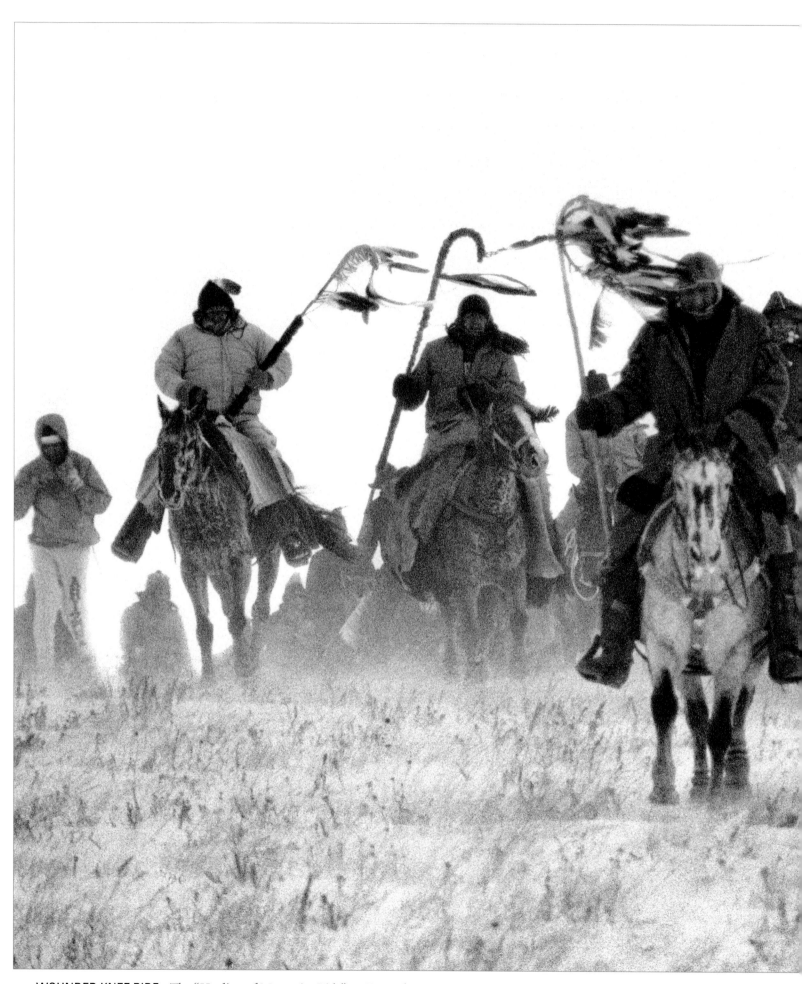

WOUNDED KNEE RIDE · *The "Healing of Memories Ride" on December 29, 1990 commemorated the 1890 ride of Chief Big Foot's band when they left Bismarck, North Dakota the night Sitting Bull was killed. Searching for Red Cloud who was leading his people in the*

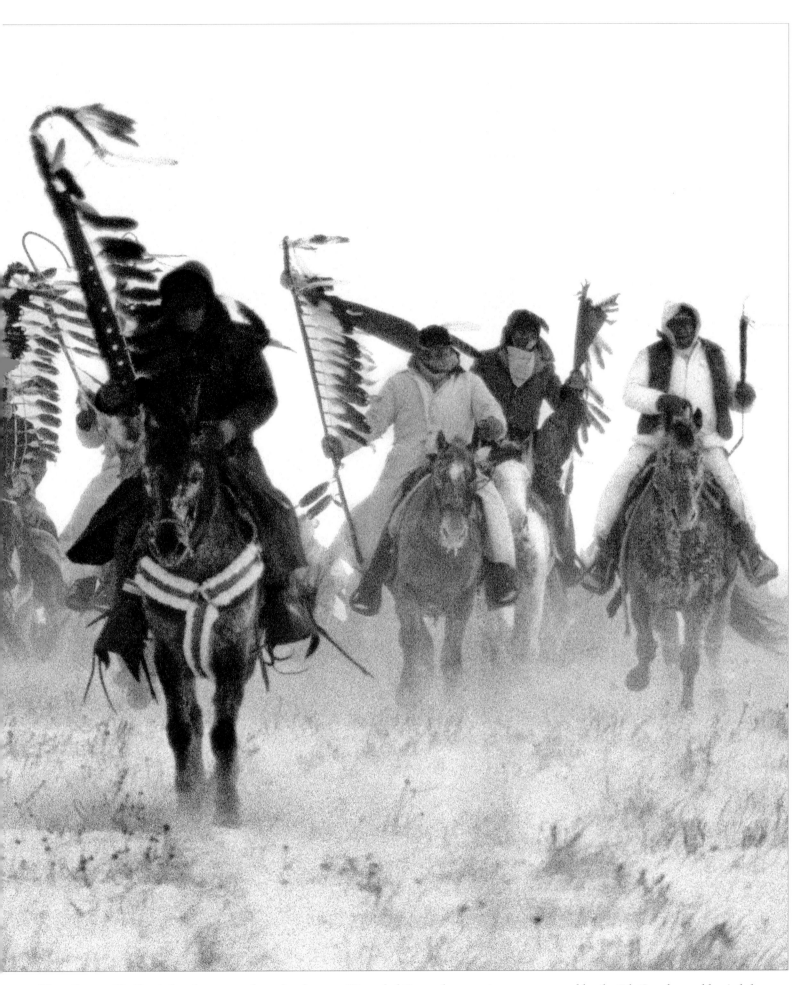

Ghost Dance, Big Foot's band encamped at what became Wounded Knee where most were massacred by the 7th Cavalry and buried there. After a four-day, sub-zero ride, Arval Looking Horse and Birgil Kills Straight lead the riders into Wounded Knee, South Dakota.

BLACK AND WHITE VERSUS COLOR

I began shooting in black and white for the Vision Quest project; however, fellow faculty at the Missouri Photo Workshop advised switching to color because native peoples had been photographed in black and white since photographers began heading West. With an archetypical native face, one couldn't tell what decade the image was made. Color meant these men and women were contemporary Native Americans.

Often I began by testing my lighting by placing a Polaroid back on my camera. The best frame of Sophia, great-granddaughter of James Holy Eagle was on the Polaroid. To my dismay, I couldn't repeat it on film.

The image highlighted on the right was in a national book on American Indians. An international advertising agency wanted to use it on a billboard for a famous beer suggesting that even Native Americans couldn't stomach American beers. Of course, I responded: "Absolutely not." The advertising agent replied that I lacked a sense of humor!

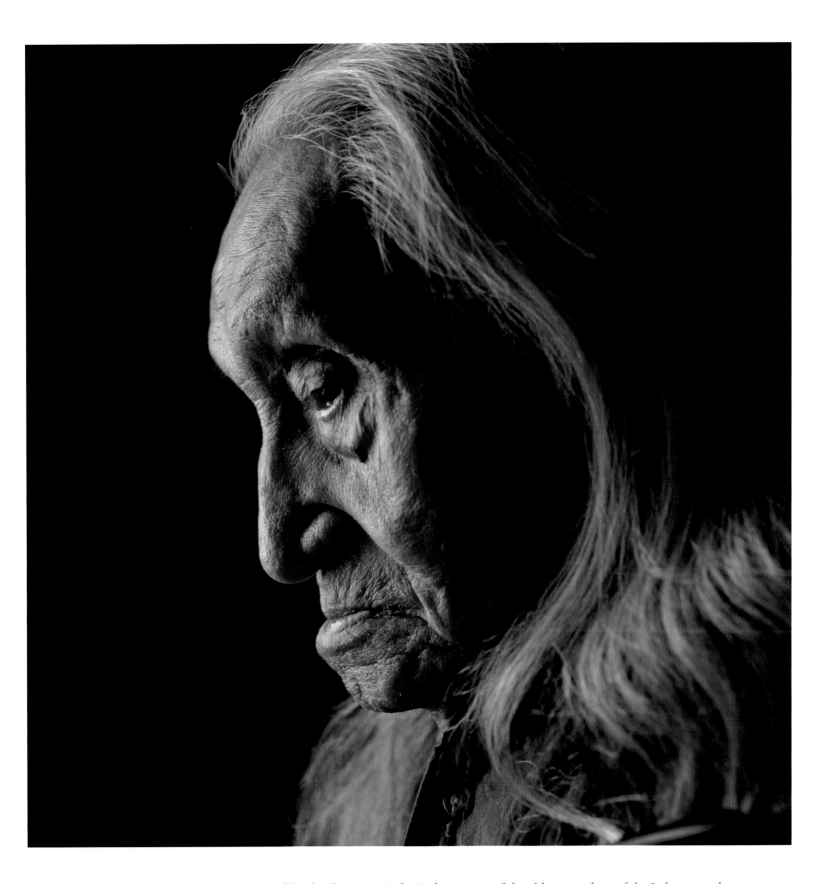

JAMES HOLY EAGLE · *At the time of his death, James Holy Eagle was one of the oldest members of the Lakota people. The revered tribal elder was born on the Pine Ridge Reservation the same year South Dakota became a state in 1889. He studied at Carlisle Indian College in Pennsylvania where he excelled in sports. He learned the coronet and played for Woodrow Wilson's inauguration. In the last 20 years of his life, Holy Eagle was outspoken in support of Lakota issues. His great-granddaughter, Sonja Holy Eagle, recorded many of his stories. He spoke of the Massacre at Wounded Knee, which occurred the winter after he was born. "I don't know how many Indians got killed there. Women, babies. My uncle. My cousin. I wish you could see the grave. … Go there someday and sit alone and read the stone monument that's on that hill. It is high and wide. It names all the names that got killed there."*

CALENDARS

NATIVE PEOPLES

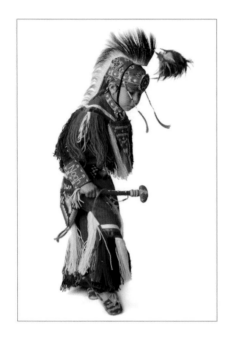 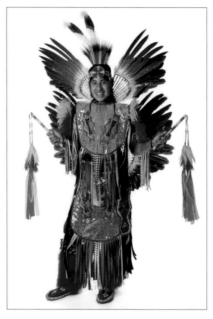 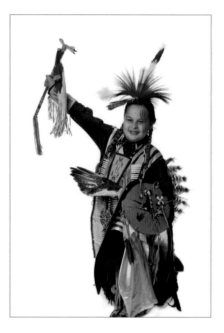

2012 RED CLOUD INDIAN SCHOOL CALENDAR

WHILE I HAD REALIZED THAT THE TIME HAD COME for me to move on to non-native subjects, I have continued to photograph Native American children for two annual fund-raising calendars. One is for the Red Cloud Indian School on the Pine Ridge Reservation, in South Dakota, and the other is for the St. Augustine School on the Winnebago Reservation in Nebraska. Both feature children in their Native American regalia, and both continue to be very popular. Since 1997, Red Cloud has mailed the calendars nationwide as a fund-raising appeal to thousands of potential donors.

For each calendar I make photographs of more than 40 children and then select the final images based on their colorful outfits, gestures, and general appeal. Before each photographic session, I pray that I will succeed in showing how precious the children are in God's eyes, and to help them to be proud of their Native American identity. It also pleases me that the parents and grandparents are thrilled with the results.

The St. Augustine calendar, which I began photographing in 2002, is an art calendar featuring full-length pictures of the children. It is designed by Pat Osborne of Mutual of Omaha. For three years it has won the National Calendar Award as the nation's best non-profit calendar.

These two schools are important to Native American children not only for the education they provide, but also because they respect the students within their culture. They instill a sense of Native American pride, and offer the children a future that might not otherwise be available to them.

It's gratifying to see how proud the parents, grandparents and children are of the calendars that represent their pride in their traditions. I am once again reminded of how grateful I am that I was able to respond to God's call and to integrate my dual vocations, a call that came long ago on that fall evening prayer walk.

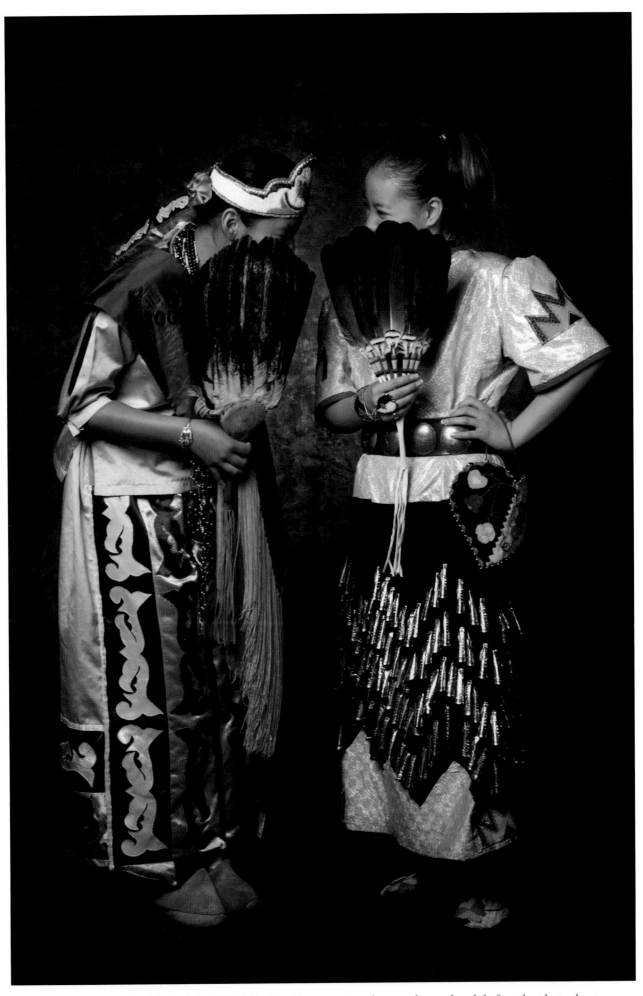

ST. AUGUSTINE INDIAN SCHOOL CALENDAR · *Two St. Augustine dancers share a laugh before the photo shoot.*

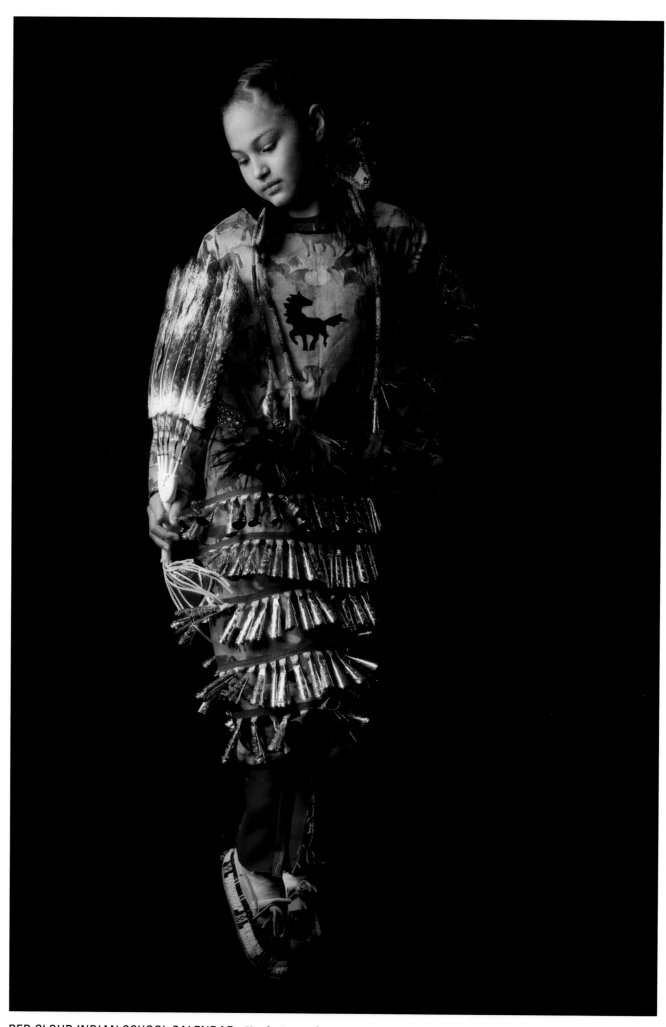

RED CLOUD INDIAN SCHOOL CALENDAR · *Jingle Dress dancing is popular with the girls.*

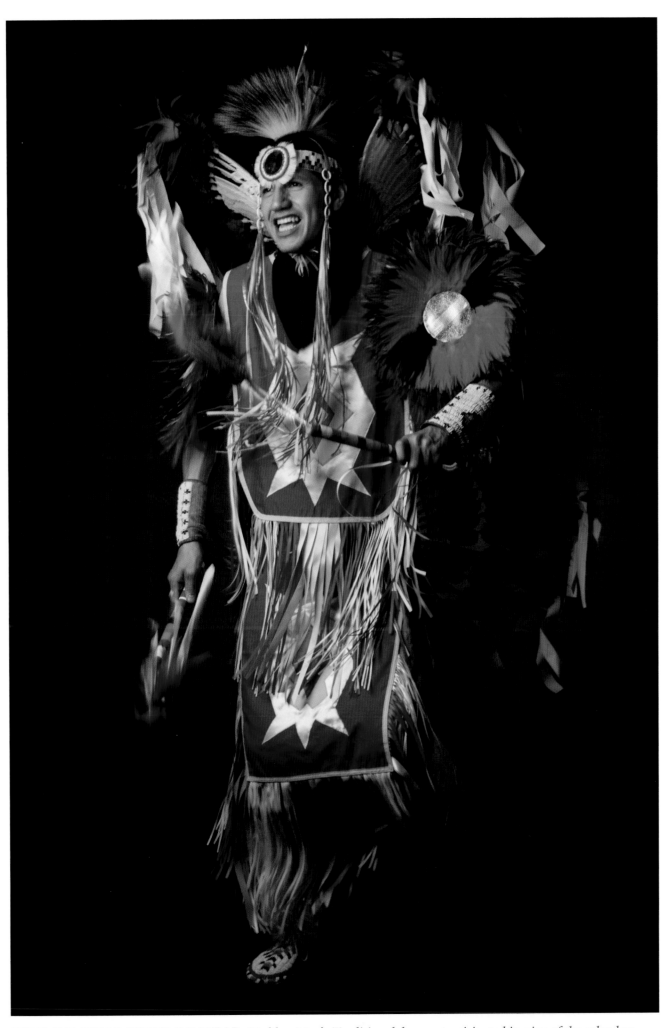

RED CLOUD INDIAN SCHOOL CALENDAR · *Todd, a Men's Traditional dancer, participated in nine of the calendars.*

ST. AUGUSTINE INDIAN SCHOOL CALENDAR · *Austin in his "Boy's Traditional" outfit.*

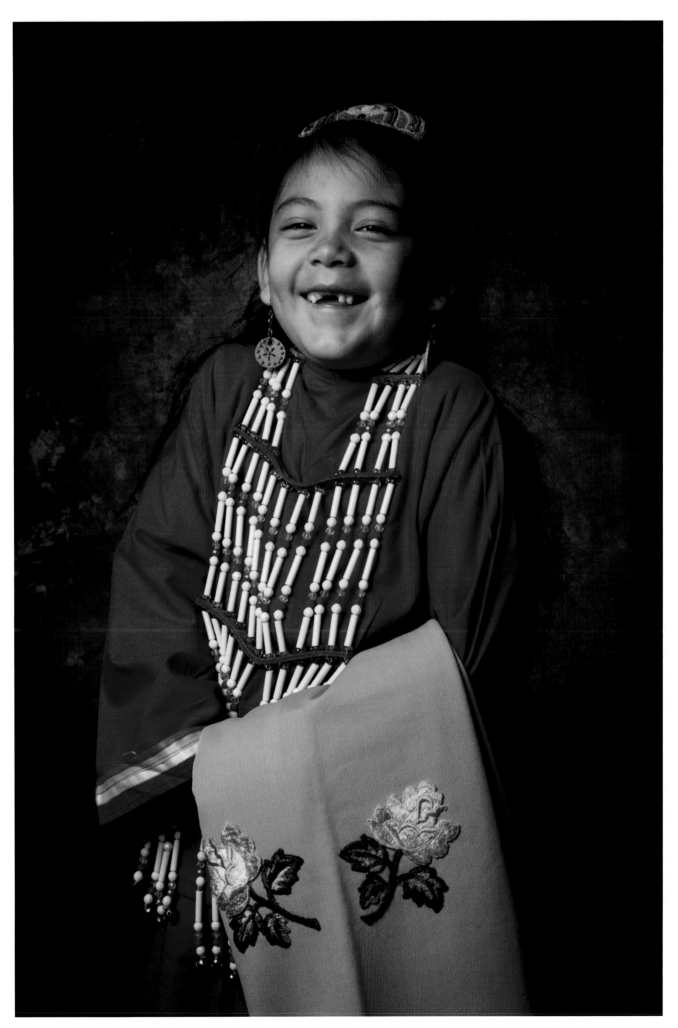

ST. AUGUSTINE INDIAN SCHOOL CALENDAR · *Isis holds a shawl in her "Traditional Girl's" outfit.*

THE CIRCLE
OF LIFE

No photo project has touched me as deeply as documenting my mother's death from cancer and the care my father and sisters provided for her. Ironically as she was dying, close friends asked me to photograph the birth of a child. The two events became inexorably linked in my mind as i went from life beginning to life ending. As Ecclesiastes says, there is a time to be born and a time to die. Amen.

GO IN PEACE

LIFE & DEATH

OF ALL MY PHOTOGRAPHS OVER THE YEARS, some of the images that have been the most important to me are those that depict the joys, sorrows, humor, fun, and work of daily life – including the photographs that chronicled the death of my mother. Think of the beautiful words from Ecclesiastes, that there is "a time for every purpose under heaven," including "a time to be born, and a time to die ...". These words capture the spirit of some of my most memorable images.

My camera was always with me. I shot candid photographs so frequently of my family and other people who were close to me, that they more or less ignored it ... with one notable exception: my mother. Marie disliked having her picture taken, so I shot very few of her. But at her 70th birthday party in September 1979, she relented and I made a picture of her that captured her spirit and strength.

This joyful occasion should have overjoyed me, but flying home to Creighton from Wisconsin I had an odd premonition of it being a lull before the storm. Little did I realize that my propensity for recording my family's lives would soon produce some of the most poignant and personally powerful photographs of my career.

After Thanksgiving my sister Judy called with chilling news. "Mom's in the hospital." She had astonished my dad and two sisters when she asked to see a doctor for the first time in more than 30 years, frightened because she had been getting lost, sometimes finding herself in a store without knowing how she got there, or why. A scan showed two walnut-sized tumors at the back of her brain. When I came to see her in the hospital at Christmas she sat on the edge of her bed, looked me in the eye, and asked: "Am I going to die?" I could not soften the news. "Yes, Mother, you will die in three months if there is no operation." We had a good cry and talked about good times and bad. She was at peace, but she wanted to spend her last days at home with my dad. He became her primary caretaker, keeping the house and doing the shopping. They did home hospice care with the assistance of St. Joseph's Church, their wonderful local parish.

After a family discussion with my mother on Christmas day, we called and cancelled her surgery. This was an emotional time for us all. After marrying our dad, Joseph, a salesman, in 1937, she devoted her life to taking care of the family. I was her only son and we had always been close. After I joined the Jesuits she became part of an extended Jesuit family network. She loved socializing with other mothers of Jesuits and volunteering for the Jesuit seminary guild. She wasn't formally educated, but she was blessed with wisdom and common sense.

I kept in close touch with my family by phone, returning to Milwaukee for Palm Sunday. My good friend Ernesto Travieso S.J. accompanied me and he insisted that we buy my mother her favorite flowers, yellow tea roses. When I walked into the apartment carrying the roses, she got out of her chair to hug me to prove that she was doing okay – but I suspected otherwise. Later, my sisters and I agreed that Mother could put on a pretty good act. But she was sicker than she wanted us to know.

Throughout that visit I photographed my dad and my sisters as they cared for her, capturing the simple but moving chronology of a family accompanying and caring for a loved one as she approached death. Because the camera had become all but invisible to my family, there's little self-consciousness in these photographs of them with my mother ... no false moves or gestures, nothing posed. It was as if the years of practicing photography with them had inadvertently prepared me to record the quiet drama unfolding in my parents' home.

I had to return to Creighton to teach, but I started to carry a pager so they could reach me instantly during those years before cell phones. Ironically the pager served a dual purpose, because my good friends Tim and Gail Dickel were expecting their second child, and they had asked me to photograph the birth.

As my mother lay dying in Milwaukee, they were anticipating this joyful event in Omaha. Tensely I awaited both calls. Finally one night, I went out for a couple of beers to relax. Naturally this was the night that the pager awakened me at 2 a.m. when Gail went to the hospital. She delivered Tad at 6:30 a.m. What a wondrous moment to see a child arrive in this world. I told a nurse that I wanted to see what the mother saw at the moment of birth. The nurse positioned me and allowed me to capture not only the miracle of birth, but the joy of the parents as they greeted their son.

Later that day my family called. It was time for me to return to Milwaukee to say goodbye to my mother, who by now was in a hospice established by a Jesuit friend. She was receiving drugs for her pain but no futile and expensive artificial medical care that interfered with her ability to say farewell.

Whenever we gathered at her bedside, I would ask her if she wanted to pray. She always responded with a hoarse "yes." One time when we said the Our Father and the 23rd Psalm, my sister Susie leaned over and said to her, "Mother go in peace." We all followed her example. We were so relieved to have given her our blessing to leave us that we relaxed over pastrami sandwiches and a six-pack. My sisters needed to return to their families, but I remained sitting with her until she died peacefully the next morning. It was as if the Holy Spirit had written a script to guide us. Sue said that she had always been afraid to die, but no more after Mother's example. I said mom's funeral Mass and delivered the homily.

> Mother could put on a pretty good act. But she was sicker than she wanted us to know.

70TH BIRTHDAY · *I surprised dad with a home visit on his 70th birthday. It was only appropriate that I do the same for mother on her 70th birthday. To my delight, she didn't object when I raised my camera to make her photograph. As I flew from Green Bay to Omaha, I felt an ominous sense of foreboding that the weekend was the calm before the storm.*

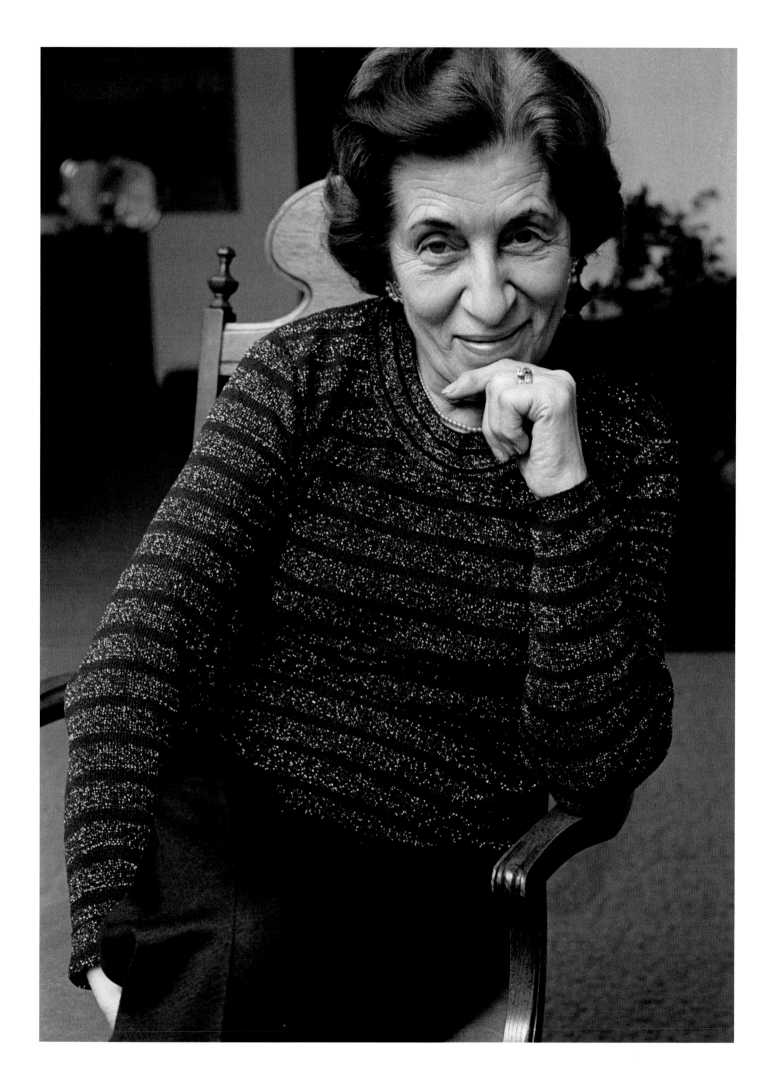

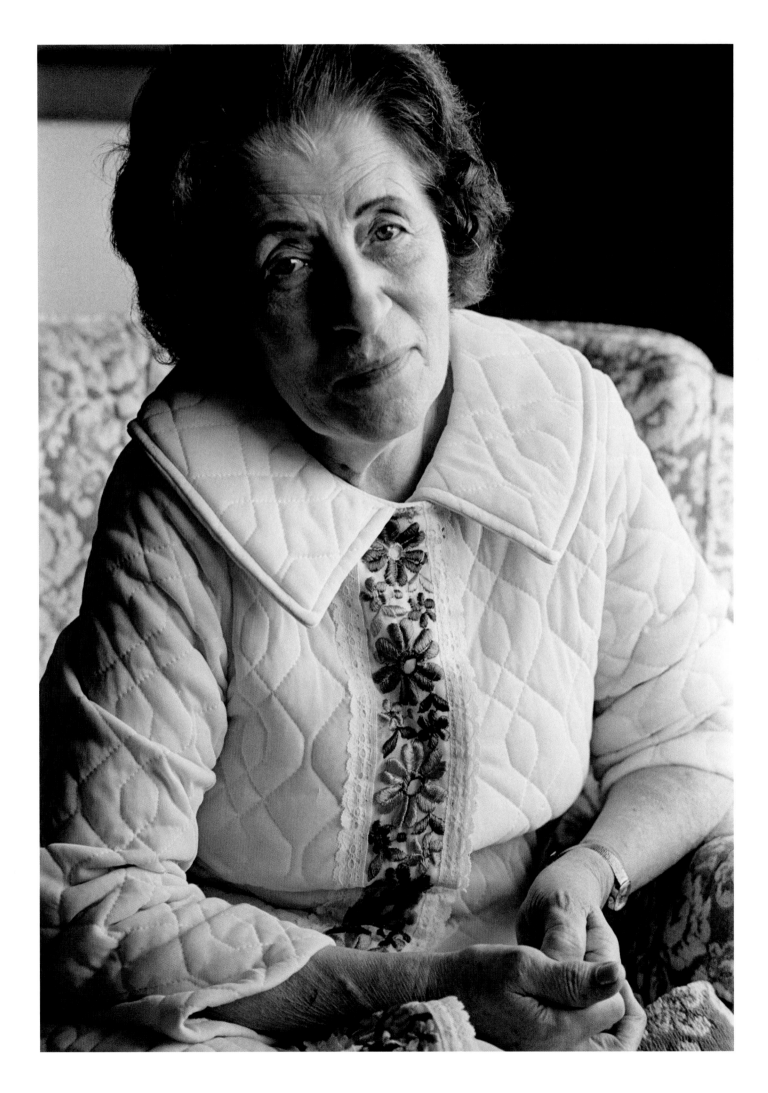

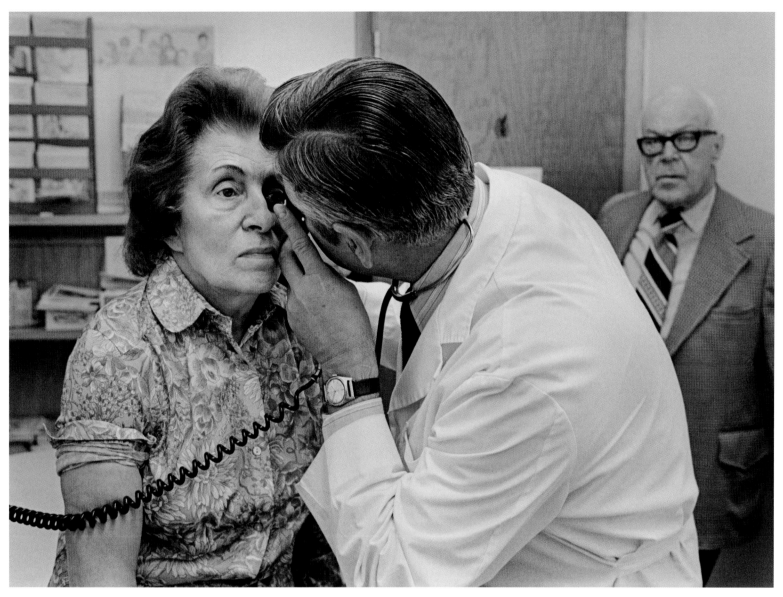

DOCTOR'S OFFICE · *Mother was gradually losing her eyesight due to the brain cancer.*

Throughout my mother's last days I had continued making photographs, although at one point a family member ordered me to "put that damn camera away." It was summer, when I returned to Alaska to work on the Geographic assignment with the Yupik Eskimos, when I finally processed the film. I wept when I saw the photographs emerging in the development tray – processing the images and my grief at the same time. As the eldest son, for some reason I felt responsible for handling our family's issues dealing with mother's sickness, death, and its aftermath. Now months later, alone and thousands of miles away from my family, I finally began to deal with my great loss. We had always been close. Like many mothers of priests, she had helped foster my faith and my vocation.

> I wept when I saw the photographs emerging in the development tray – processing the images and my grief at the same time.

As painful as it was to look at these photographs, I believed the story they told about our family's experience was universal and it might help others, something my mom would have wanted. Because displaying the pictures might be painful for my father and sisters, I asked their permission. My dad at first didn't care for the idea but eventually consented. When they were on exhibit at Creighton, one family member could not look at them.

Some people outside my family shared this reaction. Several people walked out when I showed them during a talk for the National Press Photographers Association's Flying Short Course. But far more people told me they were deeply moved, including many visitors to a 2008 Marquette exhibit of the work. The hospice where my mother died used them as a photographic essay to promote a greater understanding of hospice care.

I still marvel at the juxtaposition of the birth of Tad Dickel and the death of my mother. The two events remain forever linked in my mind because together they taught me so much about the meaning of life, birth, and death. I can only return to Ecclesiastes, there is "a time for every purpose under heaven." *Amen. Alleluia!*

CHRISTMAS · *A few weeks before Christmas, we learned that our mother had brain cancer. After some difficult decision making, she declined brain surgery. During a lull in our conversation, I made this portrait.*

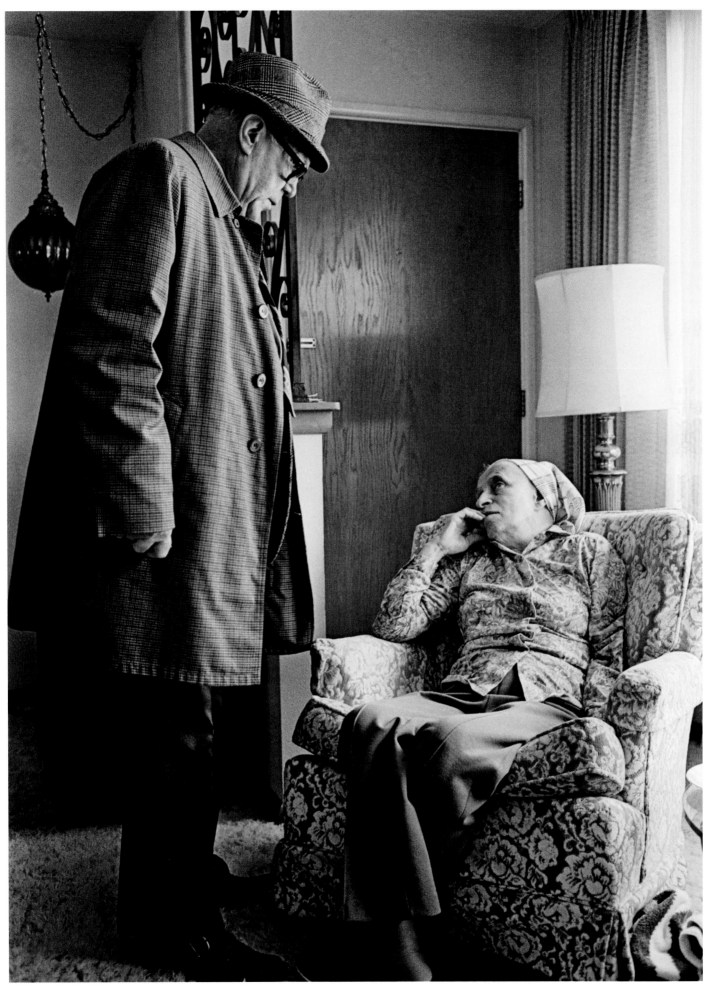

CHECKING IN · *When I came home to visit, dad could go to the office. His "checking in" with her before he left was a familiar scene. I like the way she is looking at him — with a look and knowledge that perhaps transcends the issue at hand.*

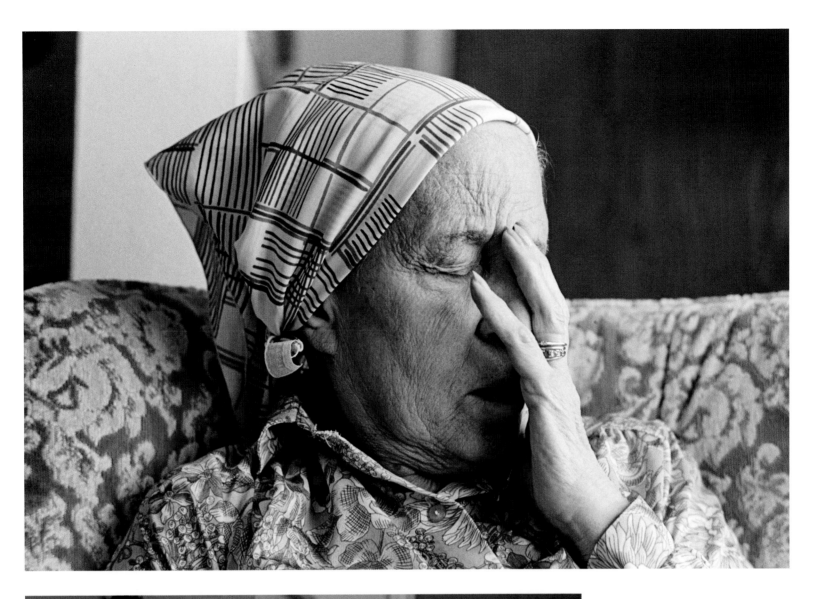

LIVING WITH PAIN
Mother experienced moments of intense pain as the two walnut-sized growths in her brain had no room to expand. She didn't like to take her pain medications.

HEAD SCARF
After the radiation therapy, mother lost all of her hair. She knew I wanted to make a photograph of her without the kerchief to show the effects of radiation. However, that photograph was not to happen.

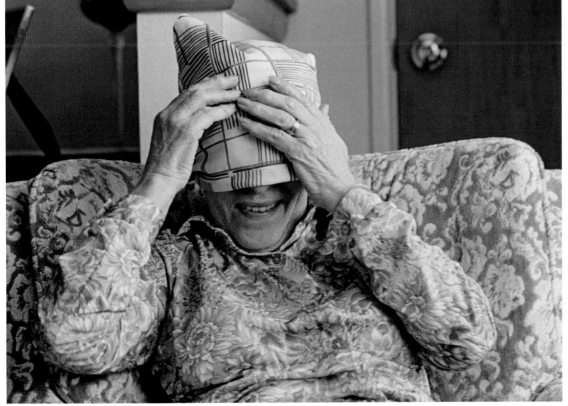

BECOMING A HOMEMAKER

At the age of 73, dad became the homemaker, cooking, cleaning, paying the bills and shopping. He was amazed at how much food cost.

Mother had difficulty with simple tasks. She became disoriented, and gradually lost her eyesight.

Her illness was a rude shock to him, as he was convinced that he would die first — at the age of 63 like his father.

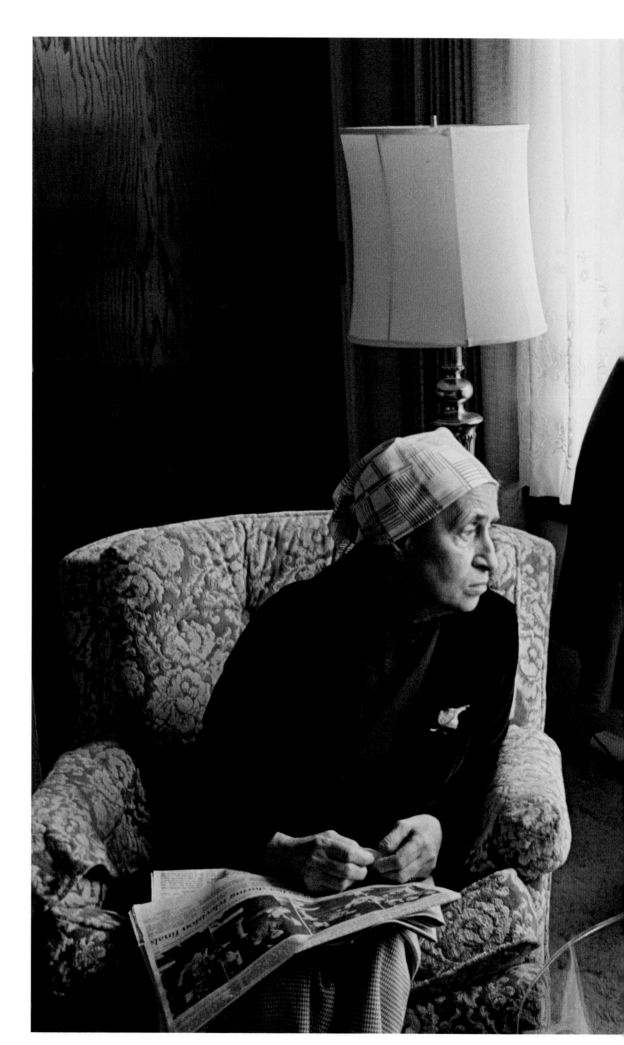

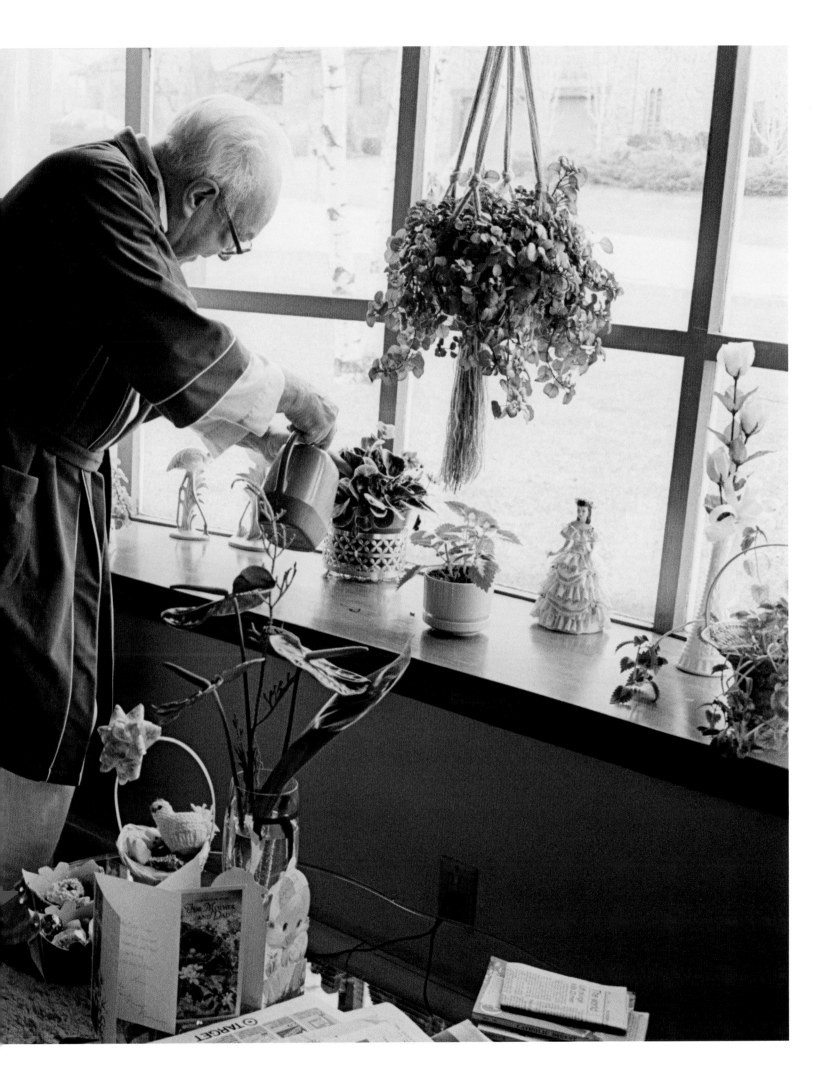

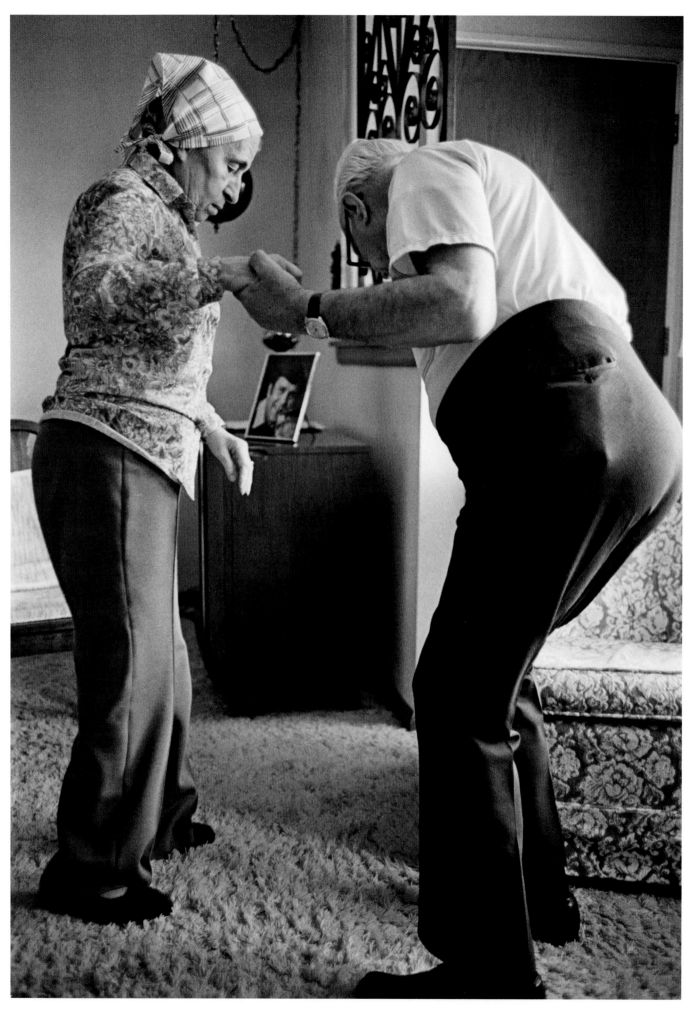

HOSPICE AT HOME · *Mother would get lost in the living room needing dad's guidance to her chair.*

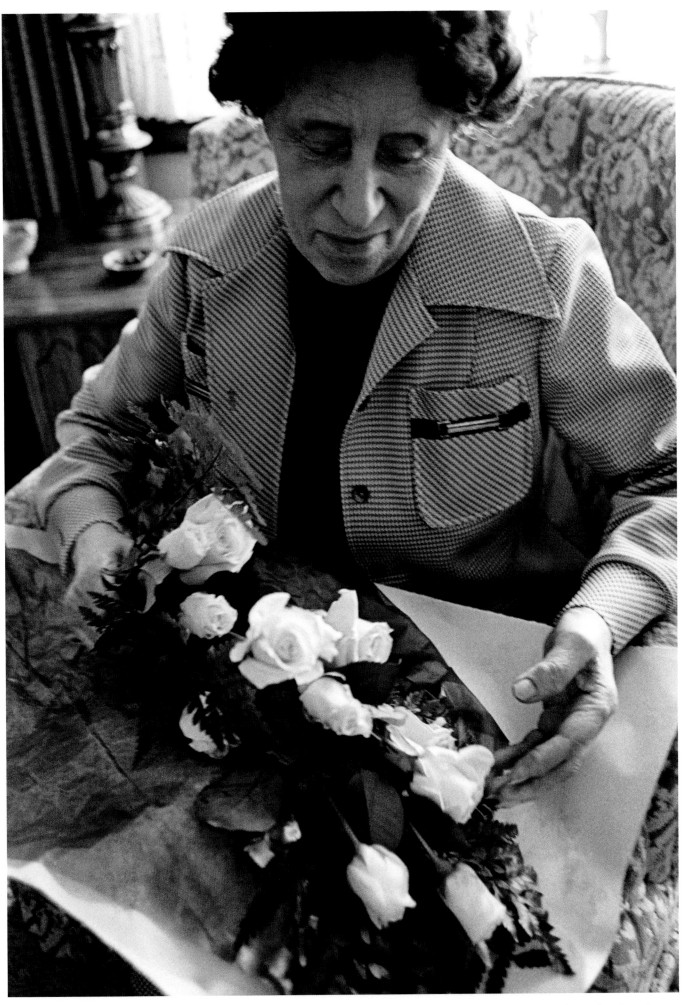

TEA ROSES · *My friend, Ernesto Travieso, S.J., wanted to see mother before she died. It was his idea to bring her favorite flowers - yellow tea roses. I thought she was putting on an act to make us believe she was better than she was.*

HOME HOSPICE

With the support of their local parish, dad was able to do home hospice for months. Here my sister Sue and dad assist mother into her bed which had a doorbell on the headboard so she could call dad.

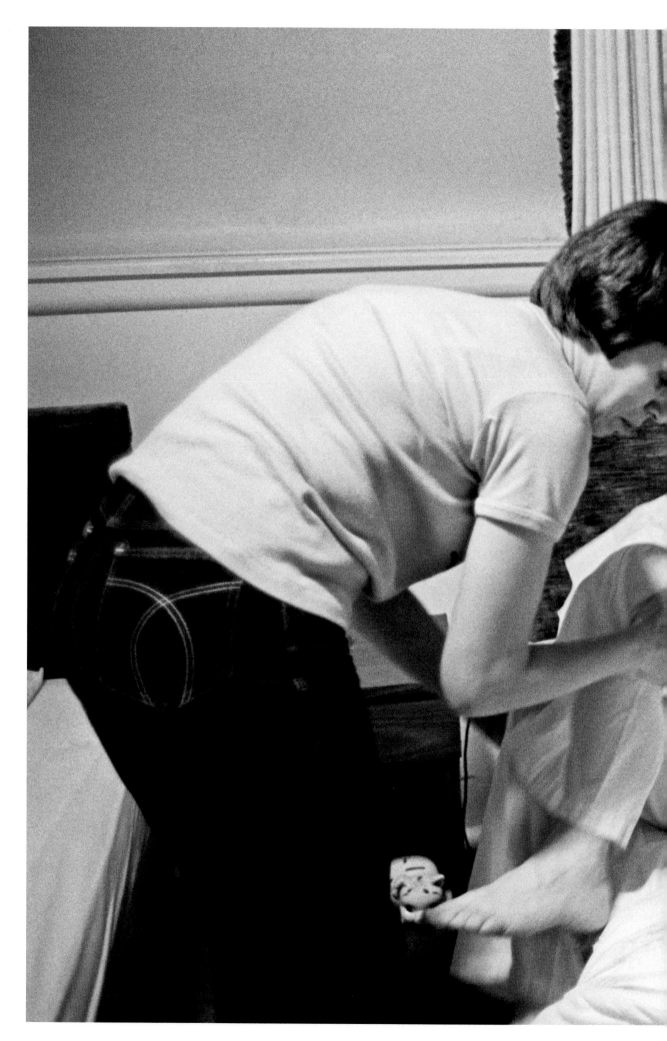

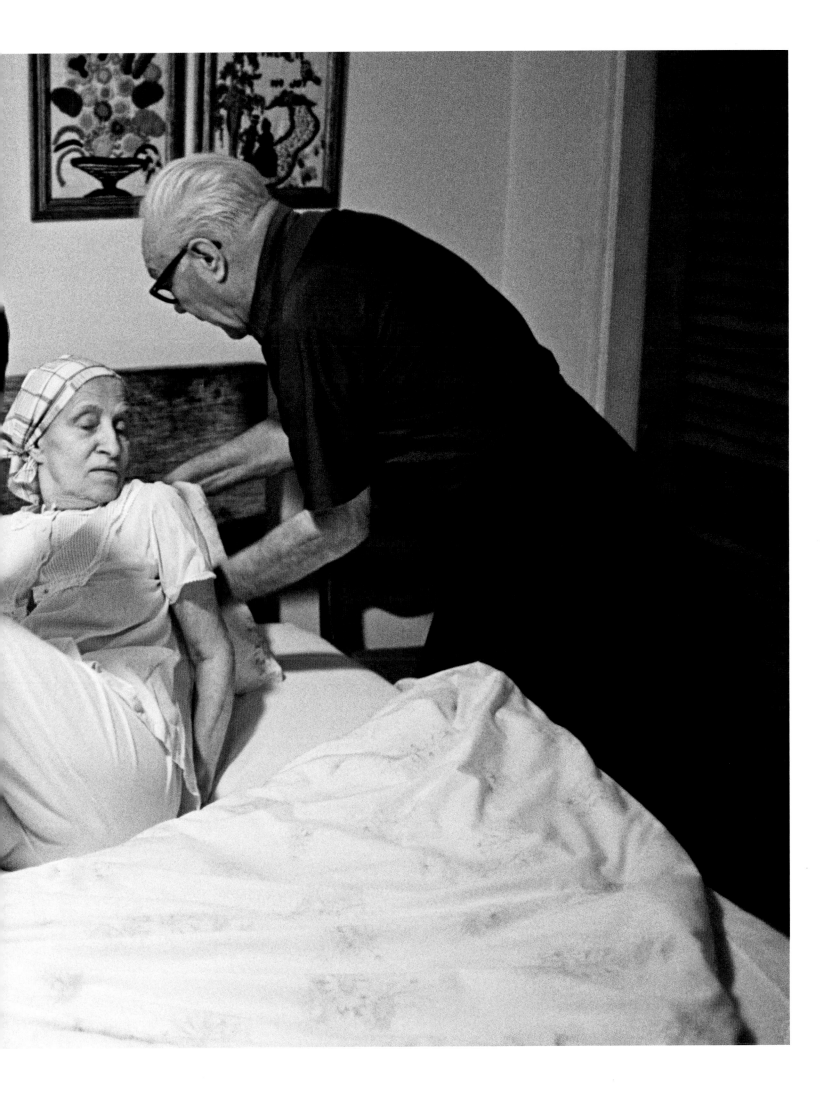

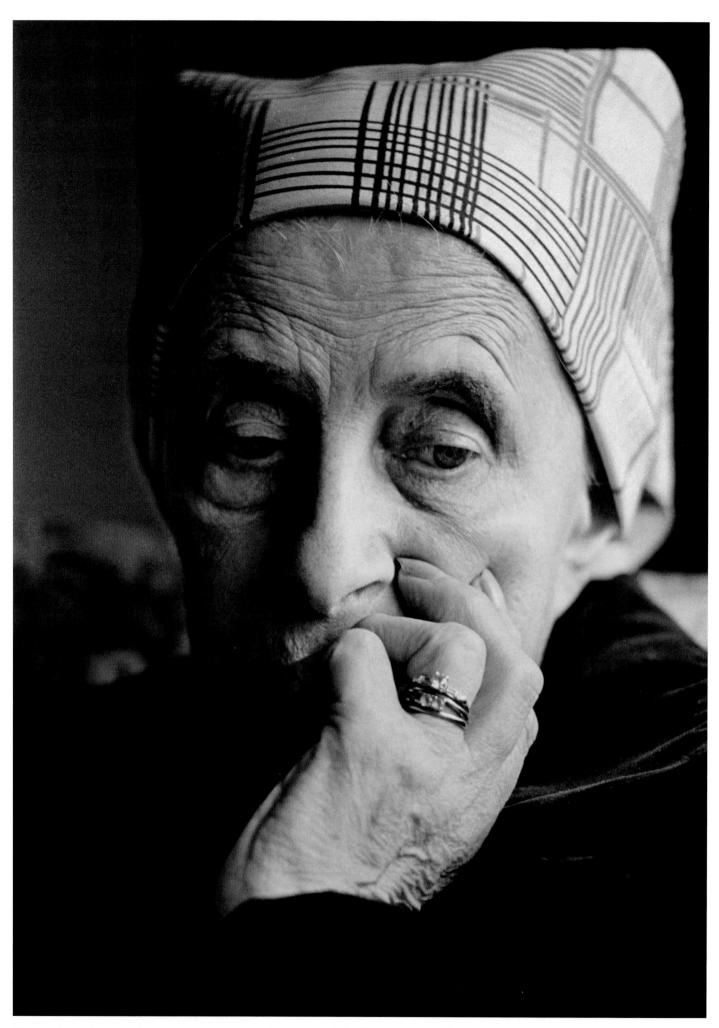

For me these photographs represent a moment when mother is looking across that chasm separating the living from the dead.

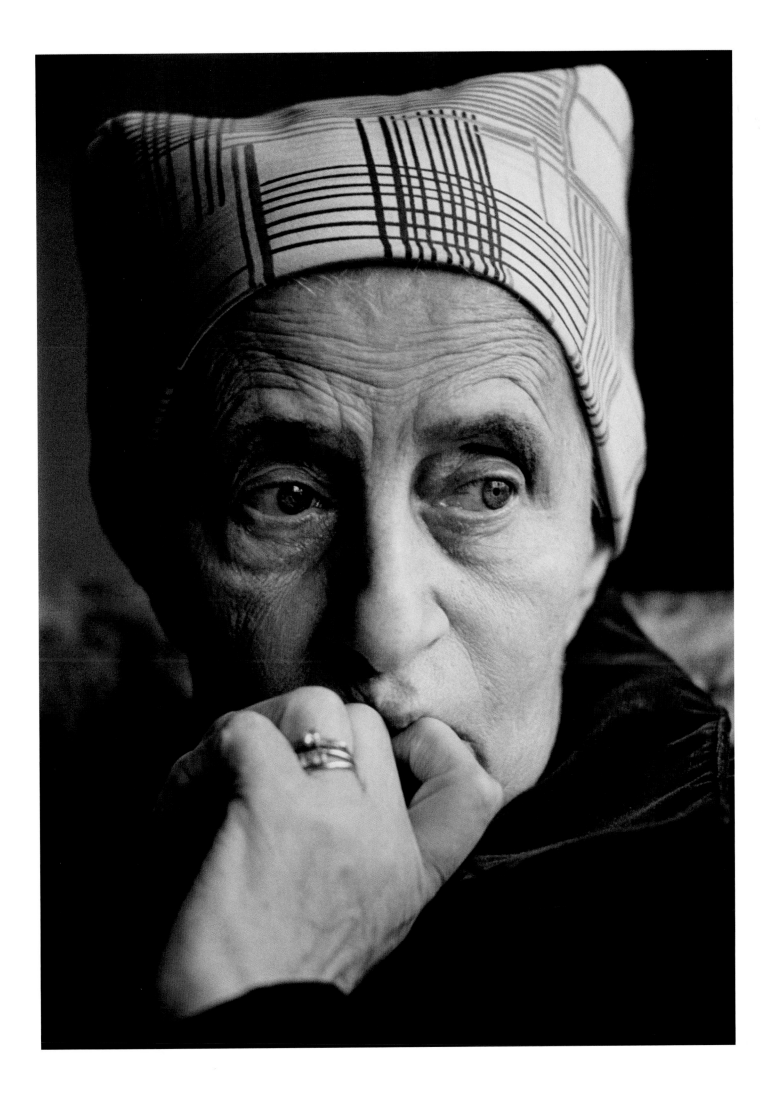

NATURAL CHILDBIRTH

While my mother was in home hospice with dad in Milwaukee, I was preparing to photograph the birth of a child in Omaha.

The Dickels had asked me to photograph the birth of their second child because Tim found it difficult to photograph while doing Lamaze with Gail during Sara's arrival.

Sara got her own pillow as her parents, Tim and Gail Dickel, practiced their Lamaze exercises.

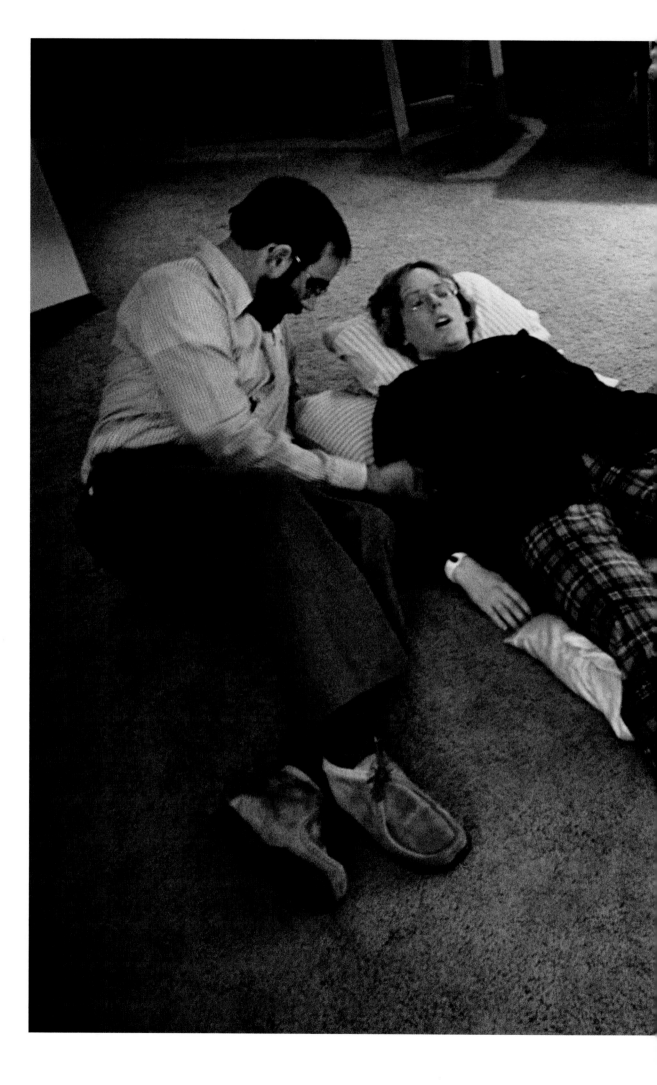

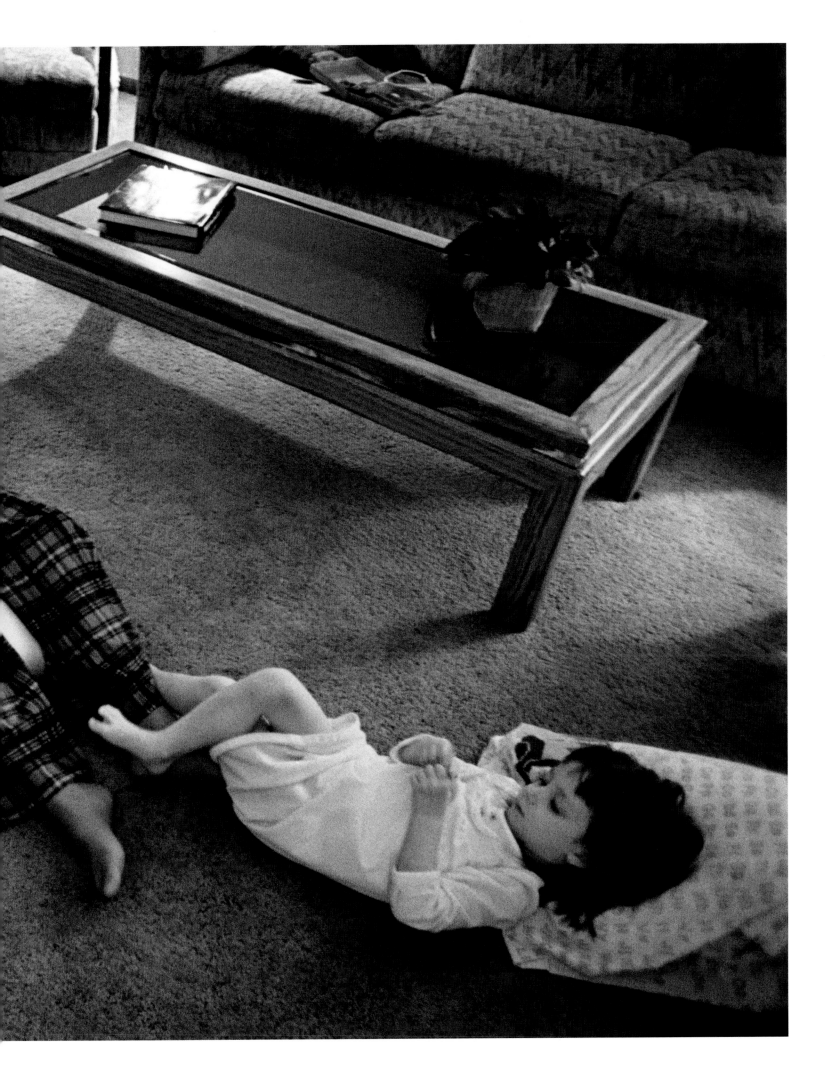

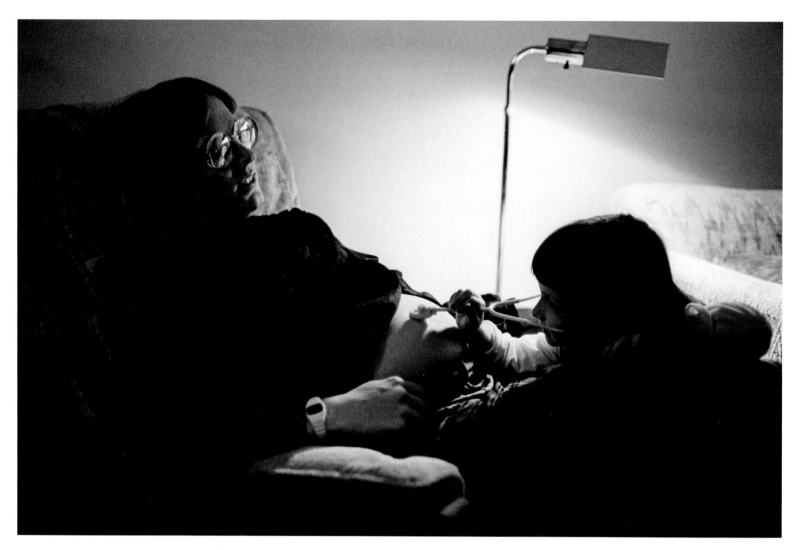

AWAITING THE BIRTH

Sara received a stethoscope for Christmas. Gail hesitated when I suggested going to the doctor with her, I said I don't need to be there at those times.

To prepare Sara for her new sibling, Tim reviews pictures of her arrival into the world.

DOCTOR'S OFFICE · *Sara weighs in as her mother did.*

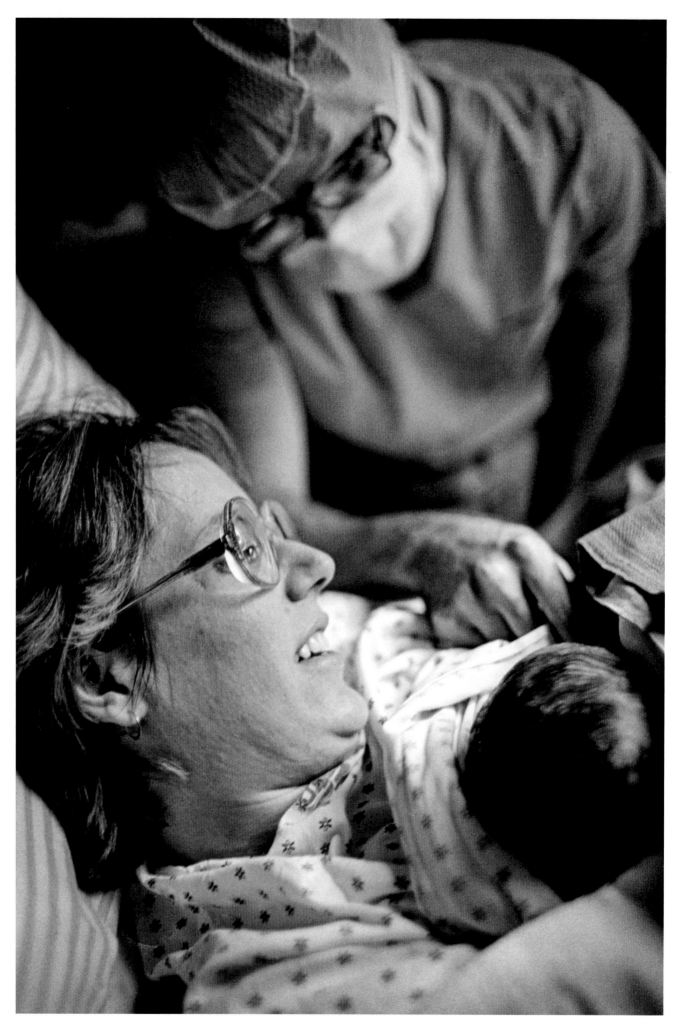

FIRST MEETING · *Tim got his first look at their new born son, Tad.*

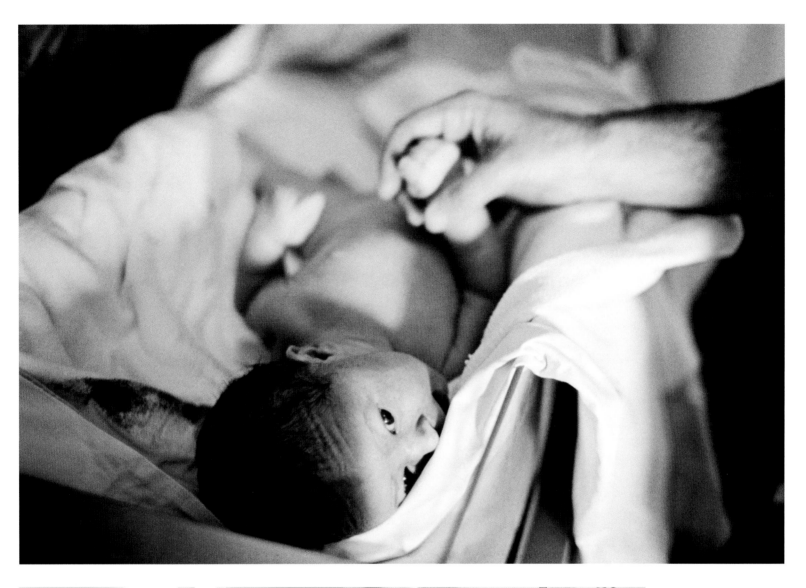

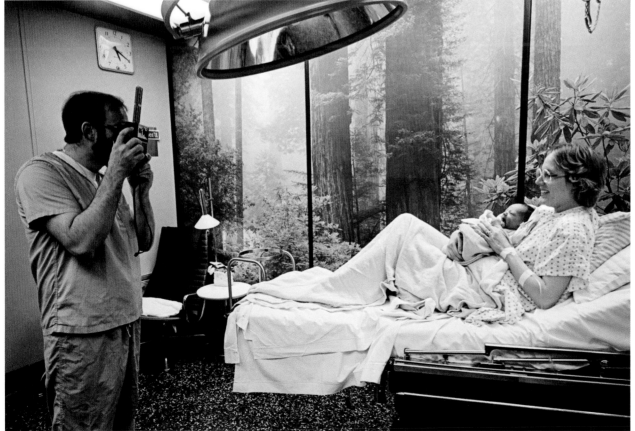

WELCOME, TAD

As Tad was placed on the scale to be weighed, Tim held his hand.

Tim took a Polaroid shot of Gail and Tad to share with their daughter, Sara.

I was scheduled to photograph Sara's reaction to her new, little brother, but I was called home because my mother was close to dying.

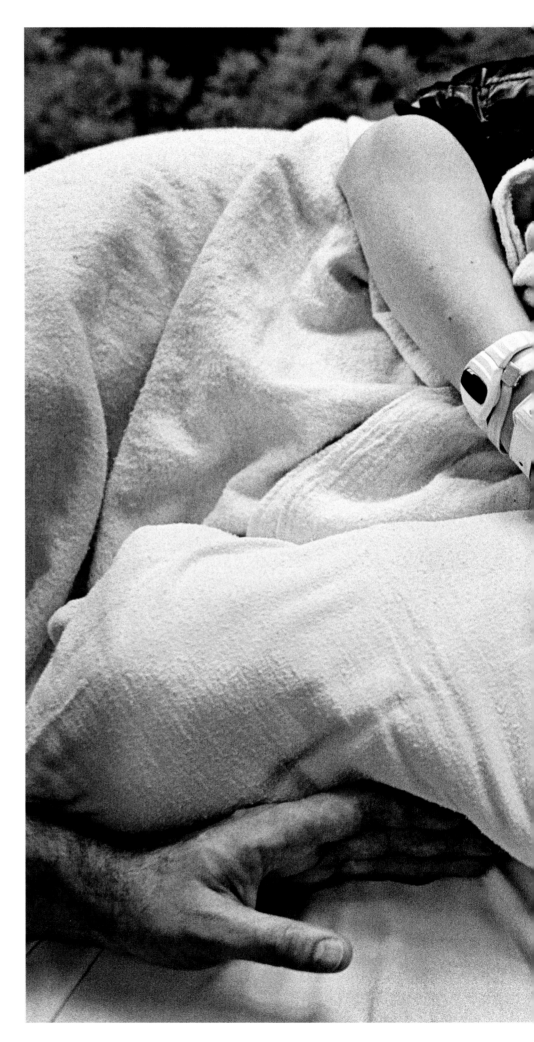

NURSING HER SON

Don't you love the supporting role of Tim as Gail nursed Tad for the first time?

The day Tad was born I was called to Milwaukee because my mother was near death at Rogers Memorial Hospice in Oconomowoc, Wisconsin.

In a few days, I went from the wonder and joy of birth to the natural end of life in a hospice.

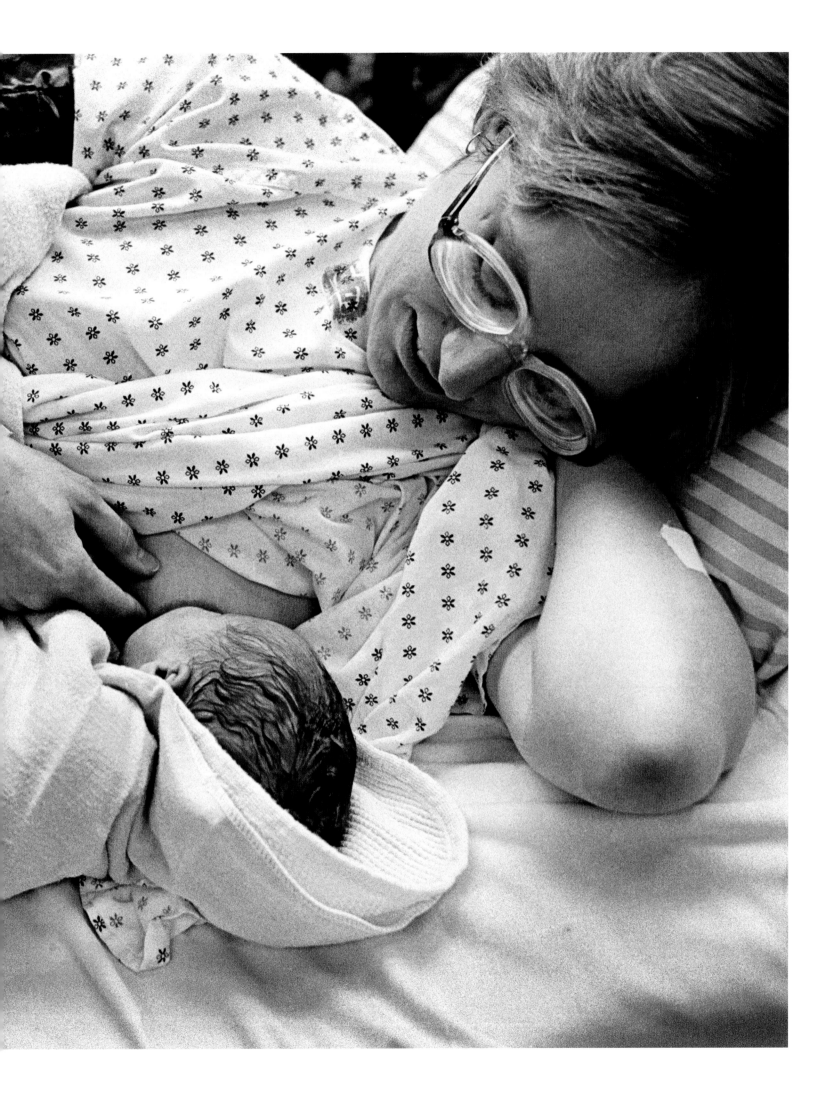

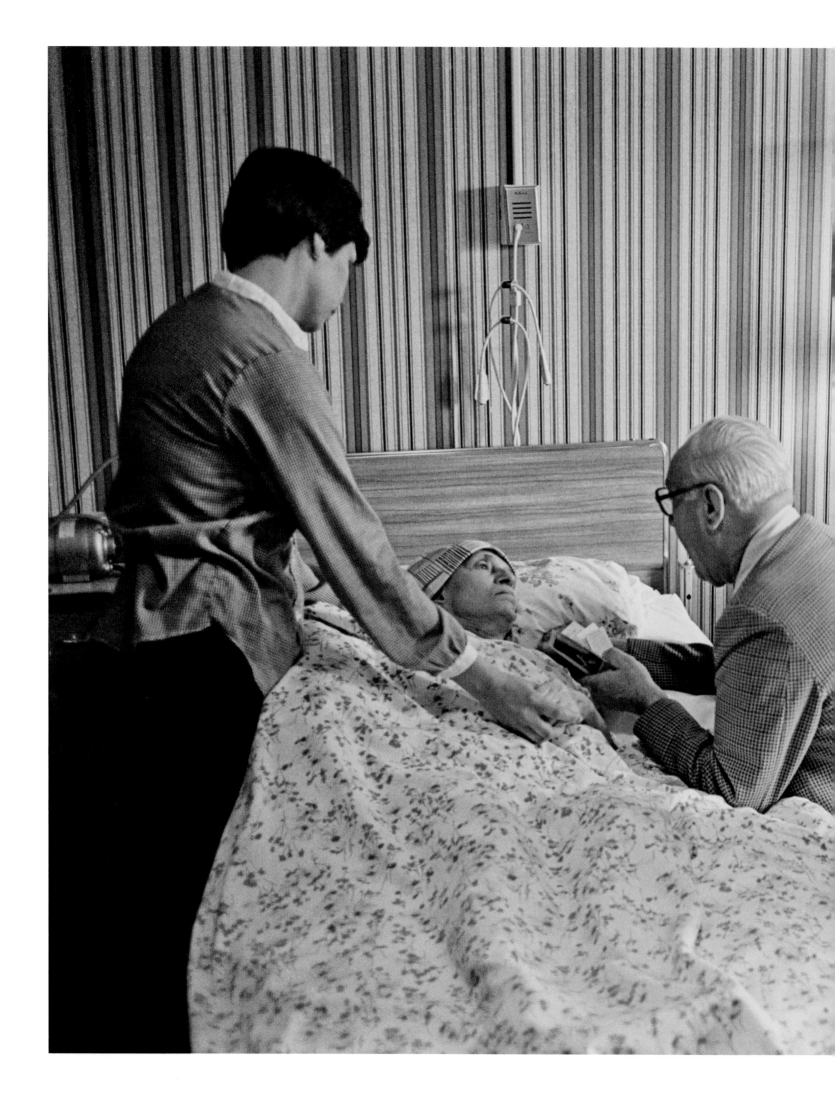

MOVE TO HOSPICE CARE

When my father could no longer do hospice at home, a Jesuit colleague visited my parents to discuss moving mother to Rogers Memorial Hospice in Oconomwoc, Wisconsin. They told her she could return home if she got better, she replied, "I'm not getting any better." She cried all day before the move.

Dad leads us in prayer: always the Our Father followed by Psalm 23, "There is nothing I shall fear even though I walk in the valley of death."

Sue, on the left, after one of our prayer sessions, leaned over and gave mother a big hug and said: "Mother, Go in peace."

Dad, my sister Judy and I followed her example. We were relieved to have commissioned her to leave us.

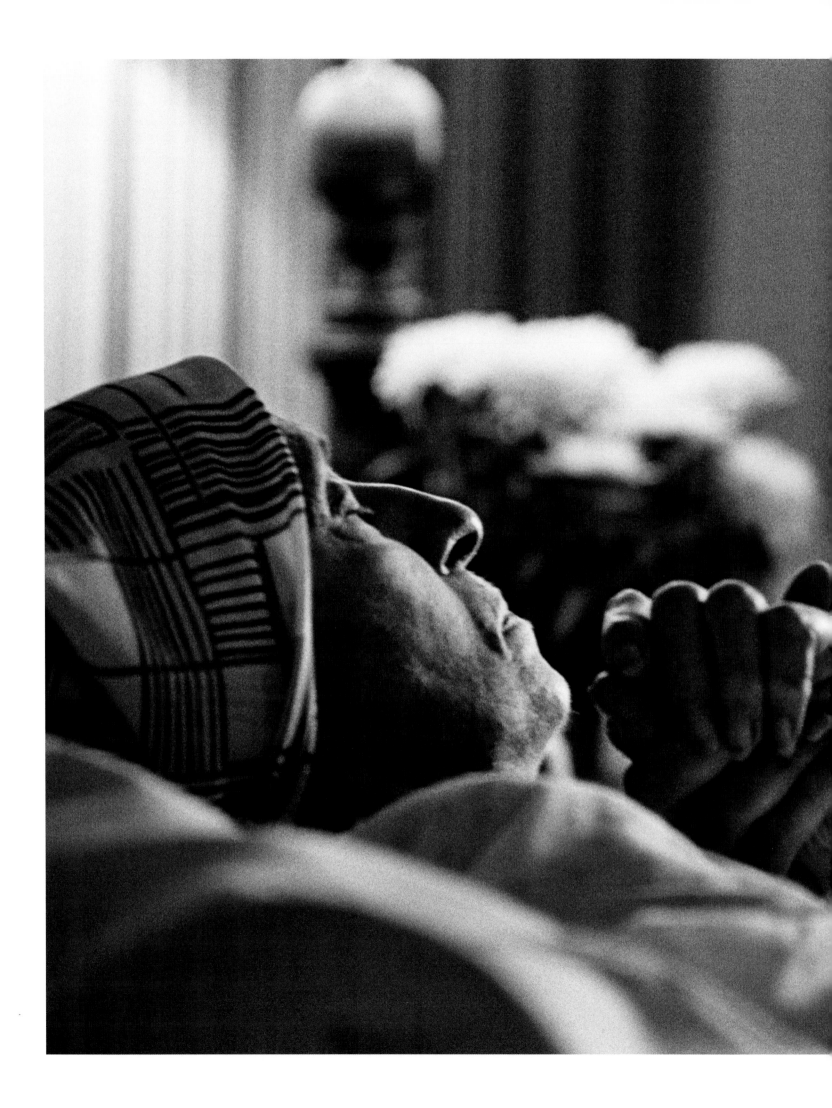

SIMPLE PRESENCE

My sister, Judy, holds mother's hand as we spent long hours at mother's bedside. When she awoke we would give her water with a straw or a bit of lemon on a tongue depressor.

It is a great privilege to be with a person at what has to be one of the loneliest times of our lives — when we face death. To be surrounded by family is surely a great blessing and a comfort as we make that final leap of faith.

Undoubtedly we will die as we live; if we have a deep faith, it is with that faith and trust in God, we will meet our Lord.

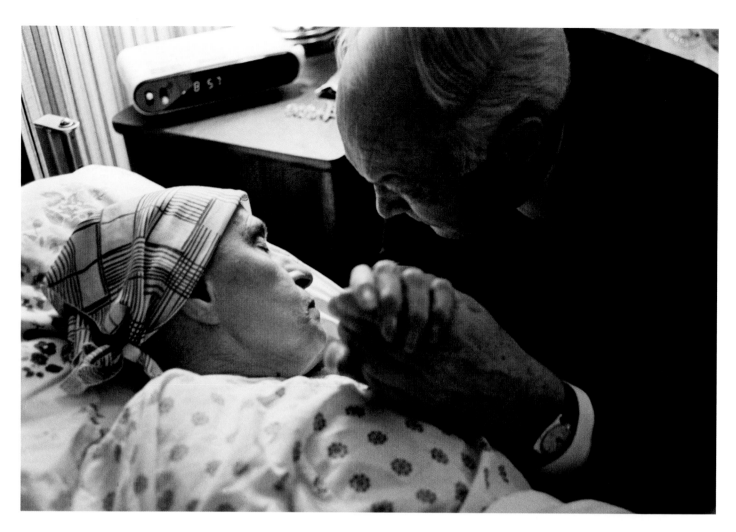

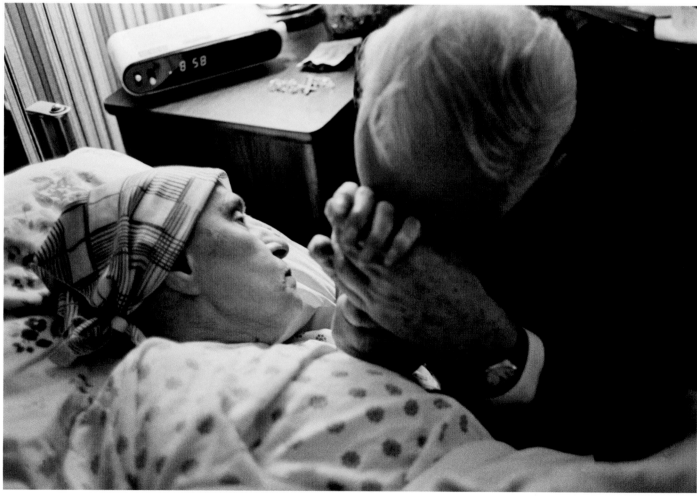

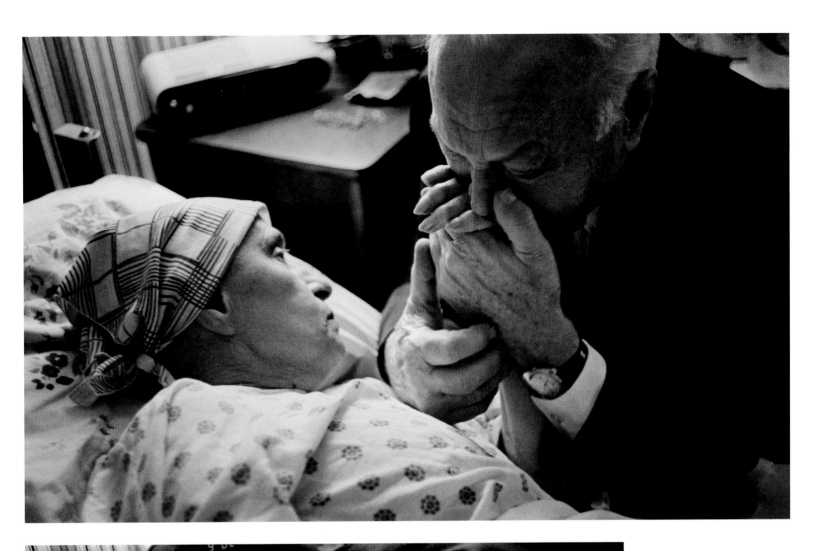

DAD'S FINAL GOODBYE

After a few days in the hospice maintaining a bedside vigil, dad was utterly exhausted. I urged him to go home for a night's rest. I would remain bedside all night with mother until the morning.

He is saying his final goodbye.

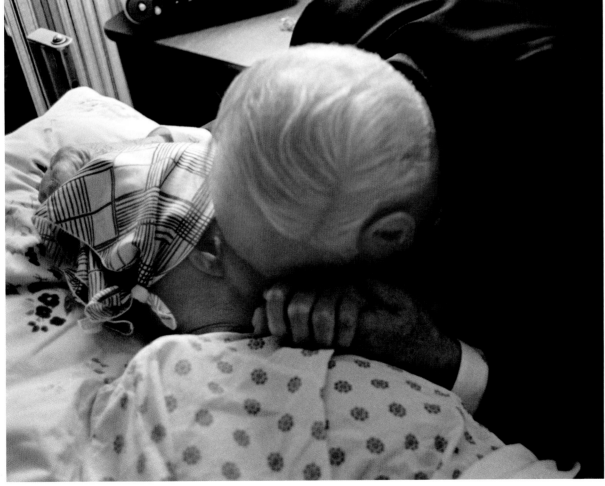

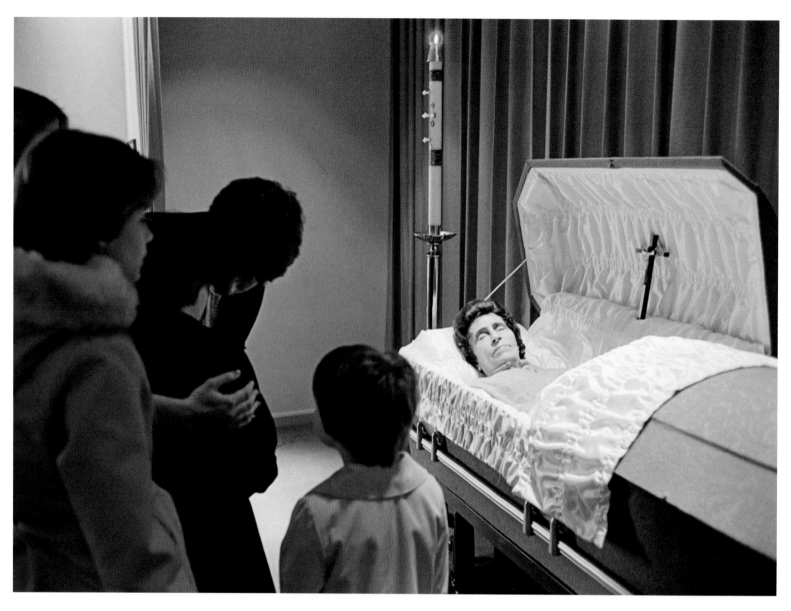

FINAL SERVICES

We opened the casket at the funeral home for the grandchildren who hadn't seen her for months while she was in hospice. It provided an opportunity to talk about death with them.

Mother would have objected to this photograph as she often said, "I hate it when people go by your casket and say how good you look when you are dead." It was closed with her portrait on top for the wake service before the funeral Mass, which I celebrated.

During the homily I reflected on how I felt our experience was scripted by the Holy Spirit into a drama in which each of the principal actors grew in grace and wisdom.

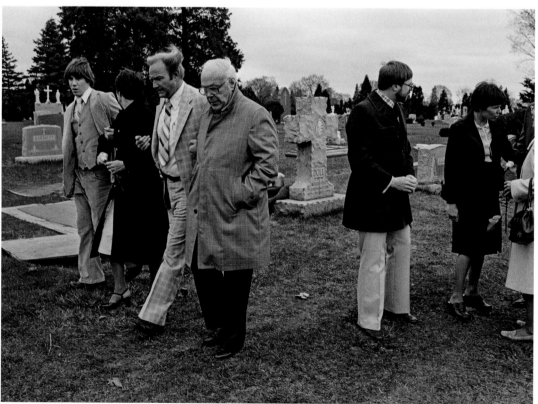

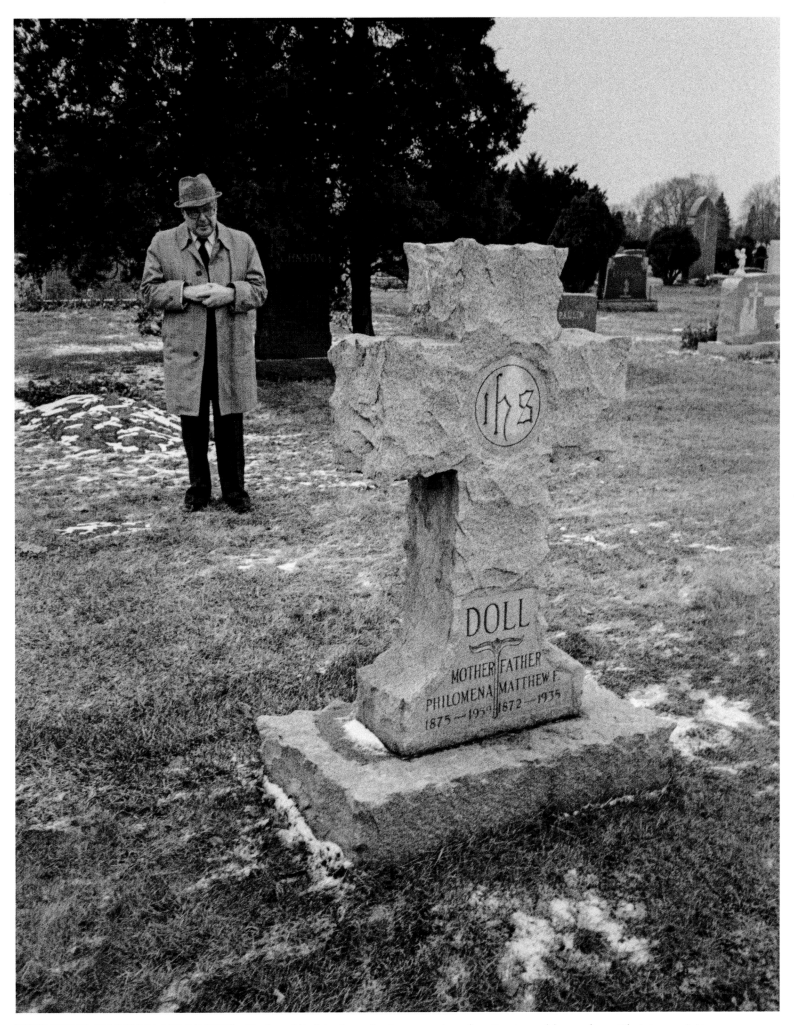

HOLY CROSS CEMETERY, MILWAUKEE · *Dad and I visited mother's grave site when I returned home for a Christmas visit.*

A Day
in the Life of...

America, California, Italy, Ireland, Nebraska and South Dakota became my destinations for these book projects, which were produced with stories from many participating photographers.

A Day in the Life of...

In the aftermath of photographing the death of my mother and the birth of a child, the 1985 invitation to take part in the popular "Day in the Life of ..." photographic book series seemed both welcoming and intimidating. It came when I was depressed and questioning my abilities as a photographer.

> When an invitation to shoot a "Day in the Life of Italy" arrived, I was thrilled because I love going to Rome. I was assigned the Pope and the Vatican.

When I taught my students to shoot photographic essays, I always showed them W. Eugene Smith's classic Life magazine story, "Country Doctor." The idea was to shoot vignettes of life simulating a single day that illumined a problem, place, or subject. Ironically, just as I was presenting this unit, I was invited to participate in the "A Day in the Life of America" project, modeled on the Smith piece.

Several years earlier two young entrepreneurs, Rick Smolan and David Cohen, turned this concept into a profitable book business. They selected a location or theme, secured corporate sponsors, and invited at least 100 noted photographers to photograph daily life during 24 hours in a chosen location. Editorial merit was the sole criteria for publication. No one, however famous, was guaranteed a page in the book.

I submitted five story ideas focused on life on the Pine Ridge Indian Reservation and headed to Wounded Knee, South Dakota. The day before the shoot I took a run to relax and pray, thinking about what images I might capture. As I was walking back to the Red Cloud mission I noticed a man painting white burial crosses, and I asked him what he was doing. With typical Lakota humor he told me that he was preparing for a big feud. When he said he would be working again tomorrow, I realized I'd found my photograph.

I became a participant in a number of "A Day in the Life Of..." shoots, one of the best things to happen to my career, restoring my confidence as a photographer. I accepted a new Macintosh computer and printer as reimbursement for the DITLO/America book and made it available to Creighton's Journalism Department. After taking a course in computerized page layout, I knew this was the future of journalism. Then I wrote a grant to the Hitchcock Foundation to create the Journalism Department's "Mac Lab", and began teaching courses in computer graphic design. This helped revolutionize our department.

My next "Day" project took me to California in 1987. I focused on the Spanish Missions because Jesuits had founded many earlier missions in the Baja peninsula. That was before the Pope suppressed the Society in 1773 and transferred them to the Franciscans. To my surprise and delight the book designer spread a photograph of workers at the San Luis Rey Mission harvesting strawberries and ran it over two pages.

In 1988 I participated in the project "Christmas in America," and went back to St. Francis on the Rosebud Indian Reservation. A variety of my ideas fell through and I was getting desperate because of the time limit. Finally a Jesuit suggested that I check out a Christmas evening Mass in an old prairie Gothic church at Soldier Creek, South Dakota. I arrived about sunset when a lovely light cast a rosy glow on the simple white church. None of the pictures indoors worked. Some instinct suggested shooting from outside. Through the translucent windows I saw a young boy praying. It remains one of my favorite photographs. Once more I thanked the Spirit that was teaching me to trust my instincts.

By 1990 when an invitation to shoot a "Day in the Life of Italy" arrived, I was thrilled because I love going to Rome. Maybe for obvious reasons I was assigned the Pope and the Vatican. I photographed Pope John Paul II exchanging gifts with the president of Portugal and his wife. Later I made photographs inside St. Peter's Basilica and after the Vatican closed for the day, I headed for the Gianicolo, a park overlooking Rome and to the nightlife of Trastevere.

The following year we tackled Ireland, another favorite assignment that carries fond memories. I proposed photographing a chapel at the top of Croagh Patrick in County Mayo, where St. Patrick drove the druids and snakes out of Ireland according to Irish lore. Shane Cunningham, the son of my host family, helped carry my equipment up the mountain. As the fog kept getting thicker I knew I wouldn't get much of a picture at the top. I noticed Shane standing like a shepherd against the mist and fog. That became my picture.

Starting in 1985, I participated in eight "Day in the Life Of" books including most recently "America 24/7", once more photographing Native Americans and Nebraska ranch families.

SAN JUAN CAPISTRANO · *The sacristan, 82 years old, lights candles at the San Juan Capistrano mission. This appeared in Day in the Life of California, 1987*

PINE RIDGE, SOUTH DAKOTA

In the carpentry shop at Red Cloud Indian School, Elmer Red Cloud, great-grandson of the famed Lakota warrior, paints crucifixes for placement in the cemetery.

With typical Lakota humor, when I asked him what he was doing, he replied: "We are getting ready for a big feud out here." Actually, he was preparing the crosses for Memorial Day, a major celebration for Native Americans proud of their service as warriors.

All the crosses became a metaphor for me as a reminder of all of my former native students who had died.

This appeared in Day in the Life of America, 1984.

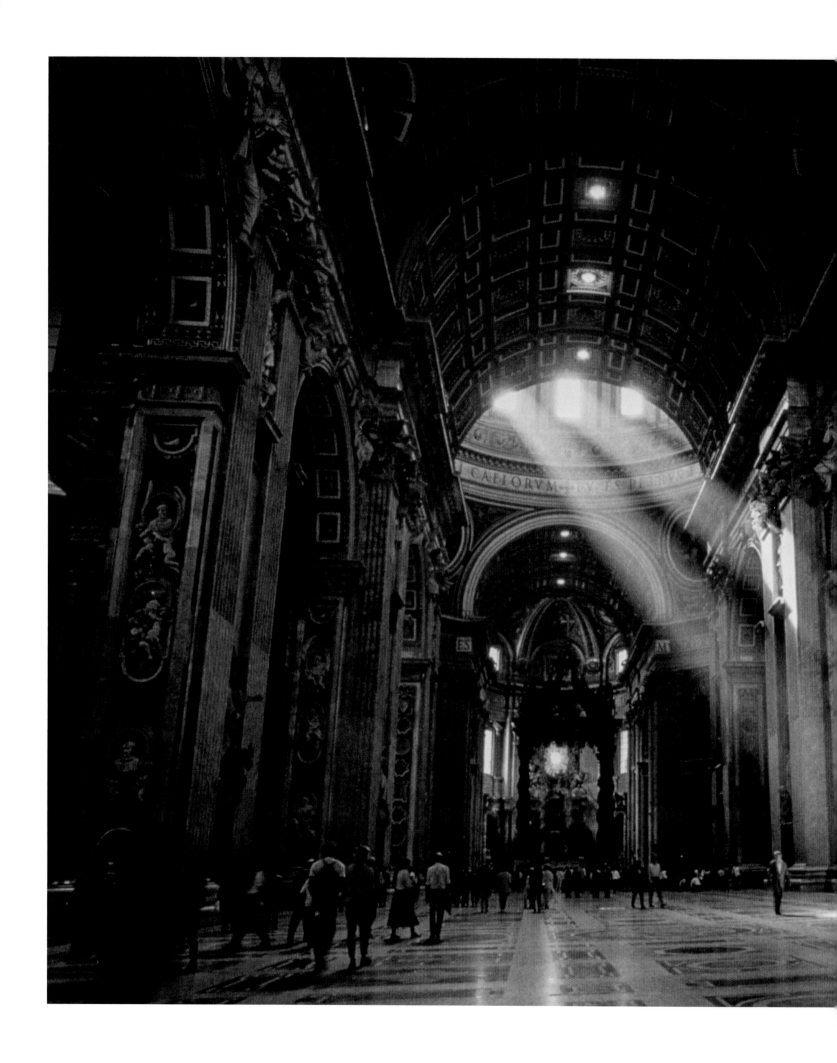

THE VATICAN

Pope John Paul II presents the president of Portugal and his wife an icon during their visit.

A view from the Gianicolo, a park overlooking Rome and the celebrated Victor Emmanuel Monument, known as the "Wedding Cake."

Saint Peter's Basilica - I had special permission to photograph with a tripod. Still, tourists looking up to the ceiling stumbled on my tripod's legs.

These photographs appeared in A Day in the Life of Italy, 1990

CROAGH PATRICK, COUNTY MAYO

Shane Cunningham, the 12-year-old son of my host family, Michael and Lily Cunningham, skipped school so he could help me carry my camera gear up Croagh Patrick, the mountain on which tradition says St. Patrick drove the druids and snakes out of Ireland around 500 A.D.

I had arranged to meet the caretaker of the chapel on top of the mountain. However, the fog was so thick, I thought there'll be no photograph on top, and I said to Shane, "Let's pause for a moment before going back." We were both soaked. That's when I made his photograph.

This appeared in Day in the Life of Ireland, 1991.

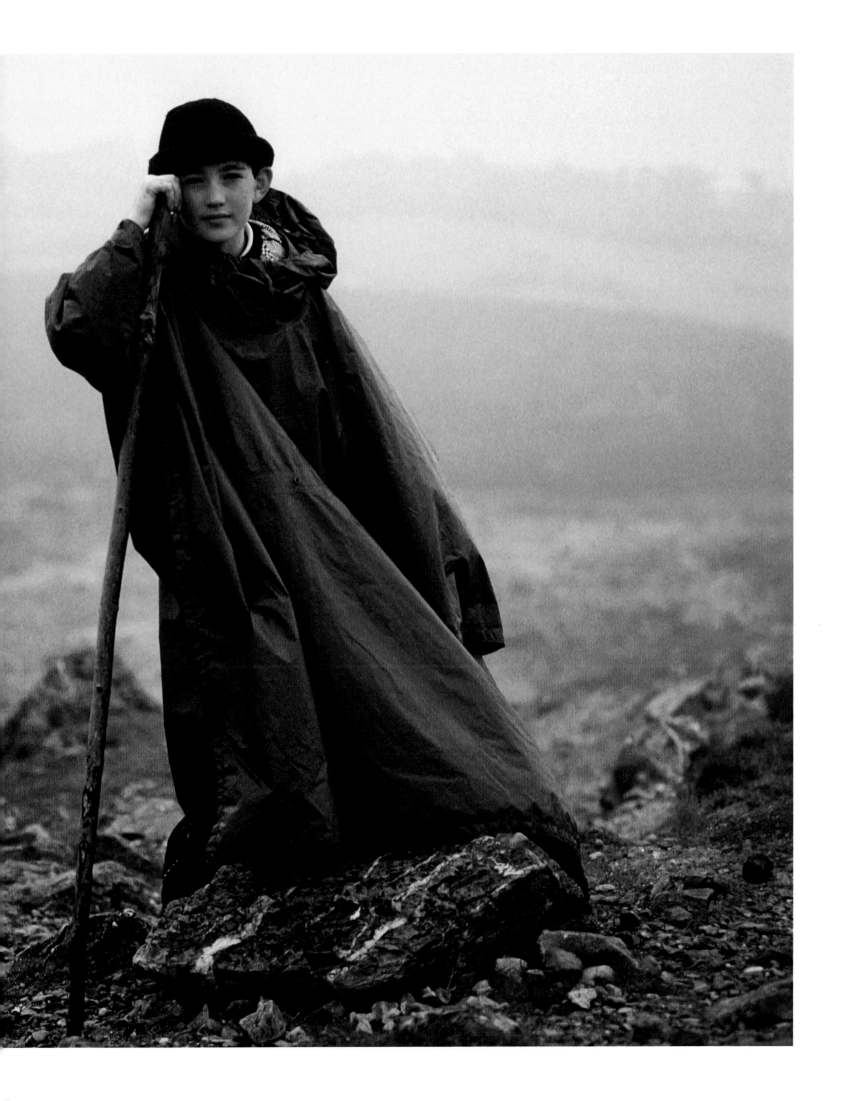

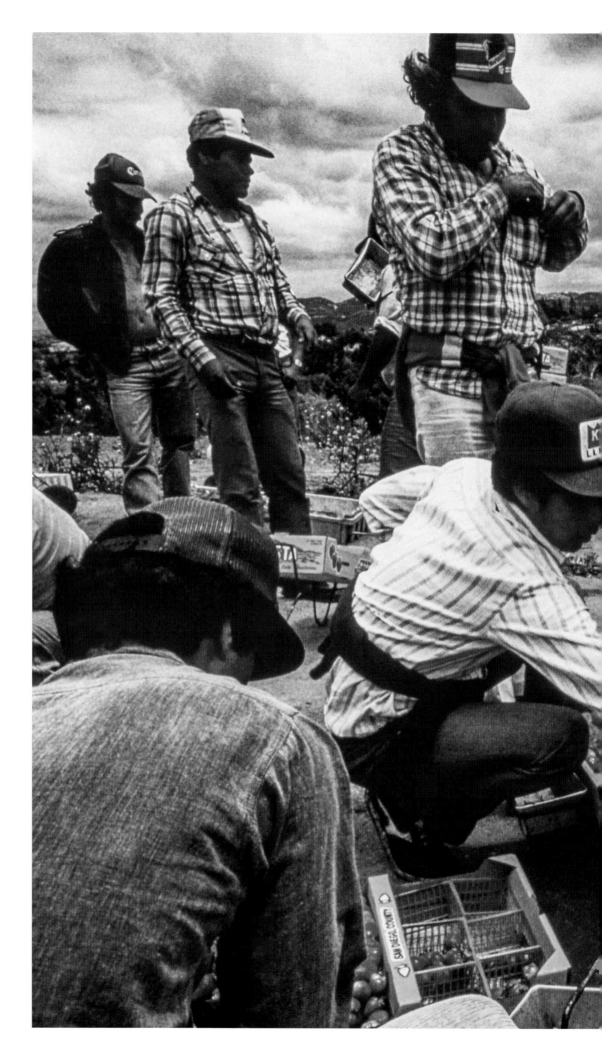

THE CALIFORNIA MISSIONS

Near the Mission of San Luis Rey, the same men who do strawberry picking also wash and package the fruit. "Field packing" is popular with migrant workers, who get a temporary respite from back-breaking harvesting work. It is also popular with wholesalers who can move strawberries to supermarkets more rapidly. More than 70 percent of the strawberries in America are grown in California.

This photograph appeared in A Day in the Life of California, 1988

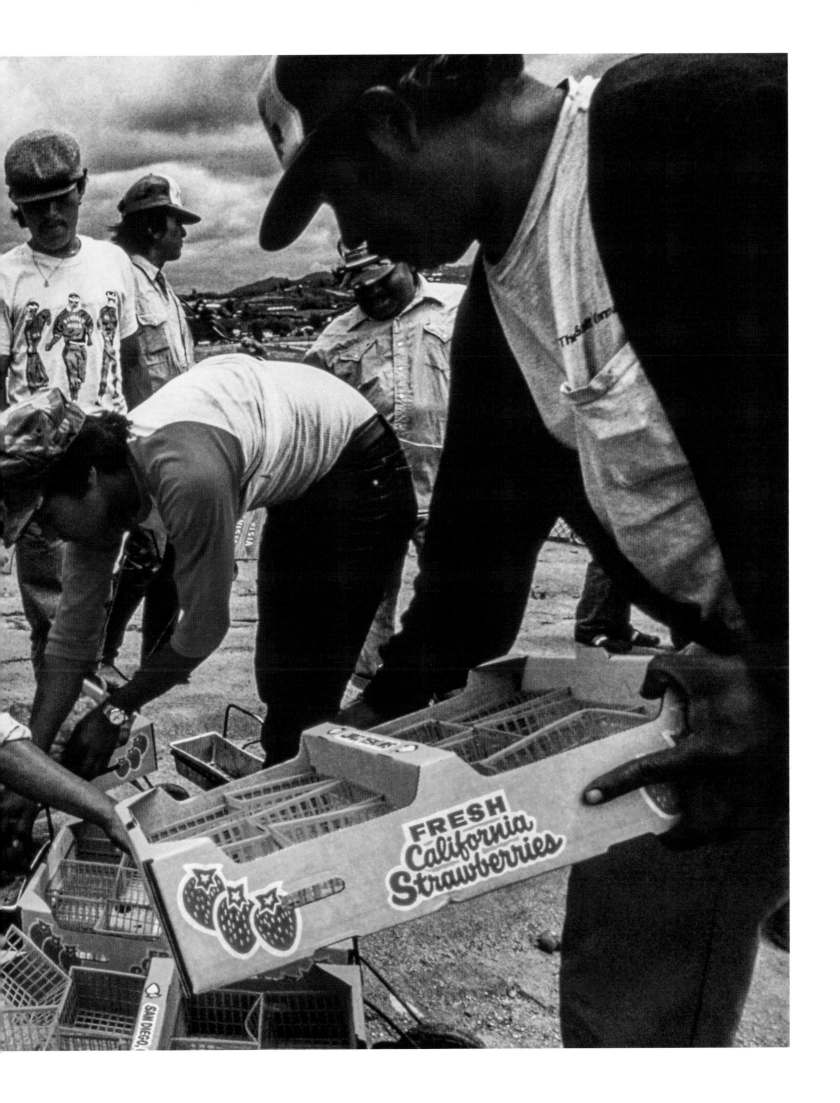

CHERRY COUNTY, NEBRASKA

It was Torie Lindsey and Nicholas Sasse's week to put up the flags at their school house. At one time Nebraska boasted 700 one-room school houses. Cherry County in the Sandhills had over 200, now only 22 are left. Hart Lake School was #134.

OGLALA, SOUTH DAKOTA

On a small reservation ranch, Lakota cowboys wrestle a calf to the ground where they brand it and give it shots.

These photographs appeared in America 24/7

MACY, NEBRASKA · *Fr. David Korth joins his parishioners in a traditional Native American sweat lodge ceremony.*

JESUITS
WORLDWIDE

My fellow Jesuits ministering to the world's poor remind me why I am happy the Spirit prompted me to become not just a photographer but a JESUIT photographer. The work they do makes me proud to be a Jesuit.

THE JESUIT MISSION

AROUND THE WORLD

A S NOVICES, JESUITS ARE SENT OUT ON A "PILGRIMAGE" to a distant city with no funding, forcing them to survive on odd jobs and the generosity of others. A Jesuit discovers how to live, trusting God will be with him to take the next right step in his journey. The exercise is rooted in the Scripture passage where Jesus sends his disciples out on such a mission.

During the mid-1990's, I felt called to pursue my own version of the novice pilgrimage, using my camera to create awareness of the victims of poverty and war worldwide.

This phase of my career began as I completed "Vision Quest." The Spirit seemed to be calling me to concentrate on photographing Jesuit work with the poor rather than trying to schedule such projects around fulltime teaching. In war-torn El Salvador, Jesuits were risking their lives to seek justice for the oppressed. In Africa, Jesuit Refugee Service (JRS) was assisting victims of civil wars and ethnic violence. In India, Jesuits were fighting for justice for the Dalit's, formerly known as the untouchables. I felt called to go to places where Jesuits work and tell their stories.

When I told Creighton President Michael Morrison S.J. that I might resign to devote fulltime to photography, he established the Charles and Mary Heider Jesuit Chair with their gift endowing the academic chair that allows me to teach during fall semesters and work on Jesuit-related photo assignments the rest of the year. There is no way to overstate how much credit the Heiders deserve for my subsequent photographic projects.

The first step in this new aspect of my career was to take classes to master the video skills needed for the major multi-media project on Jesuit works that I envisioned.

Originally the Jesuit project was to include a book on the "Vision Quest" model in addition to an interactive DVD. However, we opted to do video instead, and Creighton alum, Liz O'Keefe, of National Jesuit News joined me as a writer. We began on the Pine Ridge Indian Reservation where we interviewed Jesuits reflecting on their lives, their spirituality, and their work with Native Americans.

That process became the project's template for the segments in El Salvador and India. We then traveled to Spain to shoot the project's opening segment on the life of St. Ignatius and the birth of the Society, then to Italy to interview the former General, Father Peter-Hans Kolvenbach S.J. and other prominent Jesuits.

After we finished the 193-minute DVD, entitled "Jesuit Journeys," I continued to record the work of Jesuits worldwide on my numerous mission trips with JRS.

> My mission to photograph Jesuit work around the world has made me very proud to be a Jesuit as I see them in action.

I marvel at the willingness of Jesuits like my classmate John Mace S.J. to spend years living in cultures so different from our own. I visited John on a trip to East Timor that formerly was part of Indonesia. His duties as regional superior there include preparing young Timorese men to become Jesuit priests.

It is inspiring to visit vibrant Jesuit communities all over Asia, India and Africa composed almost entirely of natives of those regions. The next head of the Society might very well come from one of these regions.

Jesuits are quietly offering hope and help to thousands of people regardless of their religious beliefs in places that few Americans have heard of. In addition to performing their traditional religious duties they teach and fight for human rights and economic justice. They may no longer stand in public squares preaching the Gospel and baptizing thousands like St. Francis Xavier did 500 years ago but their lives are a daily witness to the Gospel. My mission to photograph Jesuit works around the world has made me very proud to be a Jesuit as I witness them in action.

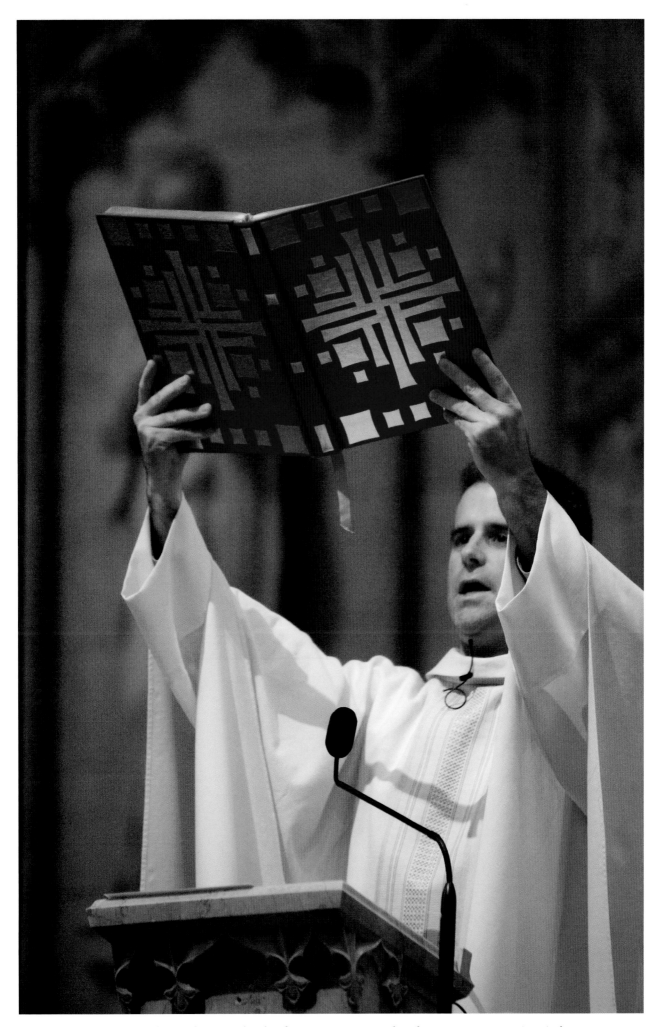

TIM MANATT · *Tim proclaims the Gospel at his first Mass in Gesu Church on Marquette University's campus.*

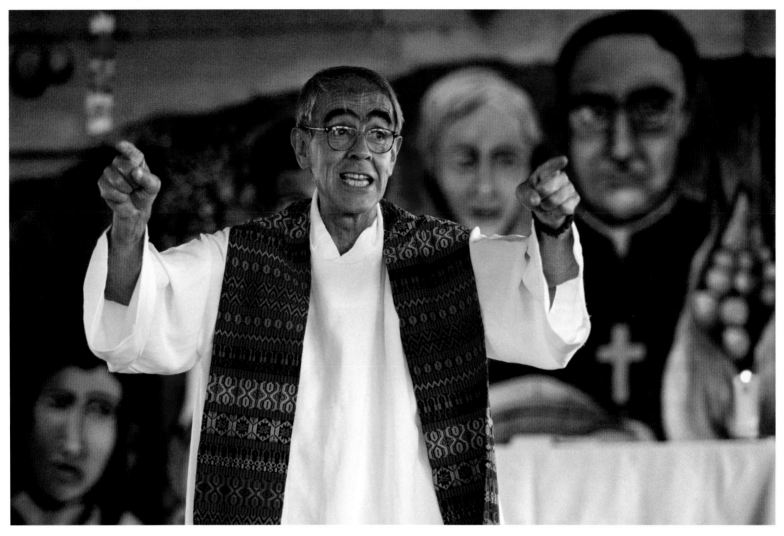

GUARJILA, EL SALVADOR · *Jon Cortina, S.J. preaches in Guarjila's community hall where he regularly celebrated Mass even during the war.*

There was no question that one segment of the Jesuit Journeys DVD would feature the Jesuits of El Salvador. They offered the most dramatic example of living out the Jesuit mandate to be in solidarity with the poor. In 1989, the world witnessed the horrific execution-style murders of six Jesuits by U.S.-trained militia. Two of my classmates who belonged to that community, Jon Cortina, S.J. and Jon Sobrino, S.J., were not home the night of the massacre and survived to continue this mission to the people.

Cortina and Sobrino were both from the Basque country of Spain, and had joined our seminary class at St. Louis University to study philosophy and engineering. Sobrino later switched to theology and became a noted liberation theologian. Cortina taught engineering at the Jesuit University in El Salvador and worked with compesinos. He was a kind, charismatic priest with a wonderfully expressive face that lit up when he interacted with the people that he loved so much. He worked to reunite families whose children had been taken, often after the murder of a parent, and put up for adoption abroad.

The story of Ernesto Sibrian, whom the government had placed for adoption after the army murdered his mother, epitomized Cortina's work. Jon had located Ernesto's adoptive mother, Kathleen Cassidy, a social worker in New Jersey, and wrote to her about Ernesto's history and family in El Salvador. This wonderful woman was a Fordham graduate who feared losing her son, but was determined to do the right thing. She agreed to participate in my project, becoming its narrative voice.

Liz O'Keefe and I recorded video and interviewed Cortina, Ernesto, and his extended family in El Salvador, including Ernesto's meeting with his family. Kathleen did a beautiful job of explaining how Ernesto's reconnection with his birth family unfolded.

This powerful story captured the impact of Cortina's work with the 100 families he had reconnected at that time. He realized that the children he found would remain with their adoptive families in their new countries because they had become thoroughly American, French, Italian or German. Cortina wanted to ease the pain of their Salvadoran families and to introduce these children to their families of origin, insisting that families had a right to know their children were all right, and the children had the right to know their heritage.

Ernesto's story was so moving that one of the professors at the Platypus Workshop opened the door to getting it broadcast on Ted Koppel's "Nightline." During the months that network editors fine-tuned the segment, I discovered that they edited for words more than for photos, the opposite of National Geographic. "Finding Ernesto" aired on Nov. 18, 1999 and taught me a great deal about the power of the narrative voice.

Sadly, Jon Cortina died in 2005. We keep his memory alive at Creighton through the Cortina Community, a residential community in which selected sophomores live, study, serve and pray together to promote the Ignatian tradition of the service of faith and the promotion of justice.

FR. JESUMARIAN, S.J., LAWYER AND DALIT · *Jesumarian leads the movement to eliminate discrimination against the Dalits.*

Another major segment of "Jesuit Journeys" featured Fr. Jesumarian, S.J.'s crusade to combat discrimination against India's Dalits, formerly called "untouchables," the lowest Hindu Caste. Jesumarian, who is both a Dalit and a lawyer, in addition to being a Jesuit priest, described how the discrimination he faced growing up fed both his vocation and his determination to change conditions for his people.

The video features him organizing Dalits in Tamilnadu to march against economic, educational, legal and political discrimination. Jesumarian's courageous efforts have given new dignity, hope and pride to Dalits, a fourth of India's population. His hero is Ambedkar, the founding prime minister of India, whose statue is behind Fr. Jesumarian, in the Dalit center. His work also strongly affected me. I have returned to India several times since this pilgrimage.

My Jesuit province has a twinning relationship with a Jesuit province there and our Creighton Jesuit community includes two Indians. There are more Jesuits in India than any other country and they are wonderful brothers.

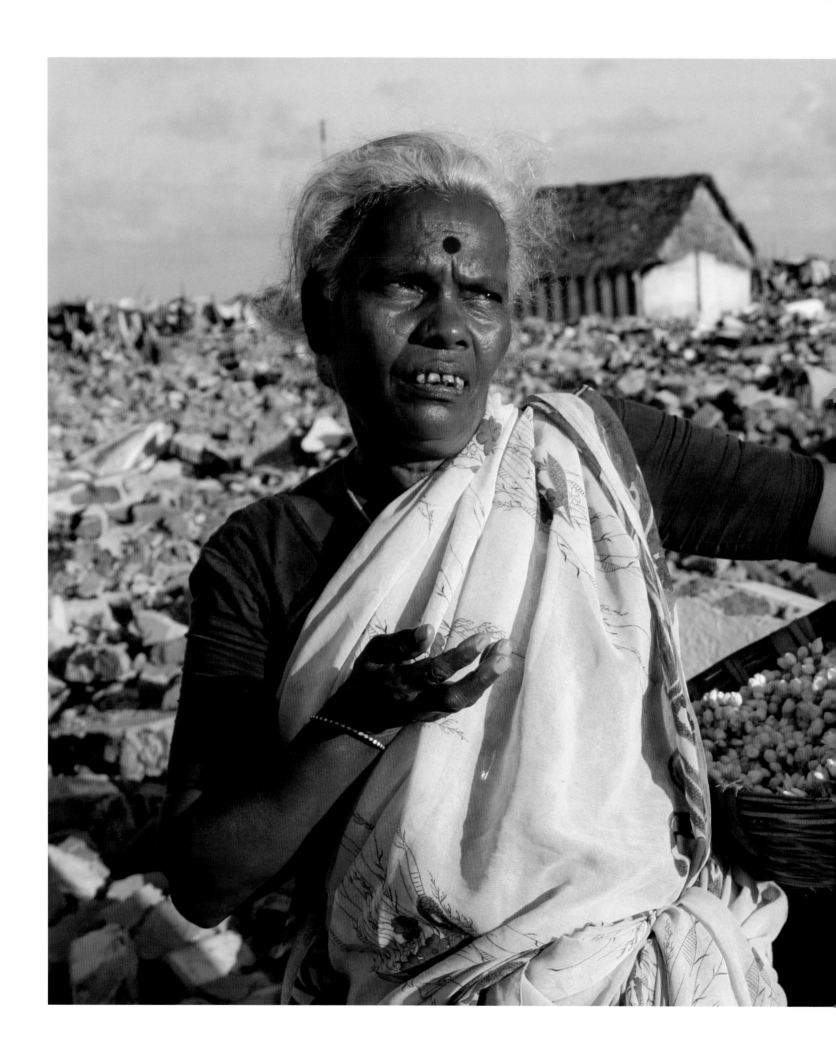

CHENNAI, INDIA

Sarasvathi sells jasmine flowers for women to place in their hair on Foreshore Beach front where the Tsunami took 24 lives, and destroyed the homes along the shore.

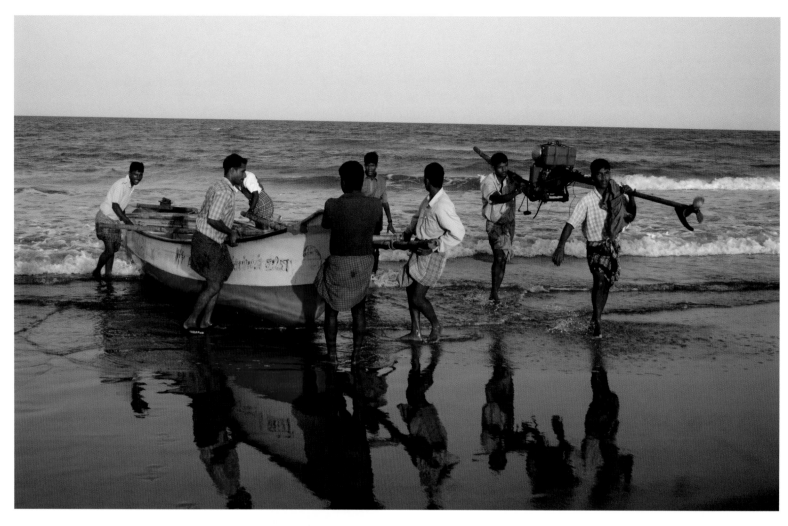

ASSISTING TSUNAMI VICTIMS

After the tsunami, the Jesuit team decided to teach the men how to repair their own diesel engines rather than have them rebuilt for them.

The young man on the right carries his motor out of the water with his instructor after testing it at sea.

The Jesuits also formed teams to lead the children in art therapy classes to process the traumatic events they had witnessed.

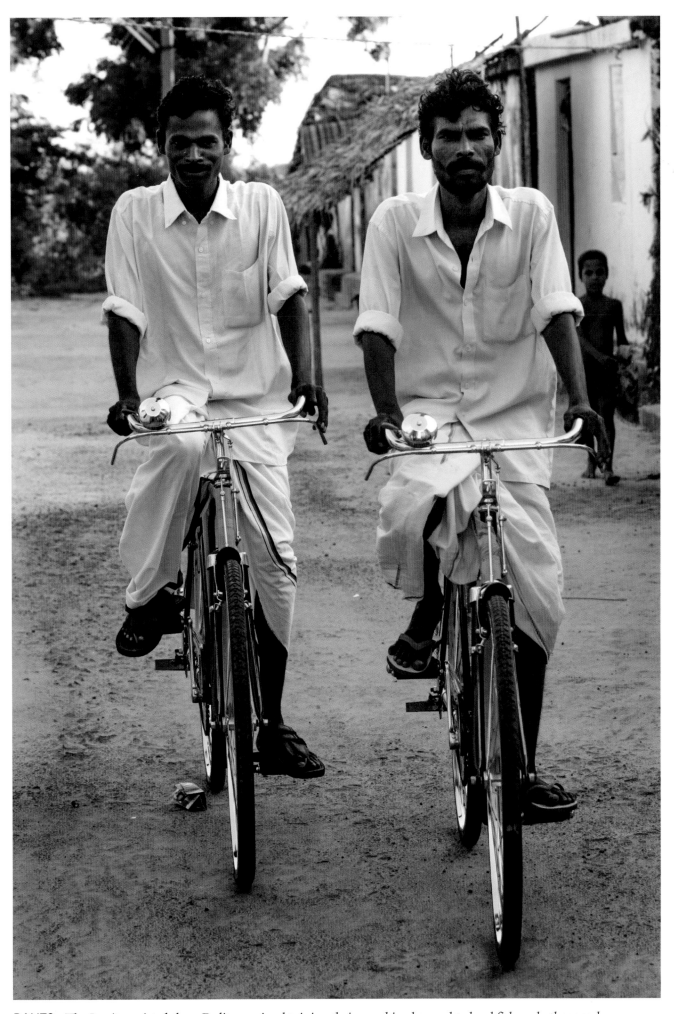

DALITS · *The Jesuits assisted these Dalit men in obtaining their new bicycles used to haul fish and other goods.*

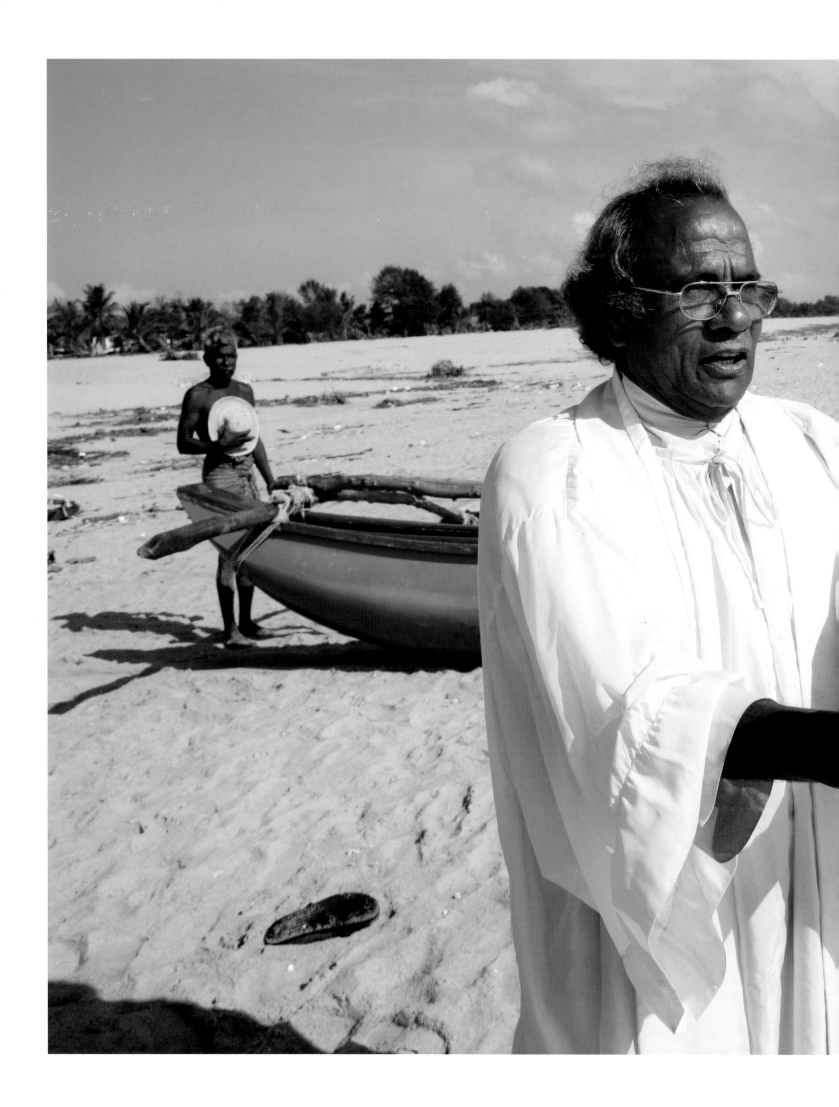

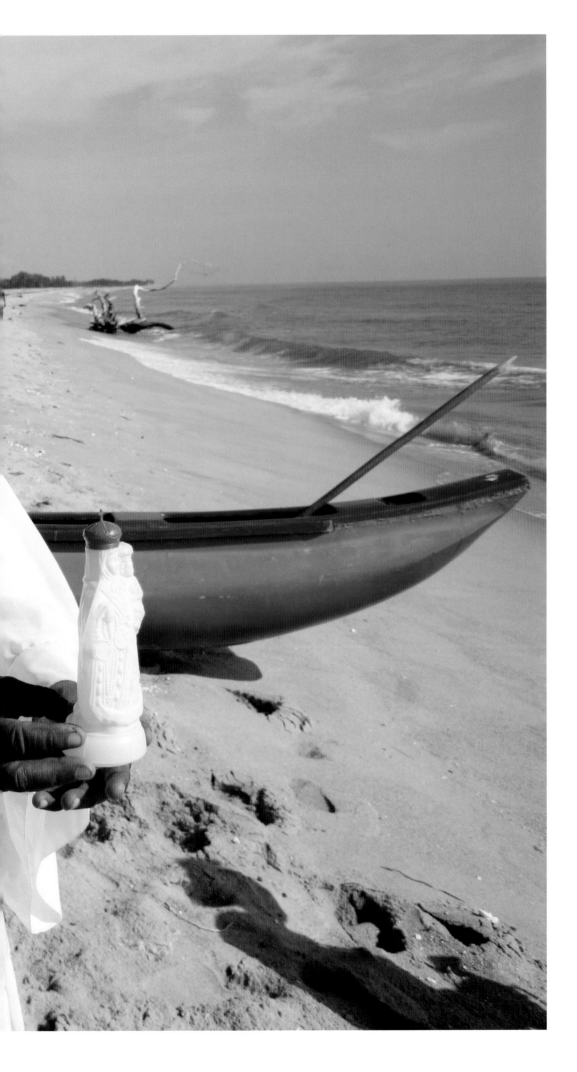

BATTICALOA, SRI LANKA

Fr. Joseph blesses the sea for his parish of fishermen. Father had funds to rebuild his parishioners' fleet of fishing canoes, and to rebuild nearly 100 homes that were destroyed when the strength of the tsunami forced the ground-water up, cracking most of their foundations.

Here he is blessing the sea — considered by many to be their mother providing food and sustenance.

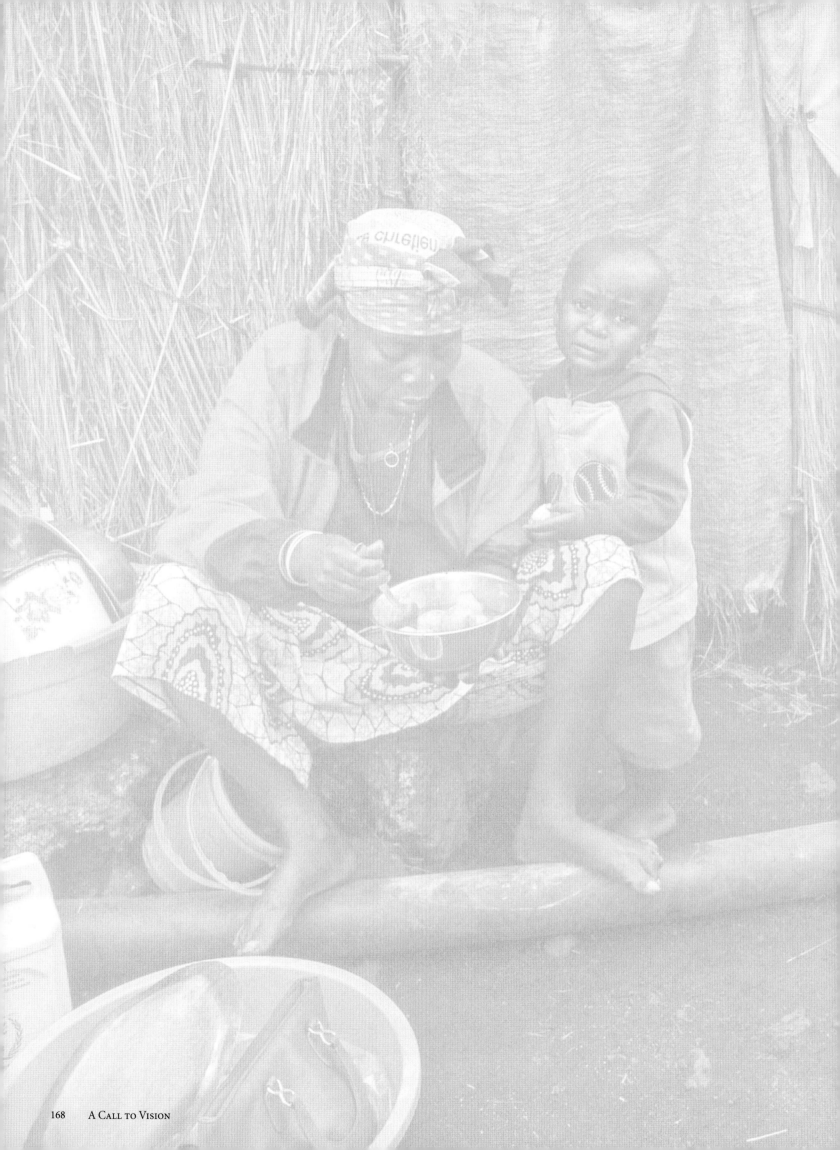

Jesuit
Refugee Service

The Jesuit Refugee Service was founded by our charismatic Superior General, Pedro Arrupe, S.J., in 1984. It reaches out to refugees forced to leave their homes in fifty-one countries.

JESUIT REFUGEE SERVICE

SERVING IN 51 COUNTRIES

AS CROWDS POUR INTO CREIGHTON BASKETBALL GAMES, I see parents and children sharing a fun family evening. Occasionally I experience chilling memories of children in Jesuit Refugee Service camps in Chad and Congo who will never enjoy such an evening with their parents. I met former child soldiers who had been forced into armed bands and forced to become murderers. These are some of the most heartbreaking victims I have encountered since I began volunteering for JRS.

My involvement with JRS began in the early 1990's when Brad Reynolds, S.J., and I wrote a white paper on JRS work with refugees from Pol Pot's genocidal regime in Cambodia. In Phnom Penh, I found JRS building wheel chairs and prostheses for hundreds of landmine victims and I photographed a genocide museum displaying skulls of the Pol Pot victims.

My next JRS assignment was to be Rwanda. However, the director, Mark Raper, S.J., wrote from Rwanda as the genocide was breaking out, "we have enough photographers here, go to the next hot spot, Sri Lanka." In Sri Lanka, JRS scheduled stops in 13 of the refugee camps it ministered for Tamils who were victims of ethnic/religious conflict. I quickly realized that it was better to focus on fewer sites and spend more time with the refugees to obtain their stories.

At these camps I was deeply moved by the faith of the Tamils. Many of them had suffered terribly. At the time I was still using black-and-white film and these stark images of war and deprivation cut to the heart of the country's tragedy.

> My work for JRS is the most profound expression of my vocation as a Jesuit photographer.

In 1997 I attended the Fourth Annual International Campaign to Ban Landmines in Maputo, Mozambique, then traveled to Angola where a major de-mining effort was in progress. I was horrified to learn that more than 10 million landmines had been buried in Angola during its decades-long civil war. Each was capable of killing or maiming anyone who took a wrong step while going about daily life. In Luena I photographed a de-mining group and learned that it cost $1,000 to remove each mine. One of the most powerful photos was of a hospitalized man who had just stepped on a mine.

I felt called to do more to communicate the evil of landmines and the following spring I went to Bosnia. Like many Americans, I remembered Sarajevo as a charming city that had hosted the Winter Olympics in 1984 but it had become a haunted shell of its former self with reminders of the war everywhere.

I've returned to Sri Lanka several times on behalf of JRS. Following the 2005 tsunami, I visited there, as well as other locations in southern India, to document JRS tsunami recovery efforts. While attempting to photograph tsunami kids in an orphanage run by a Jesuit, I climbed a child's tree house to get a vertical shot of the Jesuit surrounded by dancing children. The railing broke and I fell over 10 feet on my head, with my shoulders taking the brunt of the fall.

My companions took me to a hospital in a small tuk-tuk, a motorcycle with a rear bench. When I finally came to a few hours later, it took me awhile to recognize my colleagues. I still wanted to do the story that was scheduled for the next day, in spite of doctors' orders. After photographing the story, I lay on my back for two days and received muscle relaxants for the trip home. Unbelievably my neck didn't bother me at home but for the next year I thanked God daily that I could still walk.

Since my beginnings with JRS I have been sent to many of the locations where Jesuits and their lay colleagues accompany, serve and advocate for refugees. In the Sudan, Chad, Rwanda, and Thailand, along the Myanmar border, I photographed JRS's work in teacher education. In the Congo, Burundi and Chad, my assignment was documenting the JRS work to rehabilitate former child soldiers. Throughout Africa and South East Asia I have traveled to refugee camps where JRS is working to support efforts to assist thousands of people who have been driven from their homes because of war and regional conflicts.

On a 2011 trip to Europe and the Middle East, I saw JRS aiding undocumented refugees in major cities such as Rome where the Jesuit provincial house at the rear of the historic Gesu church has become a dining hall for refugees fleeing terrible conditions at home. It reminded me that during a famine, St. Ignatius himself once fed 300 people a day near the provincial house.

Later, I photographed JRS work with mostly Iraqi refugees in Turkey, Syria and Jordan. In Amman I met a couple whose beautiful, brilliant daughter had been killed in an attack on a church in Baghdad where she was attending Mass. If one photo sums up the hopefulness of JRS work, it is that of a nun in a veil reaching out to a veiled Arab woman. It speaks of JRS's outreach to people of all types.

I have no idea where I will go next but sadly the need to document the JRS response to violence and tragedy continues with no end in sight.

My work for JRS is the most profound expression of my vocation as a Jesuit photographer because I feel I CAN make a difference by bringing these images to people who would never otherwise encounter them.

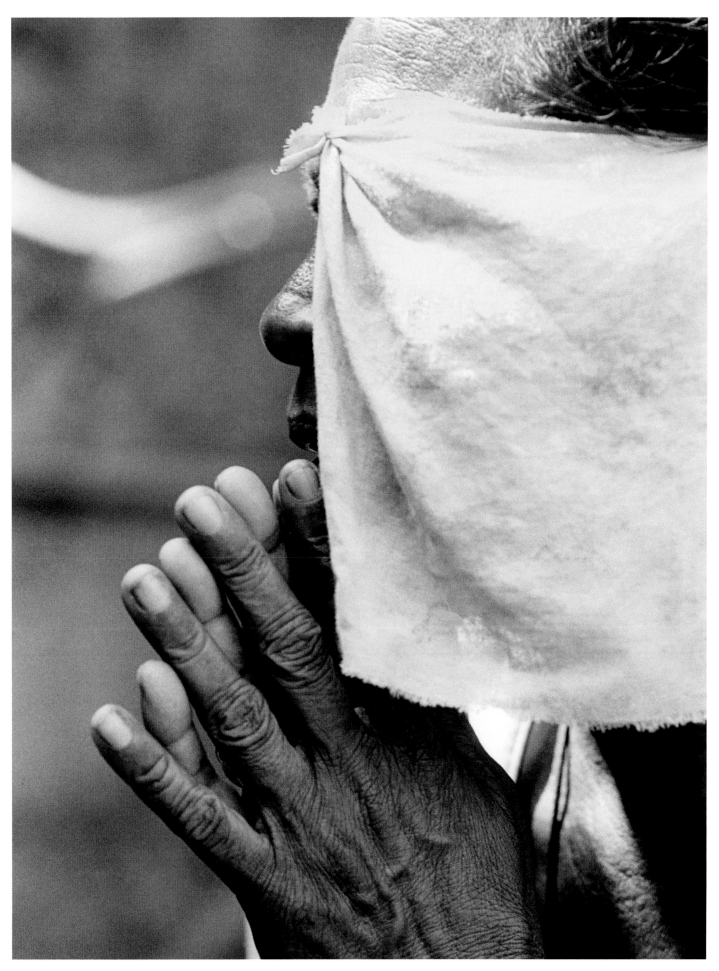

JAFFNA, SRI LANKA · *Sylvia Ihebelammer, 59, awoke in the middle of the night when she "felt a sound falling in my eye." Her small fishing village on the LTTE-controlled Jaffna peninsula had been shelled by the Sri Lankan security forces from across the lagoon. Her husband and three grandchildren were killed in the same blast. In a blank, traumatized daze she simply said: "All I can do is pray."*

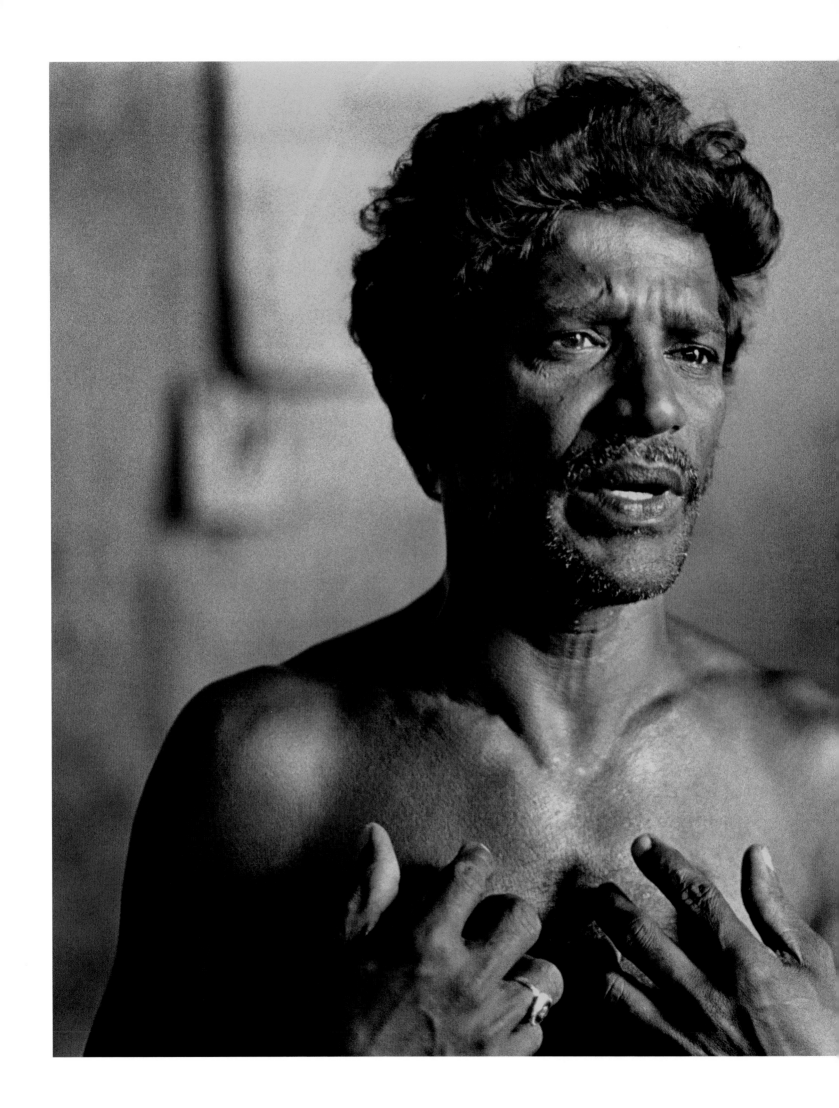

TRINCOMALEE, SRI LANKA

"We have no house, no proper home and $12 a month isn't enough to feed the nine in our family," said this man living in a rice warehouse near Trincolmalee. *Their home in Sampaltivu is less than ten miles away, but is caught in crossfire between the Liberation Tigers of Tamil Eelam [LTTE], a separatist terrorist organization and the Army. "We are made to feel like refugees — no proper home, no privacy. We had a home and now we're put in cages like animals."*

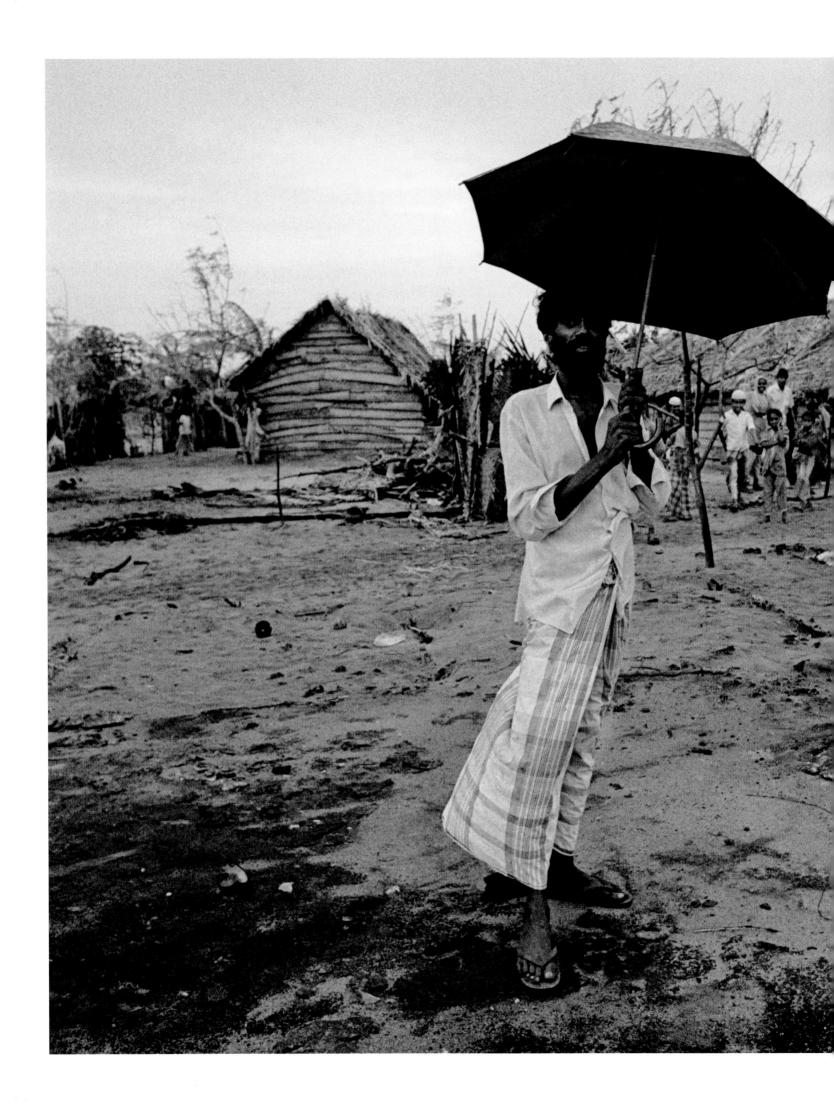

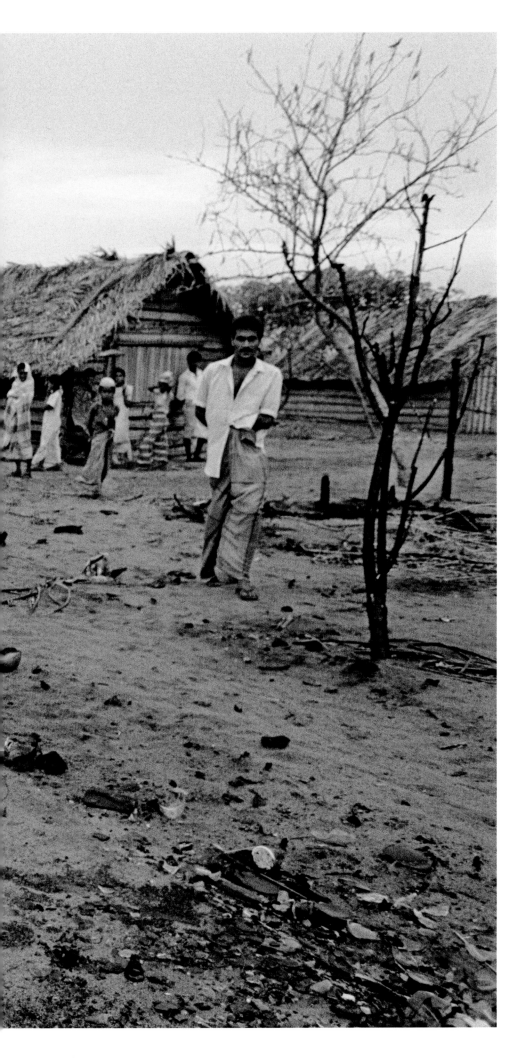

PUTTALAM, SRI LANKA

This man stands in the remains of his home along with 275 thatched roof huts in a refugee camp north of Puttalam. Although fire swept through the camp as a result of an accident, other fires reportedly have been set in nearby camps by the locals who accuse the refugees of competing for jobs and other resources.

More than 75,000 Muslims were driven out of the North by the Liberation Tigers of Tamil Eelam [LTTE]. They were given 48 hours to leave LTTE territory in 1990.

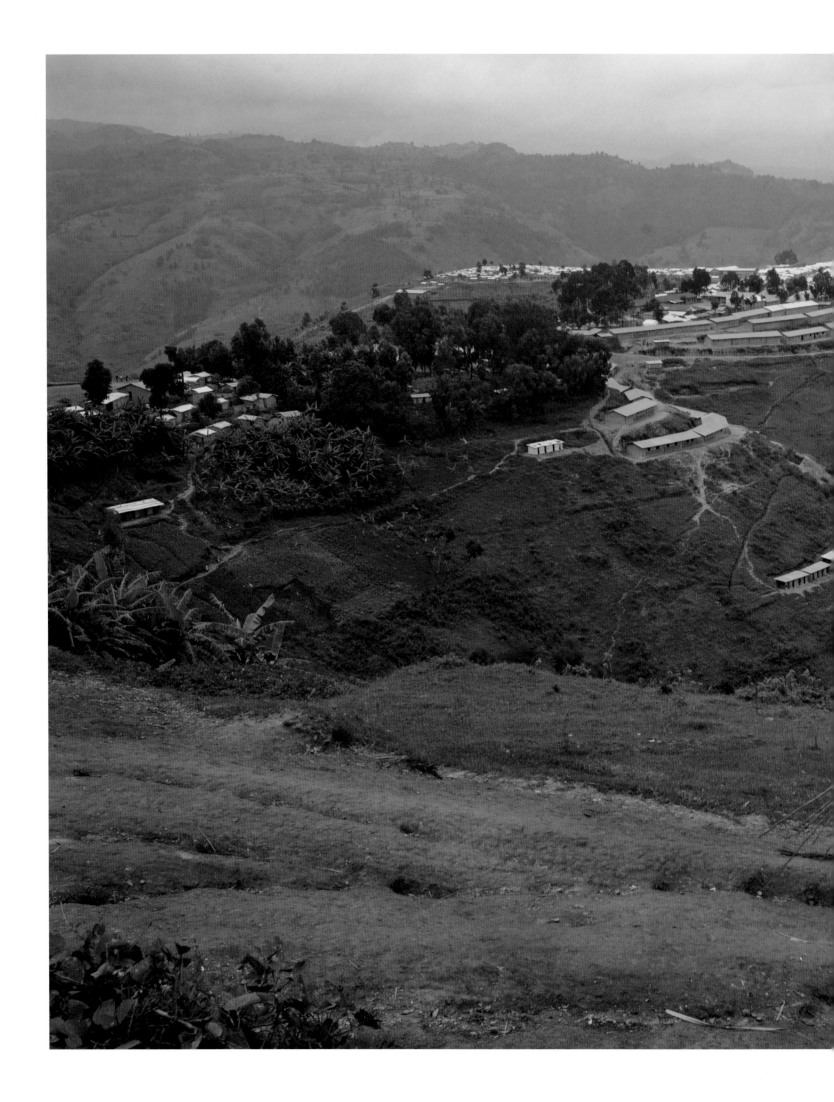

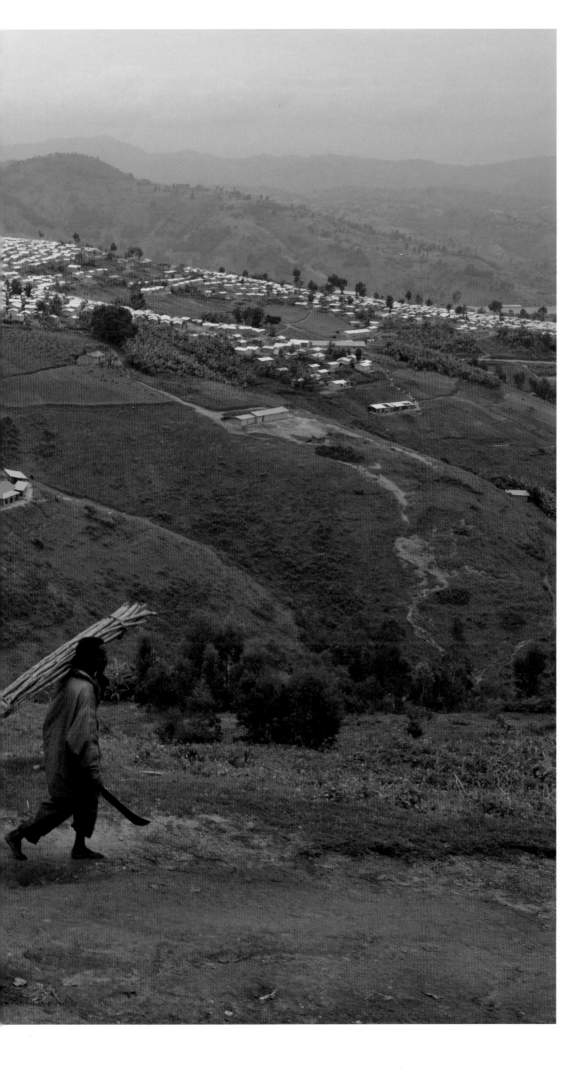

KIBUYE, NEAR LAKE KIVU, RWANDA

More than 18,000 refugees from the Congo live on 67 acres, twice the UNHCR recommended population for that amount of land.

Here at 2,100 meters altitude, JRS serves 700 students in kindergarten, 4,200 in primary school, 800 in secondary school, 210 in upper secondary, and 75 girls and boys in an informal training center to learn cooking, electricity, home economics and nutrition.

The normal stay in a refugee camp is 18-20 years. The rows of buildings in the foreground are the classrooms.

KOUKOU REFUGEE CAMP, CHAD

Students gather for class in a makeshift structure as others study under a tree in Habile #1, one of three schools in KouKou for Internally Displaced Persons.

It's too hot in the desert midday sun, so classes end at noon with a meal.

KouKou was attacked by the government soldiers about two months after I left. Two hundred died.

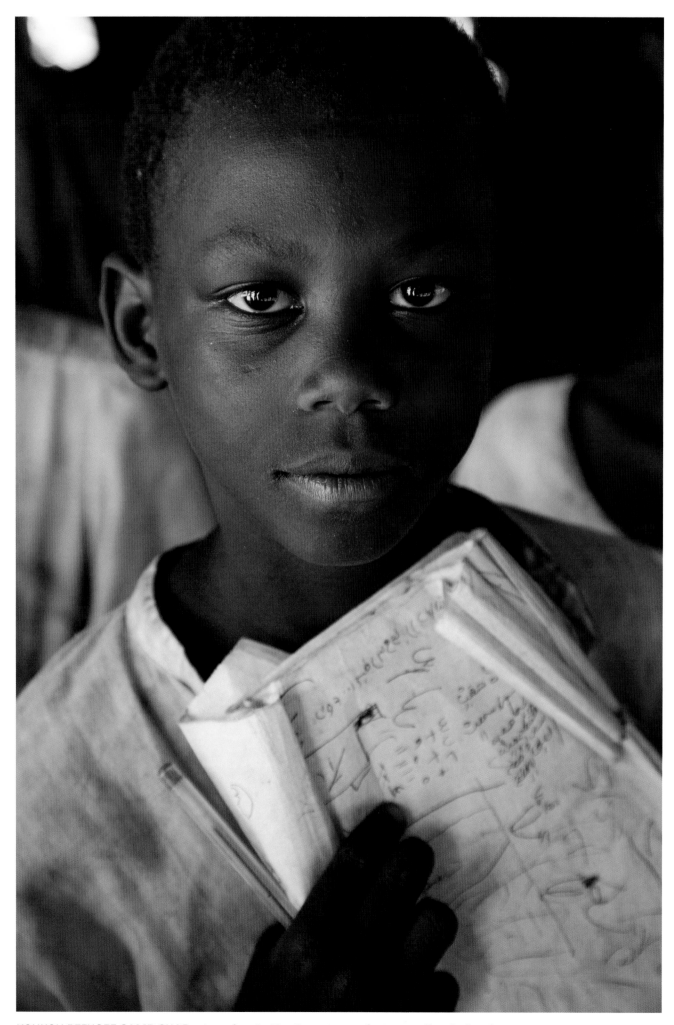

KOUKOU REFUGEE CAMP, CHAD · *A student in KouKou, a camp for Internally Displaced Persons.*

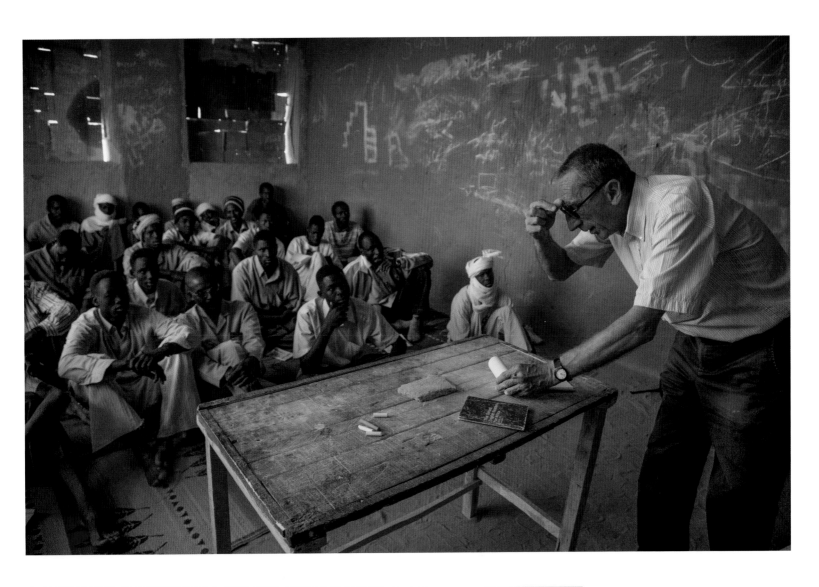

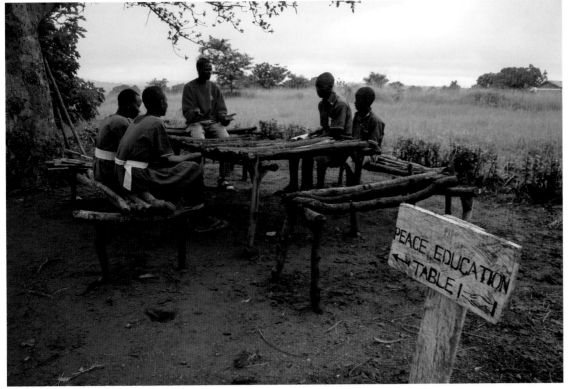

KONOUGOU, CHAD

Joaquin Ciervde, SJ, age 65, veteran African missionary, teaches English. As consultant for educational methods in Guéréda, Joaquin wrote the four teaching manuals in French, which were translated into Arabic. He has trained 69 teachers in the refugee camps.

KAJO KEJI, SUDAN

At Mondikolok Primary School, head teacher Joseph Lagu Pius, often leads the students in a conflict resolution session when arguments arise, teaching students peaceful solutions to their differences.

RANONG, THAILAND

Aung Kyan, 10, is in the first grade in a JRS training center. It helps the children make up for their lost time as refugees before entering Thailand's school system.

The marking on Aung's face is a paste made from tamarind bark used as a sun block and skin mosturizer.

Ranong is a port city about a 20-minute boat ride from southern Myanmar.

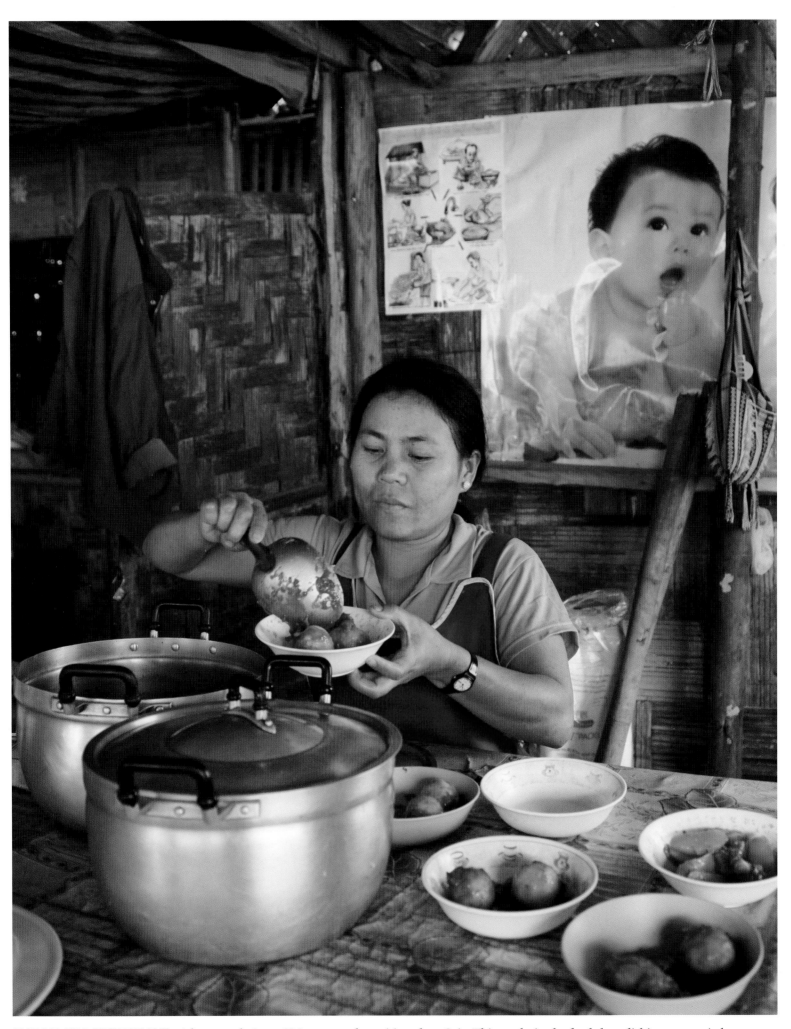

MOE MA KHA RESTAURANT · *After completing a JRS sponsored nutrition class, Sein Thit works in the food shop dishing up curried eggs.*

CAMP #1, THAILAND

JRS worker, Pleh Meh, and her newborn baby, Poe Meh, are visited in the camp's maternity ward by her traditional aunt, Htay Mo, and her mother-in-law, Ku Mo. The camp is about an hour's drive from Mae Hong Son, Thailand.

The advanced high school students have an opportunity to use a couple of the camp's working computers powered by solar panels.

ACEH, INDONESIA

In the village of Ie Merah, population 803, the community members unloaded two tractors costing 1.5 million Rupiah [about USD $1600] each. JRS supplied the tractors so the farmers of this former rebel village could begin rice farming.

The village imam, Mr. Teungku Ilyas, sprinkles rice on the tractors as a blessing. It is a practice of the Aceh people and not a Muslim ritual.

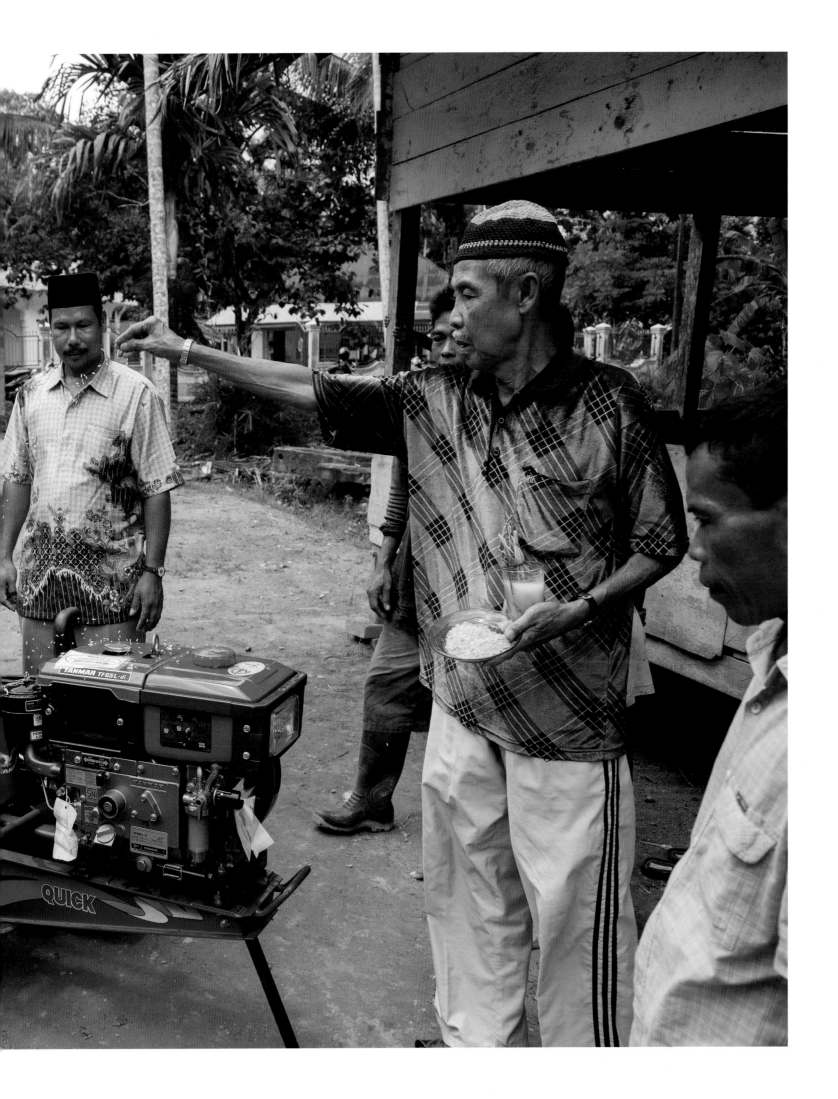

ACEH, INDONESIA · *Donatus Akur, JRS coordinator, assists villagers who build their new mosque that also functions as Lawe Buluh's community center.*

ACEH, INDONESIA

JRS Disaster Preparedness teams work in 17 schools and villages. On this day, the village of Lawe Sawah, population 2,800, simulated a disaster as they are susceptible to earthquakes, floods and tsunamis. Some men were identified as "victims."

Nelda, a JRS coordinator, helps the school children cross the bamboo bridge to the soccer field where a tent was set up to feed and minister to the villagers.

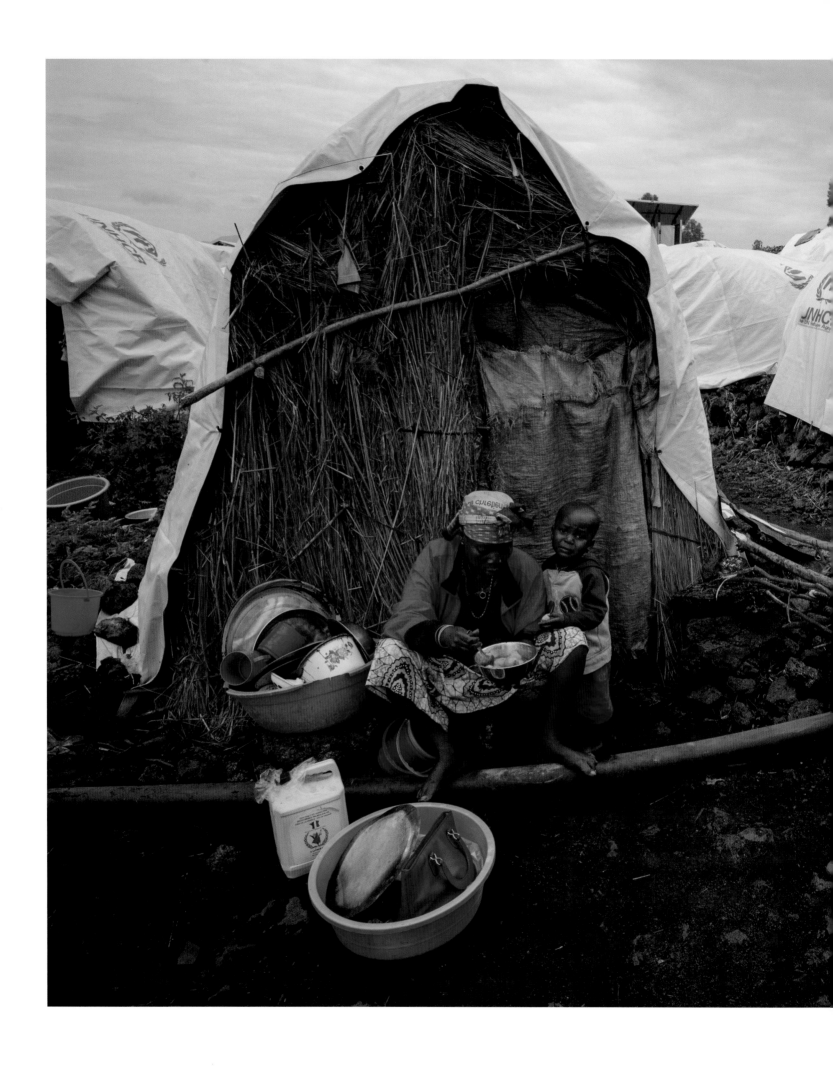

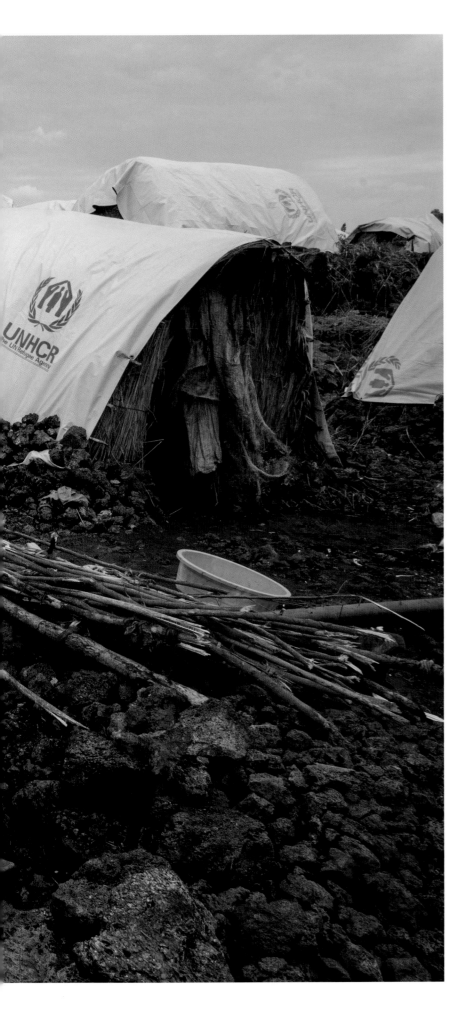

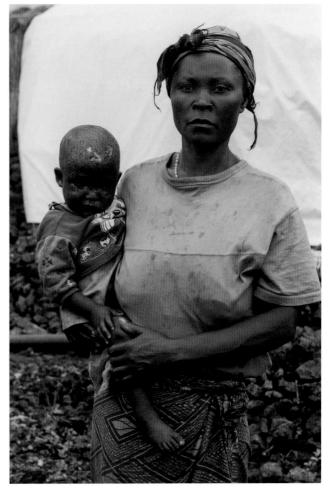

GOMA, DEMOCRATIC REPUBLIC OF CONGO

In the Mugunga #2 Refugee camp, a woman holds her child who had a skin disease the local clinic could not diagnose nor treat.

GOMA, DEMOCRATIC REPUBLIC OF CONGO

A woman lunches in the Mugunga Refugee camp, which houses over 100,000 fleeing violence. It is located on lava rocks of Mount Nyiragongo, an active volcano that killed 45 people as recently as 2002.

When I walked through the camp, it was gut-wrenching to view men or women rubbing their stomachs or putting a hand to their mouth indicating their hunger.

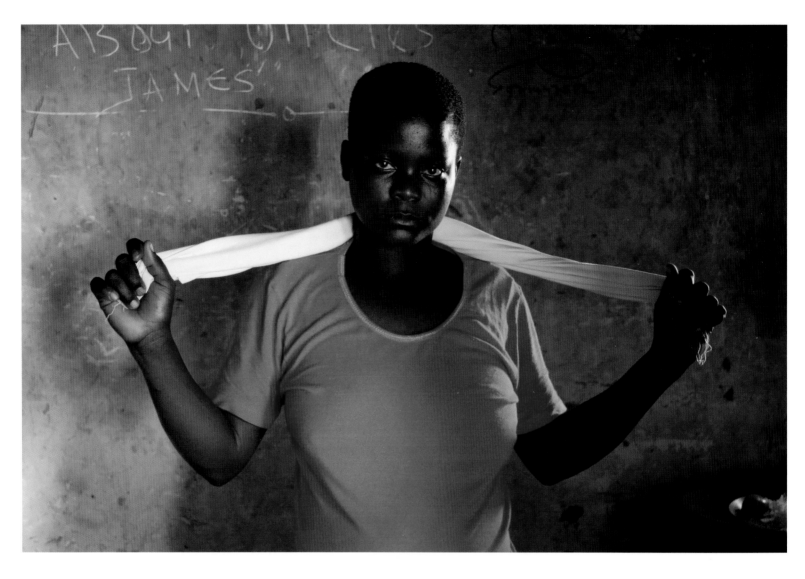

GULU, UGANDA

Consy Aloyo, age 25, was abducted in 1991 when she was 12 years old. She was freed in 2005, having spent 13 years in captivity and bearing two children to one of the commanders of the Lord's Resistance Army.

UVIRA, CONGO

Former child soldiers in the dormitory of the JRS rehabilitation center. Their counselors say they often wake up in the middle of the night screaming.

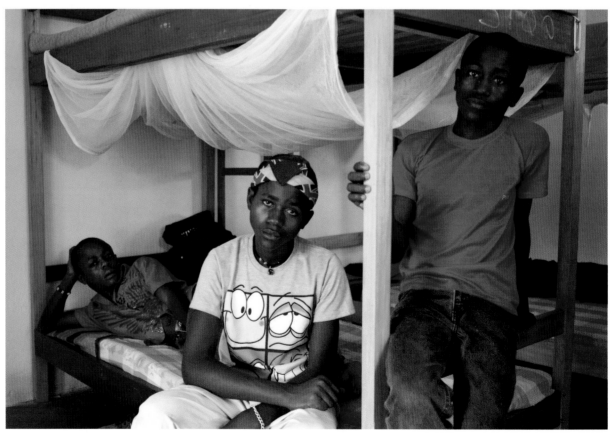

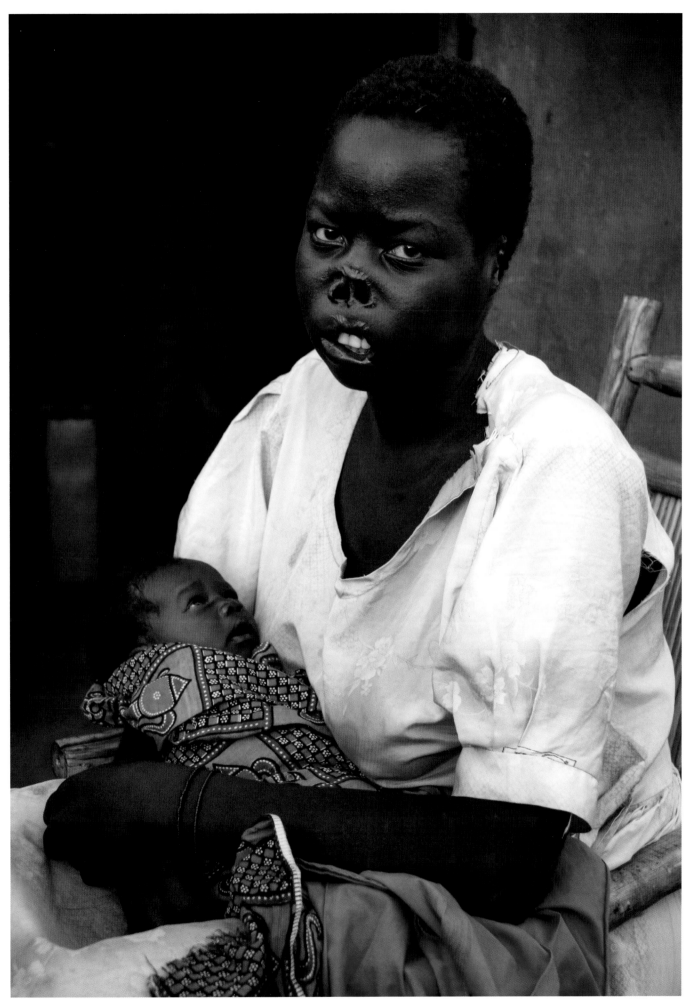

GULU, UGANDA · *Nancy Auma, age 18, with her baby, Aloyo, 'I have survived' in her native Acholi. Child solders cut off her nose, lips and ears when they saw she was with child, saying, "We have no use for you, a pregnant woman."*

GULU, UGANDA

Patrick Okello, age 12, in the blue shirt, with other former child soldiers at a local rehabilitation center where they are confined.

They get three meals a day, plus clothes and personal hygiene items. Parents sometimes complain they are being spoiled. Once they get out, they'll be lucky to get one meal per day. Some never make the transition into their local communities.

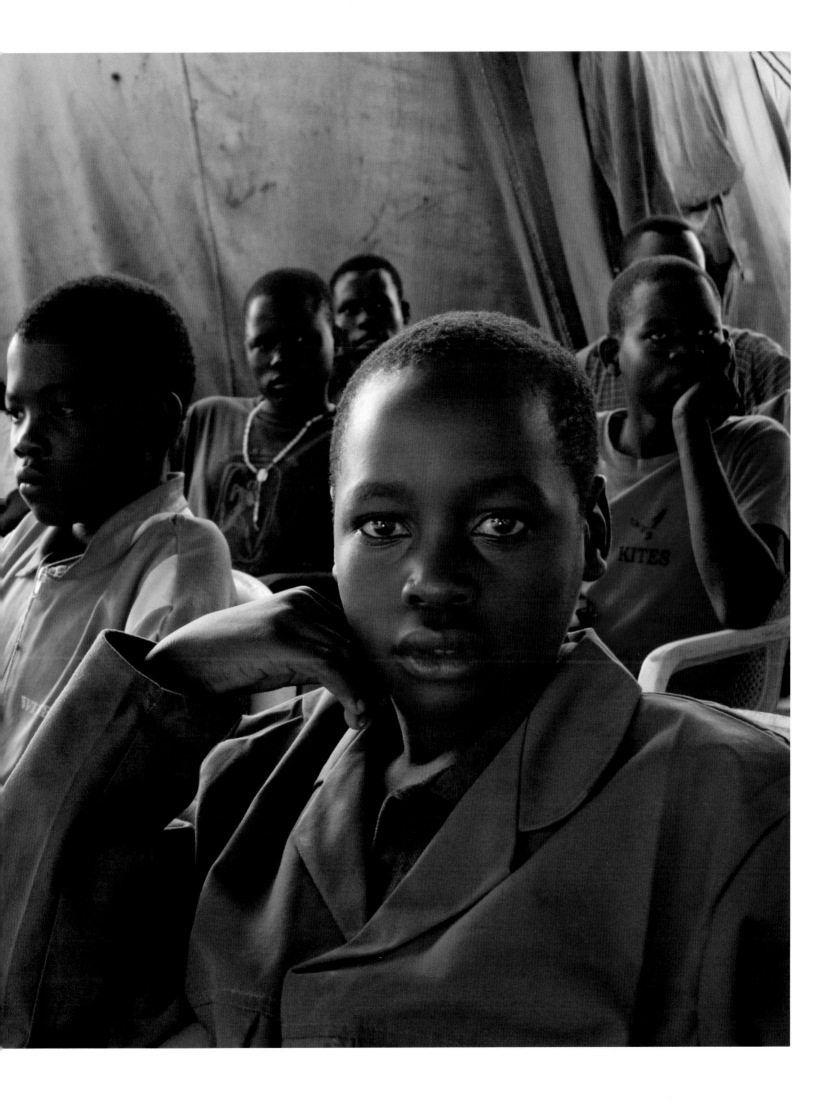

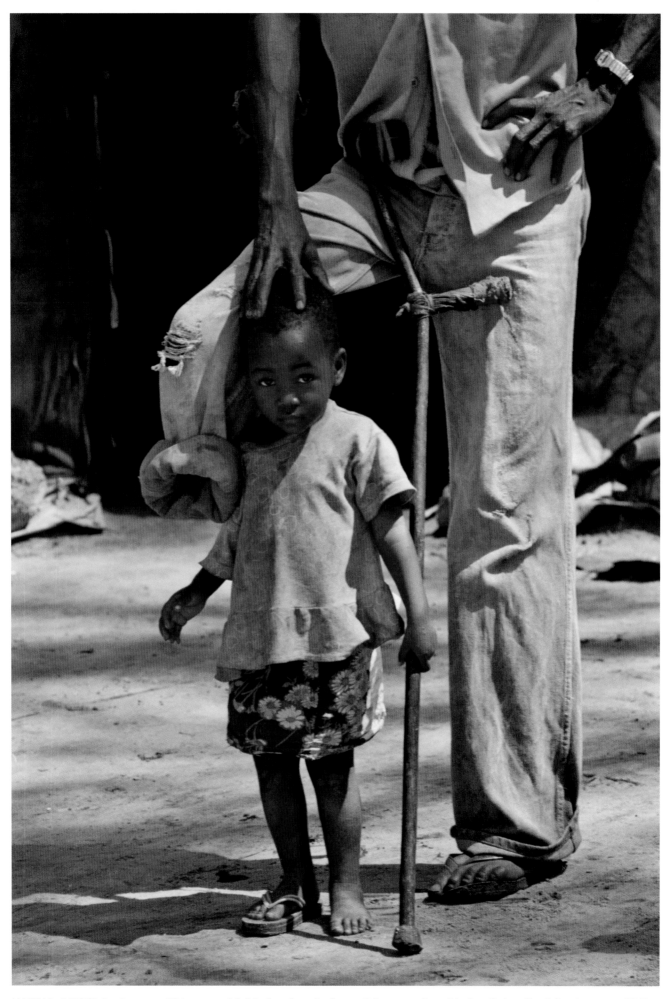

LWENA, ANGOLA · *Augusto Chimuna with his daughter in front of the tent where his family has lived for 4 years as IDPs, or Internally Displaced Persons.*

LWENA, ANGOLA · *An amputee lives with his wife in an abandoned rail car left behind by a Portuguese railroad.*

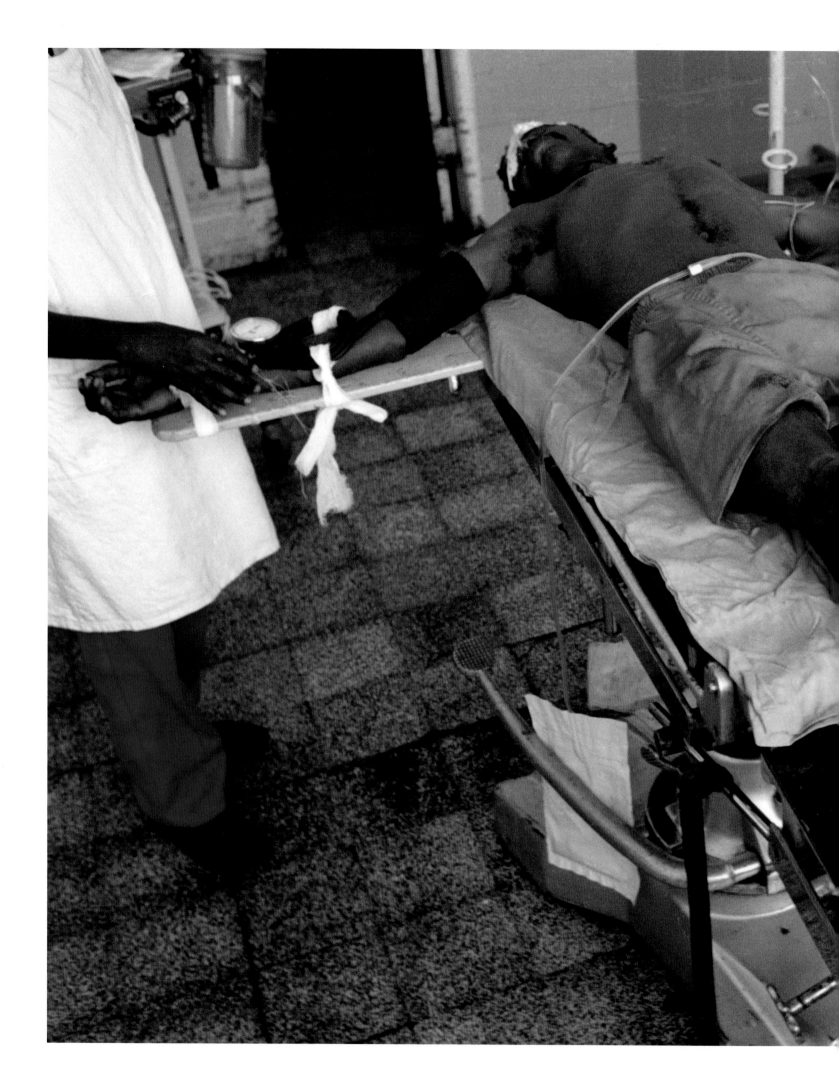

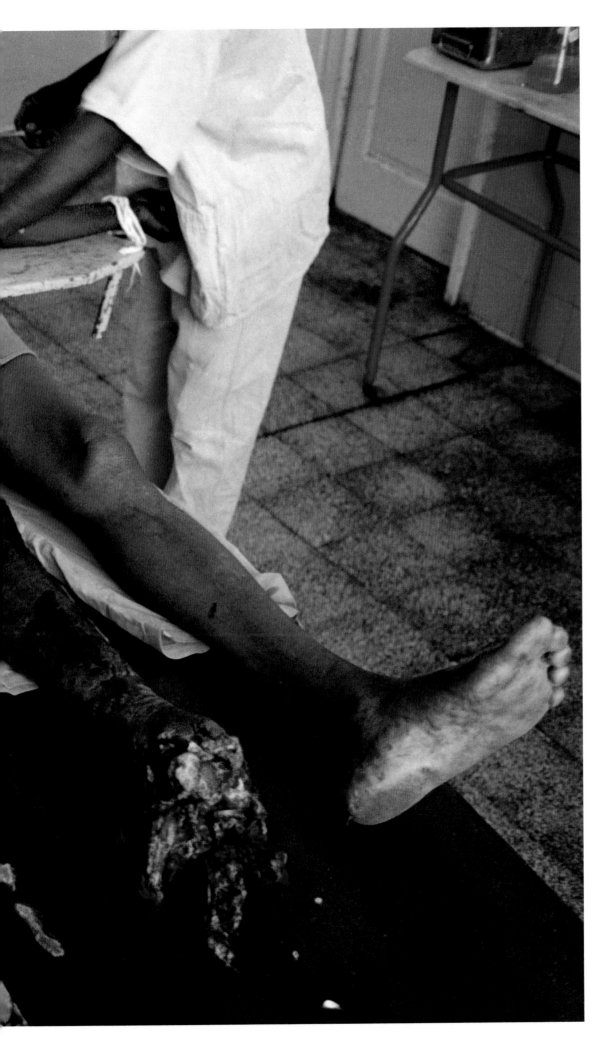

LWENA, ANGOLA

On March 11, 1997, Jose Samba, age 50, was gathering thatch for the roof of his home when he stepped on a "toe-popper" — a small plastic antipersonnel land mine about the size of a hockey puck.

His arms were tied to boards slipped under the operating table in a Luena hospital. Many amputations are done without anesthesia, and often have to be done again higher up the leg if it gets infected.

I had tears in my eyes as I took his photograph thinking, it's the poor of the world who are crucified by wars.

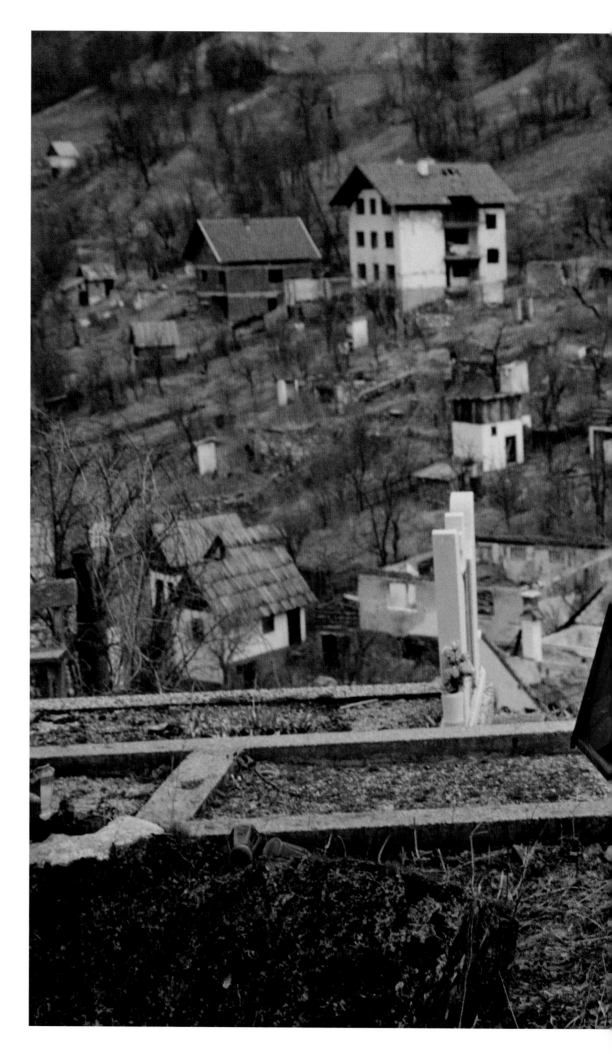

BOROVICA

About 60 kilometers north of Sarajevo, Marijan Pavlovic attempts to reposition a vandalized crucifix at the Borovica cemetery where his grandparents are buried.

Muslims from a nearby town had destroyed his village after giving the Catholic community 48 hours to leave the area.

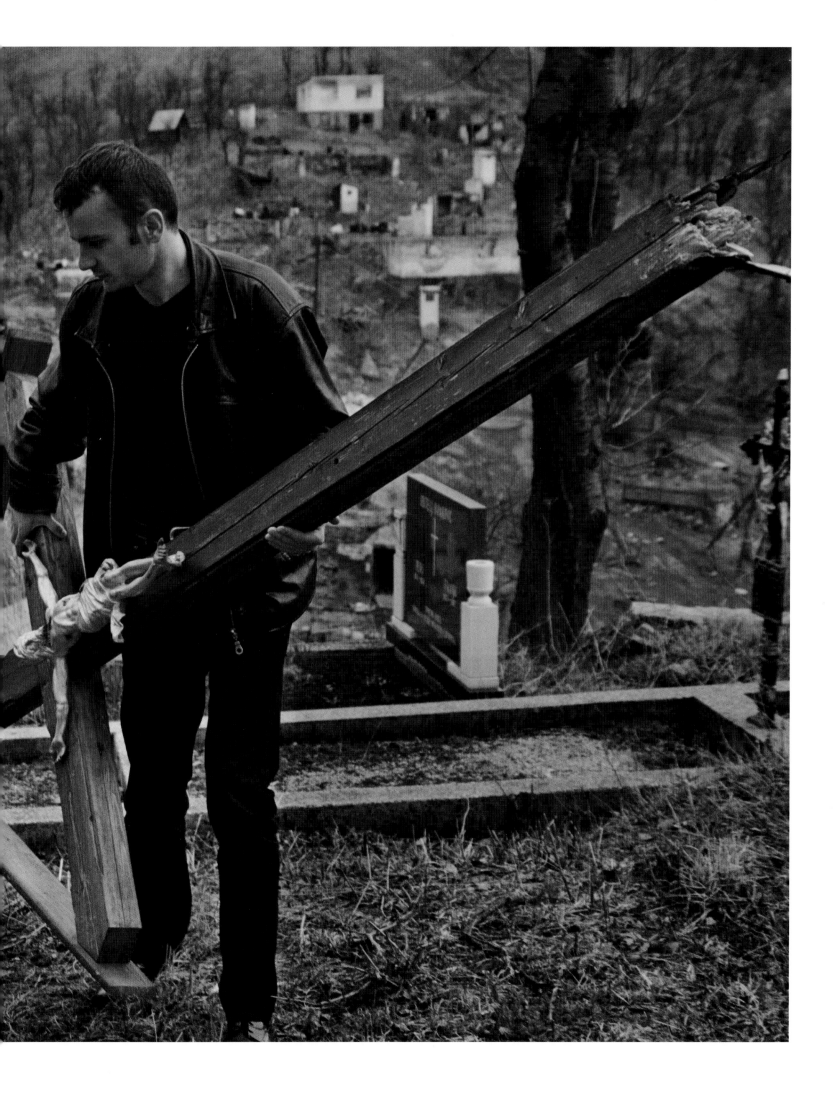

AMMAN, JORDAN

AN IRAQI FAMILY MOURNS THE LOSS OF THEIR DAUGHTER

I was on assignment in the Middle East for Jesuit Refugee Service when I met Wafi and Jenan Youssif, who like many Iraqi Christians, have left their country for Syria and Jordan.

The couple left their home, their possessions, everything in Bagdad in early February 2011 when they received threats to their lives. They lost their 22-year-old daughter Raghda when she bled to death in the same Baghdad Church where she had been married. The locked doors of Our Lady of Salvation Church were stormed by terrorists during Mass October, 2010.

Tears welled in all of our eyes when Wafi and Jenan showed me Raghda's near perfect grades while she earned her Ph.D. in chemical engineering, her plaque from representing the Syrian Christian youth community at the Eucharistic Congress in Amman, and the photos of her crowning the statue of Mary at the Baghdad church. We saw pictures of her wedding in that same church.

Wafi asked if I could look at some awful pictures. I said yes, not quite sure what he meant. Wafi showed the photos of his daughter's body in the church where she died, a place where she was actively involved in parish life. On that October day in 2010, when the terrorists attacked, Raghda took refuge in the church's sacristy with about thirty others.

They barricaded themselves in the darkened room. When the terrorists discovered their hiding place, they threw stun grenades into the room. A grenade rolled under Raghda's legs and exploded, breaking them, and causing her to bleed to death along with the child she only recently discovered she was carrying in her womb.

She called her father on her cell phone about 5:15 p.m., and he stayed on the phone with her until almost 9 p.m. She told Wafi that his sister was shot in the leg, and Raghda presumed she died. Later, Wafi learned that his sister survived the ordeal, and now lives in Toronto.

> When security forces finally broke into the church, the terrorists set off their suicide bomb vests. When it was over, 58 people had been killed.

Heart-wrenching as it was, Wafi stayed on the phone with his beloved daughter until she died. When security forces finally broke into the church, the terrorists set off their suicide bomb vests. When it was over, 58 people had been killed.

Wafi said he had asked Raghda not to go to church because the churches had been bombed for years. She told her dad: "If I have to die, I don't mind dying in church."

Wafi reminisced how he and his daughter, Raghda, rode daily to the Baghdad Technical University where she received her degree. He had worked there as an engineer and his wife worked in campus planning as a Computer Aided Design operator.

Wafi and Jenan said they really didn't want to live any more after losing their beautiful daughter, but they have their 20-year-old son, Yousiff Wafi, to look after.

Refugees in Jordan, Syria or Turkey are not allowed citizenship, not allowed to apply for a residency permit and not allowed to work. Wafi and Jenan live off of their savings and wait for United Nations High Commissioner for Refugees' approval for resettlement in Toronto, Canada, where they have relatives. Jenan's mother and her brother are there. Wafi has two sisters there, one a doctor, and the sister who was shot in the Baghdad church attack.

AMMAN, JORDAN · *Wafi and Jenan Youssif agreed to a photograph when I promised to send the photo and their story to the Toronto Catholic newspaper where it was published.*

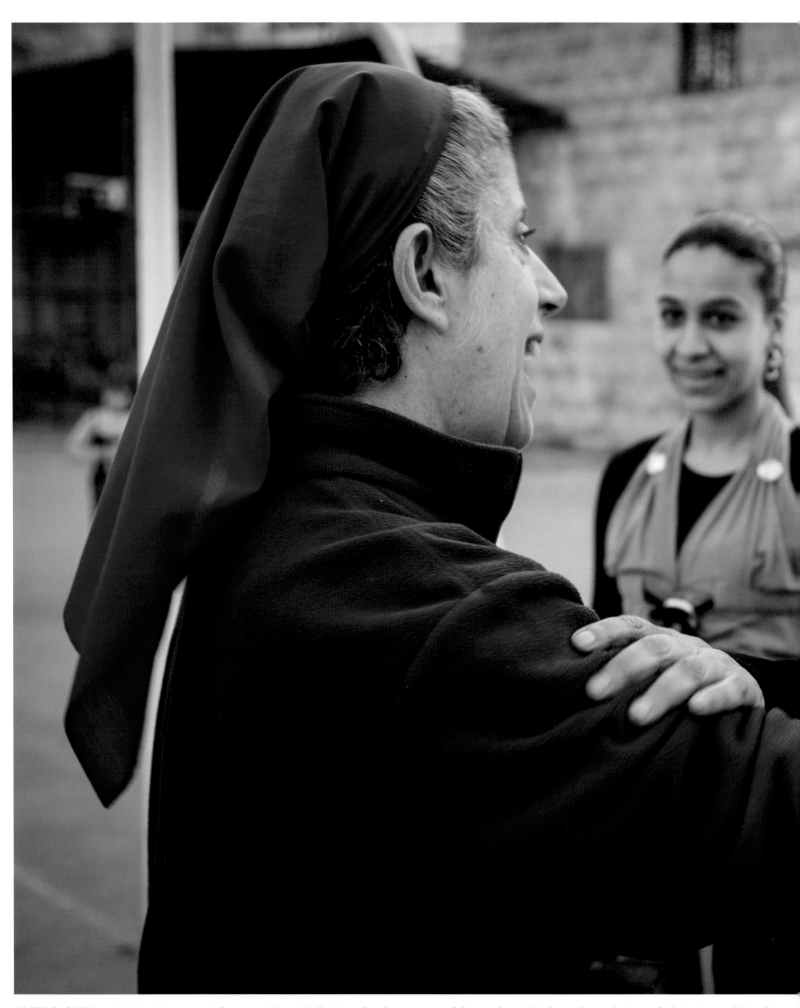

ALEPPO, SYRIA · *At Saint-Varan parish center, Sister Hala Daoud welcomes one of the mothers. JRS hosted a gathering of Christian and Muslim mothers on Syria's Mother's day.*

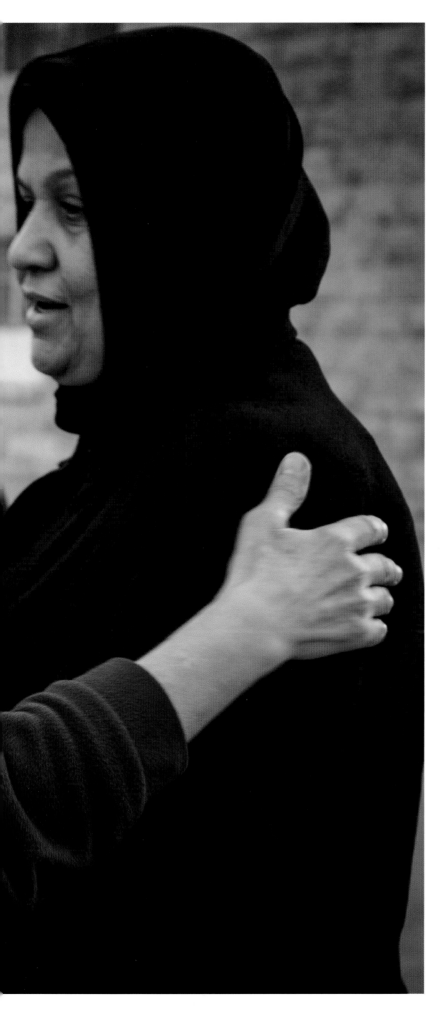

ANKARA, TURKEY · *A JRS staff member consoles Zamam Mahhammed, age 42, whose leg was shattered by a U.S. bullet in Mosul when his taxi was caught in a cross fire between the Americans and insurgents.*

REFLECTION

The Spiritual Exercises of St. Ignatius help each Jesuit probe his relationship with God, grow in prayer, and discover how he is being 'called' to serve.

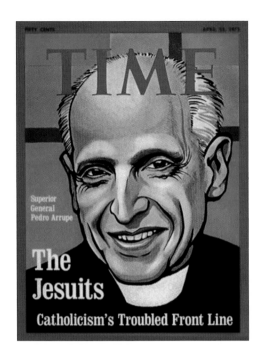

TIME COVER · *When I saw this cover of Time I said to myself, "that looks like my photograph!" Well, it was. Years earlier as a fledgling photographer I had sent it to Time Magazine, thinking it was a good photograph and hoping they might use it.*

When I didn't see a photo credit, a fellow faculty member and lawyer helped me craft a letter to Time's picture editor via registered mail requesting an answer within ten days.

An assistant photo editor got back to me with an offer of $50. When I hesitated, the head picture editor came back with a better offer.

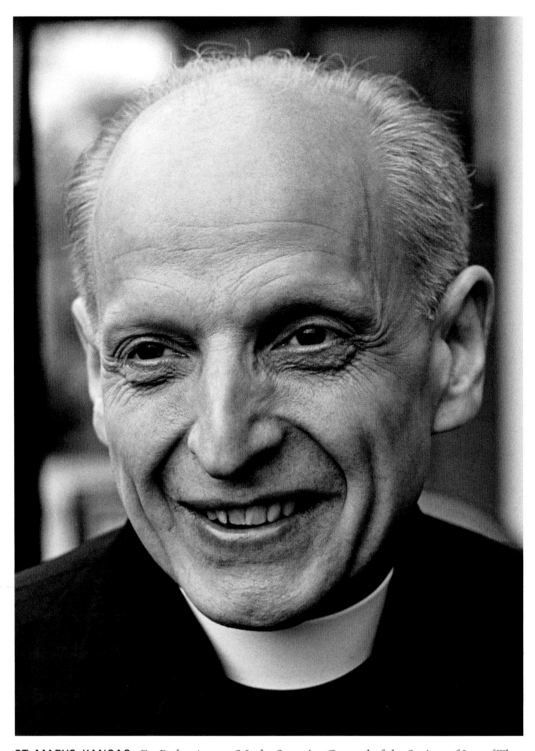

ST. MARYS, KANSAS · *Fr. Pedro Arupe, S.J. the Superior General of the Society of Jesus [The Jesuits], was visiting the school of theology in St. Marys, Kansas, where I was a student. and made this photograph of him in 1967.*

THE PRIVILEGE OF BEING A PHOTOGRAPHER

In 1996, as the relatively new holder of the Charles and Mary Heider Endowed Jesuit Chair, I volunteered to photograph the 34th General Congregation for Fr. "Pepe" de Vera, S.J., the Jesuit's secretary of communication.

That assignment went well. When Fr. de Vera was preparing the 35th General Congregation, he welcomed me back to Rome to be the official photographer of the gathering that would elect a new Superior General of the Society of Jesus in 2008. It was truly a privilege to meet the many stellar Jesuits from around the world who were chosen by their confreres to represent them at this historic moment.

As I posted photographs nightly, Creighton's Online Ministries website became the "go-to" URL for news from the Congregation in Rome.

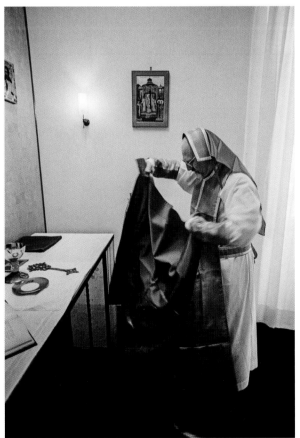

ROME, ITALY · *When I asked Fr. Peter-Hans Kolvenbach, why there were no images on the walls of his office, he replied he didn't want any distractions.*

During a visit to Rome, he allowed me to do a 'day-in-the-life of' photo shoot of himself. Here he was vesting for his very early morning, private Eastern rite Mass.

Often Father would invite Jesuit visitors to the roof overlooking St. Peter's Basilica where they could make photographs. He also invited visiting Jesuits to dine with him where he proved to be a witty raconteur.

ROME, ITALY · *At only the 35th General Congregation [meeting] in over 450 years, Jesuit representatives from the 95 provinces around the world gathered in a meeting room referred to as the "Aula" to elect a new Superior General of the Jesuits, and formulate other policy matters.*

On the roof of the Jesuit headquarters in Rome after his election, Fr. Adolfo Nicolás, S.J., poses with Fr. Peter-Hans Kolvenbach, S.J., who held the job as Superior General for over 24 years.

ROME, ITALY · *After his election by the delegates in the Aula, Fr. Adolfo Nicolás, S.J., former provincial of Japan, and superior of the Asia Pacific Region takes his oath of office as Superior General of the Society of Jesus.*

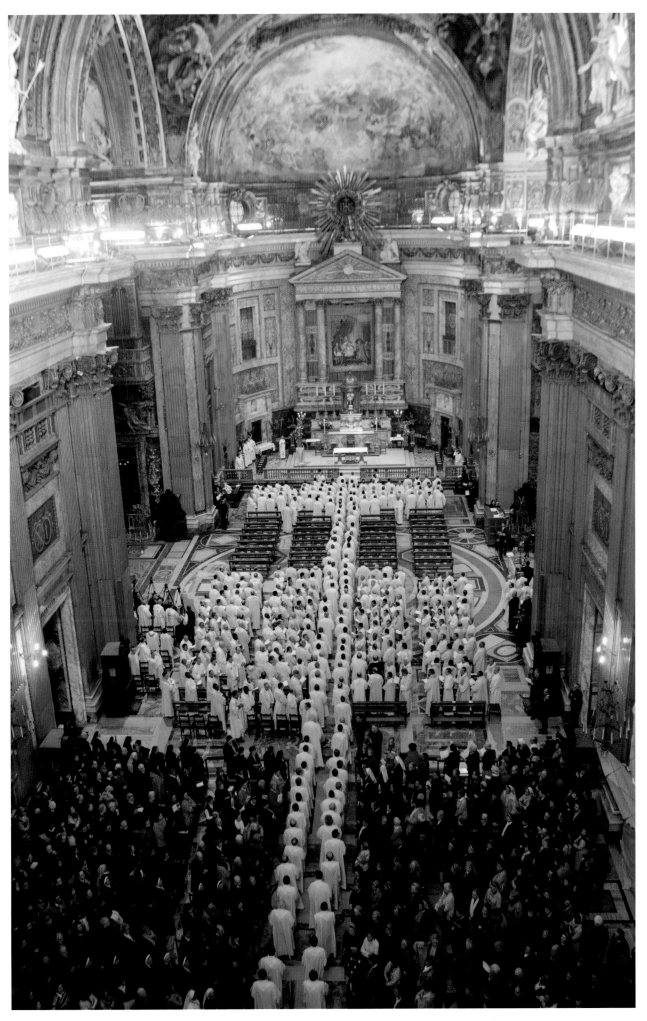

GESU CHURCH, ROME · *Delegates and Jesuits gather for a Mass to celebrate Fr. Adolfo's election.*

NOVOSIBIRSK, SIBERIA · *At a meeting of all Jesuits working in Russia, Fr. Adolfo wears a traditional hat, a "Tybeteyka," presented to him by a Jesuit from Kyrgyzstan.*

HOMS, SYRIA

Fr. Adolfo enjoys the sparkler and the gigantic cake in the shape of a bible at a celebration after he heard the final vows of Fr. Nawras Sammour, S.J. , in a Byzantine rite mass.

L-R: Jesuits, Ziad Hilal, Frans van der Lugt, Fr. Adolfo, Fr. Nawras Sammour, and Fr. Antoine Kerhuel.

BERKELEY, CALIFORNIA · *Fr. Nicolás presides over a meeting of the Jesuit School of Theology's board as it approves its transfer to Santa Clara University.*

REFLECTION

AN IMPORTANT PART OF EVERY JESUIT'S LIFE is his annual retreat in which he withdraws from his normal duties to pray and reflect on the year just past in an effort to determine God's will for the year ahead. St. Ignatius instructed us to listen for the voice of God in our lives, meditating both on the blessings we have received and any sinfulness that impedes our response to His will for us. As I reflect on my 50 years as a Jesuit photographer, I am struck by how important my annual retreats in Wyoming have been – how differently this story might have unfolded without this annual opportunity to take stock and meditate on where the Spirit is calling me next. So let me close with some thoughts like those I normally ponder on a retreat.

■ How blessed I have been to spend my life as a Jesuit, sharing community with members of the Society everywhere from Omaha to Amman, especially those serving the poorest of the poor.

■ How blessed I am to celebrate Mass at St. John's Church on the Creighton campus where the spirit of the people is as beautiful as the liturgy and the Gothic architecture.

■ How blessed I have been to combine teaching and a career in photojournalism serving the Society and the people whose lives we touch.

■ How blessed I am to have had the support of everyone, from university officials who sanctioned my requests to take off on photographic missions, to native families who trusted me as both their priest and as a photographer to chronicle their lives.

■ How blessed I have been to share life with a rich assortment of friends, students, colleagues, photographic mentors, and people of all types all over the world.

■ How blessed I have been to capture the images of children on the calendars for Red Cloud and St. Augustine Schools, and in some of the world's saddest places. They remind me that God has only one child and that child is all children.

■ How blessed I have been to enjoy good health, energy and continued enthusiasm for life and learning in a field which offers endless opportunities for new adventures.

This retrospective has helped me reflect on the past half century to discern what God has in store for me next, just as I do on my annual retreat. I hope to be like the 90-year old I read about, sitting on his front porch making photographs of clouds, still listening to the promptings of the Spirit.

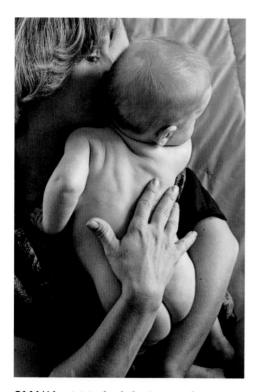

OMAHA · *A Mother's loving touch.*

MILWAUKEE · *Mother Teresa prays at Mass.*

JERUSALEM · *A young boy appears to be opening the tomb door with a delicate touch.*

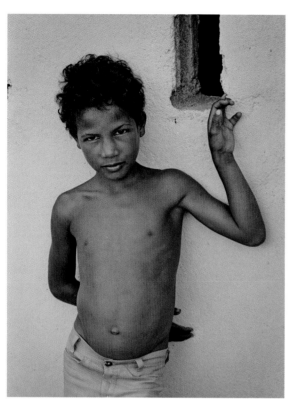

CLINIC · *Waiting for the clinic to open.*

ILAC IN THE DOMINICAN REPUBLIC

Two wonderful Cuban Jesuits, the late Narciso Sanchez Medio, and Ernesto Travieso founded The Institute for Latin American Concern in the mid '70's because they wanted to help North Americans better understand and appreciate the richness of the Caribbean culture.

The ILAC Center in the Dominican Republic is housed at "La Mision" located 7.5 kilometers outside Santiago. Located in the second largest city of the Dominican Republic, the ILAC Center provides numerous opportunities for students and professionals to grow personally, professionally and spiritually.

At Creighton ILAC has evolved into a full panoply of educational programs, for dental, medical, nursing, pharmacy, law, physical therapy, occupational therapy, undergraduate, and high school students. Faculty-led groups, medical/surgical teams and other colleges use the facility for service-learning and immersion experiences in rural Dominican Republic.

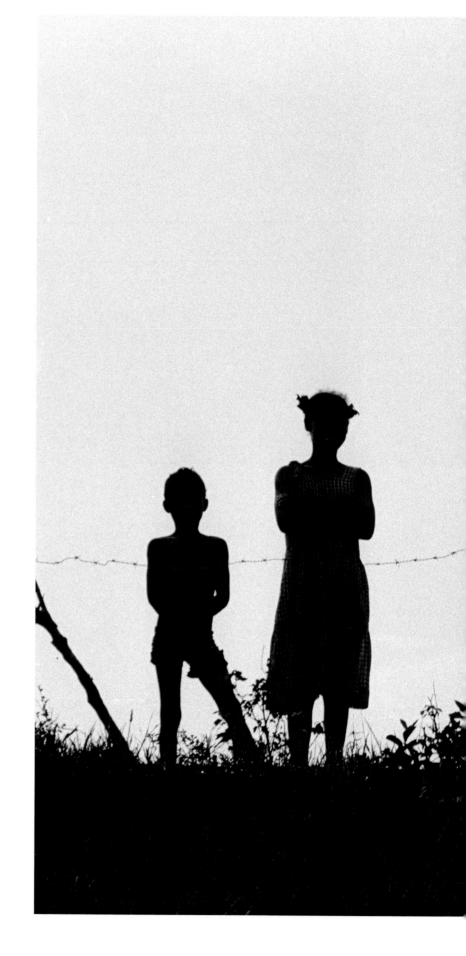

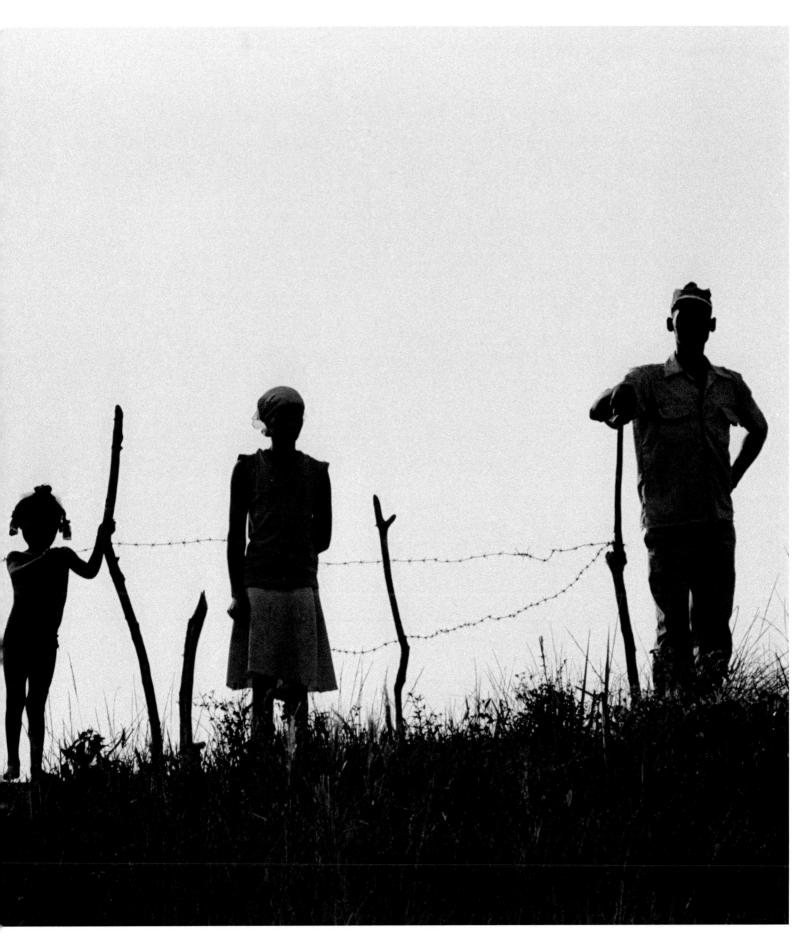

DOMINICAN FAMILY · *After I had photographed them winnowing beans, they gathered to watch us leave their mountain village of Jamamucito.*

THE PINES OF ROME · *St. Peter's Basilica is framed among the pines that were an inspiration for Respighi's symphony, The Pines of Rome.*

BELLA ROMA

My first trip to Rome was with my friend, Ernesto Travieso, S.J., who had lived in the Eternal City for four years as he obtained his degree.

It was a thrill to explore the city with Ernesto because he knew it like the back of his hand. He loved pointing out details like the leaves [above] that he said were the inspiration for the Corinthian columns, and the Pines of Rome that inspired Respighi's composition.

BELOW GREAT FALLS, MONTANA · *May 31, 1805 – Missouri Breaks, Montana "The hills and river Clifts which we passed today exhibit a most romantic appearance. The bluffs of the river rise to the hight of from 2 to 300 feet and in most places nearly perpendicular; they are formed of remarkable white sandstone." – William Clark*

LEWIS & CLARK TRAIL

Alan Klem, theater professor at Creighton, asked me if I had a student who could make photographs for a new musical he had written about the explorers Lewis and Clark, narrated by Clark's slave, York. I replied: A student? I'd like to photograph along the Lewis and Clark trail! The production was brilliant and featured in Creighton's Magazine.

I made it a rule to travel only 250 miles a day, camping out from Wood River in Illinois to the Pacific Ocean — a beautiful way to see and photograph the American West.

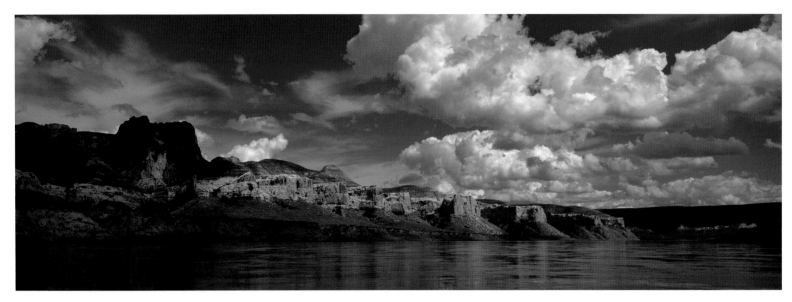

MISSOURI RIVER BREAKS, MONTANA · *May 31, 1805 "As we passed on it seemed as if those seens of visionary inchantment would never have and [an] end; for here it is too that nature presents to the view of the traveler vast ranges of walls of tolerable workmanship. . ."*

– Meriwether Lewis

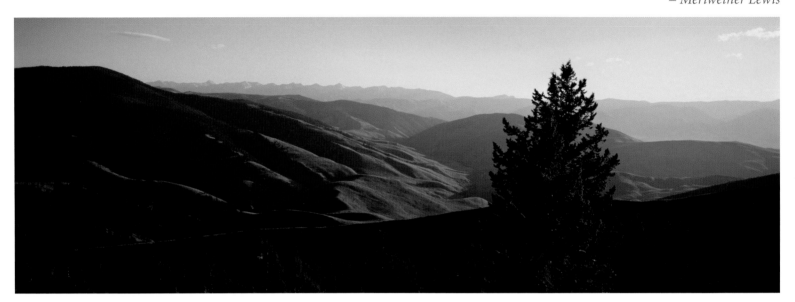

LEMHI PASS, CONTINENTAL DIVIDE, IDAHO/MONTANA · *August 19, 1805 "We saw snow on top of a mountain, and in the morning there was a severe white frost, but the sun shines very warm where we now are."*

– William Clark

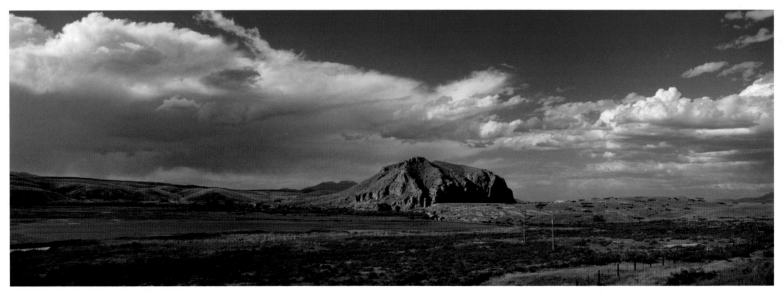

BEAVER HEAD ROCK, MONTANA · *August 8, 1805 ". . . the Indian woman recognized the point of a high plain to our right which she informed us was not very distant from the summer retreat of her nation on a river beyond the mountains. . ."*

– Meriwether Lewis

Acknowledgements

Publishing a book is never done single-handedly. It pleases me to acknowledge the following individuals who made this book a reality.

Carol McCabe, who is superbly organized, scanned the black and white photographs, and prepared all images for publication.

Maggie Wissink, who loves archives, found many of the images buried deep in my 50 year archive as she organized it.

Eileen Wirth, friend, colleague, and chair of Creighton University's Department of Journalism, Media, and Computing, interviewed me and wrote the original text.

Donald Winslow, friend, colleague, and editor of News Photographer, the magazine of the National Press Photographers Association, helped me edit 50 years of photographs, and did the original page layouts to make this a book of photographs.

Patrick Osborne, friend, designer at Mutual of Omaha, who for ten years designed the award winning St. Augustine Indian Mission calendars, gave the book its final design and typography.

Carol Zuegner, friend, colleague in Creighton University's Department of Journalism, Media and Computing, proof read the text.

Maureen Waldron, friend, and colleague in the Creighton University's Collaborative Ministry office, provided invaluable editorial advice.

Sponsors

Publishing a book requires a substantial investment. The following sponsors made it possible:

Charles and Mary Heider

The Karen and Mark Rauenhorst Foundation

Terry and Judy Haney

Louie and Sue Andrew

Peggy A. Reinecke and Dean F. Arkfeld

Camilla Parson, M.D.

Jim and Betty Quinn

Judith K. Stoewe, M.D.

Sandy, Amy, and Hope Matthews

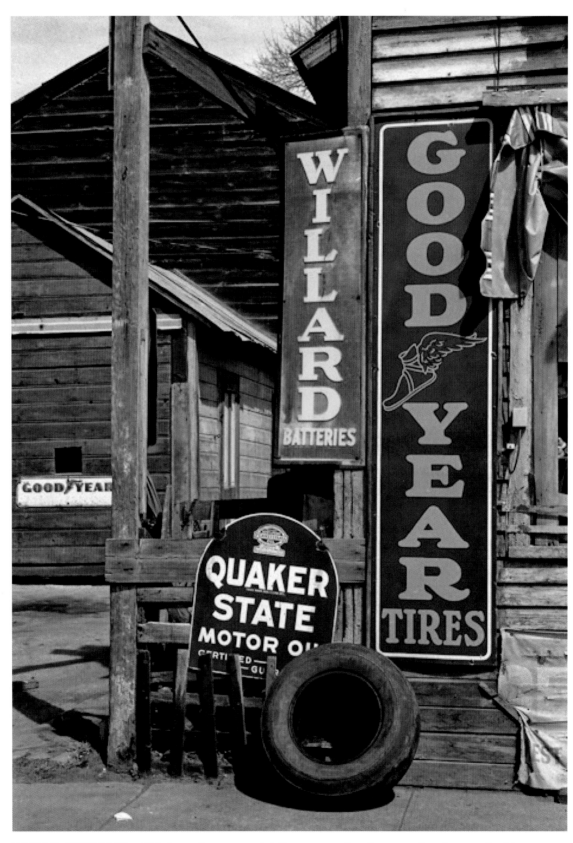

WISNER, NEBRASKA · *This is my homage to Walker Evans, the photographer famous for his photographs of the Dust Bowl years in 1930's.*